BUT IS IT
ART?

VALUES AND PHILOSOPHICAL INQUIRY
General Editor: D. Z. Phillips
Also in this series

BUT IS IT
ART?

The Value of Art
and the
Temptation of Theory

B. R. TILGHMAN

Basil Blackwell

© B. R. Tilghman 1984

First published 1984
Basil Blackwell Publisher Limited
108 Cowley Road, Oxford OX4 1JF, England

Basil Blackwell Inc.
432 Park Avenue South, Suite 1505
New York, NY 10016, USA

British Library Cataloguing in Publication Data

Tilghman, B.R.
But is it art?
1. Art—Philosophy
I. Title
700'.1 N66
ISBN 0–631–13663–0

Typeset by Oxford Publishing Services
Printed in Great Britain by
Billings & Son Ltd, Worcester

Contents

Foreword

Some of this book is about art, but mostly it is about the philosophy of art and it is also in part about Wittgenstein. One may be forgiven for thinking that this latter pair of topics are like veins that have been pretty well exhausted and for wondering why anyone should have the temerity to suppose that there is anything left in them that is worth getting out. After all, books on the philosophy of art have been appearing recently in astonishing numbers for a subject that within living memory was castigated for its dreariness; and now, more than thirty years after his death, the volume of literature on Wittgenstein is proving positively burdensome. My defense of the undertaking meets these reservations head on by affirming my conviction that both topics are important and that both have, in one way or another, been misunderstood.

The philosophy of art is important because art is important. That, I think, can go without saying, at least it doesn't need to be argued here. If we are going to think about anything as important as art – and it is very difficult not to think about it – it is important that we think clearly about it. One of the burdens of this book is to show that much philosophy of art is not clear thinking. It is the techniques of philosophical investigation that can be learned from Wittgenstein that allow the confusions in recent philosophy of art to be recognized and shown for what they are and it is some rather neglected aspects of his work that permit a better

understanding of what it is that generates those philosophical missteps. Thus armed we can avoid those missteps and, perhaps more importantly, by getting a clearer view of the confused nature of the questions we are inclined to ask, purge ourselves of the inclination to take them.

G. E. Moore remarked somewhere that he did not believe that the world or the sciences would have suggested to him any philosophical problems; it was, instead, what philosophers said about those things that got Moore's philosophical wheels turning. I must confess to being like that with respect to art. I do not believe that art would have ever suggested to me any philosophical problems. When I look at paintings, read poetry, or listen to music there are frequently many questions that I want to ask, but these are not philosophical questions. As in Moore's case, my philosophical questions come from what philosophers say about art.

Before going on to describe more of what this book is up to, something needs saying about my use of the word 'philosophy'. Traditionally philosophy has sought to construct theories designed to answer a number of questions about the nature of the world, our knowledge of it, the nature of man, his values and his place in the world. From Wittgenstein, however, I have gained the notion that this traditional philosophical enterprise is a species of (deep) intellectual confusion resulting from misunderstandings about how language is used and it comes into being when language goes, as it were, on holiday. From this notion arises another sense of the word in which philosophy is understood as the activity of uncovering the roots of those questions and confusions and of seeking a sufficiently clear view of those regions of language that led us astray in the first place so that we will not longer be tempted into those mistakes and can then stop doing philosophy. Thus there is a kind of 'systematic ambiguity' in my use of 'philosophy', but I don't believe the reader will have any difficulty recognizing which conception is being invoked on any particular occasion.

One important technique in this latter kind of philo-

sophical practice that I draw from Wittgenstein is to remind ourselves continually by means of a variety of examples of how certain words are actually used in the activities of life that is their home and then to compare that use with the philosopher's picture of their use. If this book were to have a motto, it would be Wittgenstein's description in the *Philosophical Investigations* of this aspect of his philosophical method: 'What *we* do is to bring words back from their metaphysical to their everyday use' (§116).

The present investigation concentrates on the word 'art' itself and some of the many attempts to formulate a philosophical definition of it and thus arrive at a theoretical understanding of art. The principal question to be investigated is therefore the traditional one, What is art? In the first half of the twentieth century aestheticians and philosophers of art had no doubt that one of the chief tasks, if not the chief task, of their discipline was to answer that question with a definition or general theory of art. This assumption about the chief task of aesthetics was challenged in the fifties. The grounds for this challenge were to a large extent drawn from what was thought to be suggested by Wittgenstein's *Philosophical Investigations* which was published in 1953, although a number of its ideas had been circulating earlier. On the basis of some of the things Wittgenstein had to say about the nature of language and the meaning of words, it was argued that no definition of the kind traditionally sought was possible, indeed, was not needed, and that any such attempt at definition could only result in a misdescription of the actual use of the word 'art' and its relatives, 'painting', 'poem', 'novel', and so on.[1]

If there is a philosophical consensus at present on these

[1] See Paul Ziff, 'The Task of Defining a Work of Art', *The Philosophical Review* 62 (1953), pp. 58–78; Morris Weitz, 'The Role of Theory in Aesthetics', *Journal of Aesthetics and Art Criticism*, 15 (1956), pp. 27–35; and W. E. Kennick, 'Does Traditional Aesthetics Rest on a Mistake?', *Mind*, 67 (1958), pp. 317–34.

things, it is that the Wittgensteinian partisans were not successful in demonstrating either the impossibility or futility of philosophical definition and theories of art, and as a result there has been a new wave of essays on theory and definition. The failure of the Wittgensteinian faction to win general acceptance for its case has, I believe, at least two causes. In the first place, it misunderstood certain of the things that Wittgenstein was talking about and failed to make clear the full range of application and the full implications of the ideas of Wittgenstein that were being appealed to. In the second place, we cannot overlook the grip that certain pictures of language and its workings has on philosophers, that bewitchment of intelligence by language of which Wittgenstein spoke, that makes Wittgenstein's way of looking at questions so uncongenial to contemporary philosophers.

Since we begin with the assumption that art is important to our lives, we must also be prepared to assume that reflective questions about art and its value are bound to be important questions. Those philosophers who seek theories and definitions are thereby seeking answers to important questions. Those philosophers who challenge the feasibility of that search are also seeking answers, albeit of a different kind, to the same important questions. The aim of both parties to the dispute, after all, is to understand art and it is tempting to suppose that the form the understanding will take, whether by way of definition or some other, is not the sort of thing that can be specified prior to any investigation. My own interest in the question, What is art?, however, is not really in answering it, but in trying to understand it, because I do not believe that it is at all clear what one is after in trying to find out what art is. And if that is right, then it is not at all clear what is being denied when one denies the possibility of that kind of aesthetic theory.

I happen to agree with those who contend that the search for theory and definition is misbegotten and based on a misunderstanding of the nature of the questions it was designed to answer, but for rather different reasons. I also

happen to believe that those who have challenged traditional aesthetic theory have misunderstood the nature of those questions as well and, as I have already stated, I believe they have misunderstood Wittgenstein's philosophical reflections about langauge that inspired their objections to the traditional enterprise of philosophical aesthetics. I shall try to make all of this clear in the following chapters.

Chapter 1 begins the study with a description of the logical structure of a couple of examples of what we now think of as the traditional theories and definitions of art and of the methodology of their construction and also with how those theories conceived questions about identifying something as a work of art and judging the value of art. Chapters 2 to 5 comprise an extended argument which comprehends and weaves together several themes. These include the criticisms of traditional theory in the name of Wittgenstein, together with an examination of the misunderstandings of Wittgenstein manifested by both the proponents and opponents of these criticisms; there are the difficulties involved in trying to isolate defining properties of art, whether in the guise of aesthetic qualities of works of art themselves, the aesthetic experiences of art, or the 'artworld' background of intention, convention, history, and the like; more recent attempts to offer theories of art based on excursions into its ontology; and the problems encountered in trying to understand and appreciate avant-garde movements in art, especially the conceptual art of the sixties and seventies. The outcome of all this, which resists summary on a chapter by chapter basis, in which I try to bring 'art' back from philosophical theory to our actual dealings with particular works of art in gallery, study, and concert hall is that the problems we meet there and which are thought to require philosophical solution are not philosophical problems at all and are not to be solved by doing philosophy. The questions, What is art? and its relative, Is this art? turn out to be of a rather different kind than they appeared to be at first. I argue that recent attempts by both artists and philosophers to disconnect all aesthetic con-

cerns from art is a mistake and chapters 6 and 7 are devoted to questions about the aesthetic character of art, aesthetic perception, and aesthetic experience. These questions are approached by way of an investigation of Wittgenstein's ideas about seeing-as and aspect perception, experiencing the meaning of a word, and secondary sense in order to show their importance for aesthetics generally and for understanding how we experience, describe, and judge works of art.

Material from several previously published articles has found its way into these pages. 'Wittgenstein, Games and Art', *Journal of Aesthetics and Art Criticism*, 31 (1973), pp. 517–24, provided some of the substance of chapters 2 and 3; 'Artistic Puzzlement', in *Culture and Art*, ed. Lars Aagaard-Mogensen (Atlantic Highlands, N J: Humanities Press, 1976), did the same for chapters 3 and 4; some of chapter 6 first saw the light in 'Seeing and Seeing As in Wittgenstein's *Tractatus*', *Philosophical Investigations*, 6 (1983), pp. 116–34; and chapter 7 embodies some of 'Aesthetic Descriptions and Secondary Senses', *Philosophical Investigations*, 3 (1980), pp. 1–15, and 'Reply to Professor Kivy', *Philosophical Investigations*, 4 (1981), pp. 39–40. In most instances this material has been reworked in the hope of correcting mistakes and making some of the argument clearer.

The following works of Wittgenstein are referred to in the book, but not further identified in the notes: *Tractatus Logico-Philosophicus*, tr. D. F. Pears and B. F. McGuinness (London: Routledge & Kegan Paul, 1961); *The Blue and Brown Books* (Oxford: Basil Blackwell, 1953); *Philosophical Investigations*, tr. G. E. M. Anscombe (Oxford: Basil Blackwell, 1953); and *Remarks on the Philosophy of Psychology*, 2 vols, eds G. E. M. Anscombe and G. H. von Wright (Chicago: The University of Chicago Press, 1980).

I am grateful to Richard Scheer and James Hamilton who have read parts of this work and with whom I have had profitable discussions, and especially I am grateful to Robert Herbert, Robert Hurlbutt and Ted Cohen who have made extensive and helpful comments on the whole thing.

1

The Aim and Structure of Traditional Theory

Philosophers in the recent past have been more than eager to tout the twentieth century's revolutions in philosophy. Following their lead, there may be some justification, despite the pretension of it, for speaking of a revolution in aesthetics and philosophy of art. Be that as it may, in the fifties the legitimacy of previous modes of aesthetic theorizings was called into question. Whether this was indeed a revolution or not, the fact of this challenge did capture the interest of a number of philosophers and open to them opportunities to practice their trade upon issues they once would have shunned. Much of this interest was motivated by a reaction to what had gone before, and sometimes exactly what it was that was being reacted to was not totally understood. Add to that the changing philosophical fashions of three decades and both the nature and appeal of some of those traditional theories may have dropped out of sight. It is, therefore, appropriate to begin this study with a detailed examination of the logical structure of some of those traditional theoretical definitions of art. This examination will, of course, prepare the way to move on to the investigation of those critical rejections of traditional theory and will have as a by-product the identification of several issues and questions to be readied for later discussion.

The search for definition in aesthetics can be traced back at least as far as Plato when he represents Socrates asking in the *Greater Hippias* for a definition of beauty. The theoretical

concerns of the ancients were concentrated largely on poetry, the renaissance, as we know, was much taken with theories of painting, but the question about art in its most general form, however, probably could not have been asked before about the middle of the eighteenth century, since it was not until then that painting, sculpture, music, poetry, dance, and architecture came to be classified together as *les beaux arts*.[1] The related question, What is beauty? is, of course, an older one, but What is *aesthetic* value? or What is aesthetic experience? could not antedate Baumgarten who coined the term 'aesthetics'. In the wake of this eighteenth century restructuring of ideas about the arts and its invention of the idea of aesthetic experience have come any number of now familiar theories and definitions designed to answer the 'What is . . .?' questions about art, beauty and the aesthetic. In addition to the theory that art is imitation that stretches back to the Greeks there are theories of art and beauty as expression, significant form, empathy, play, wish fulfillment, and so on.

Within all this theorizing two distinct motives can be recognized, one of which is purely theoretical or philosophical while the other is rather more practical. The former is an expression of the philosopher's theoretical desire to tidy up the boundaries of the various compartments of the world in general and human activity in particular and to exhibit them in their relations to one another. More immediately, however, definitions and theories have been thought to be needed for the practical purpose of distinguishing works of art from things that are not and for establishing principles for the interpretation and evaluation of particular works of art. Unless we know what art is – that is, unless we have a theoretical definition of it, it has been said – scholars and

[1] See P. O. Kristeller, 'The Modern System of the Arts', *Journal of the History of Ideas*, 12 (1951) (pp. 496–527) and 13 (1952) pp. 17–46. Reprinted in *Renaissance Thought* II: *Papers on Humanism and the Arts* (New York: Harper Torchbooks, 1965).

historians of art would not know upon which objects to ply their trade and critics would have no principles by means of which to arrive at and justify their critical evaluations.[2] The Abbé Batteux, who was influential in developing the modern classification of the arts, announced that a major purpose of his work was to simplify 'the rules' both for 'l'Auteur qui veut composer, & l'Amateur qui veut juger',[3] but more than a century and a half later Vernon Lee could write in that other, more theoretical, vein that she 'does not pretend to tell how things can be made beautiful or even how we can recognize that things *are* beautiful . . . [but instead] seeks to analyse and account for Beauty's existence and enjoyment'.[4]

The most philosophically interesting of these two motivations for my purposes is clearly the practical one. The recognition of that as the dominating interest immediately suggests several questions that will eventually have to be addressed: In what circumstances do we find ourselves called upon to identify something as a work of art? In what circumstances do we have doubts about whether something is a work of art, doubts that a philosophical definition could allay? When are we called upon to assess the value of a work of art and is this something that requires rules or principles derived from a definition? Whether the motivation is practical or purely theoretical, underlying the very idea that a definition of art is needed as well as attainable is the old assumption, sometimes thought to be Platonic although Wittgenstein also connects it with Augustine, that the meaning of a word is what it names and the assumption that is

[2] 'If we are to have any aesthetics at all, we must have some sort of definitions. Unless we have an understanding of the signification of the term 'art', how are we to write histories, or sociologies, or criticism of art?' Lewis K. Zerby, 'A Reconsideration of the Role of Theory in Aesthetics – A Reply to Morris Weitz', *Journal of Aesthetics and Art Criticism*, 16 (1957), p. 255.

[3] *Les beaux arts reduits à un même principe* (Paris: Librairie Durand, 1747), p. i.

[4] *The Beautiful* (Cambridge: Cambridge University Press, 1913), p. 1.

often associated with it that a common designation must signify a common property or essence that it is the philosopher's task to reveal. The operation of this asumption in aesthetic theory can be seen at its baldest when Clive Bell said that 'either all works of visual art have some common quality, or when we speak of "works of art" we gibber',[5] a contention that can be easily generalized to apply to all art forms as well as the visual. The influence of this assumption about words and their meanings on the philosophy of art cannot be overestimated, just as its influence on the rest of philosophy cannot be overestimated. It was this assumption among others about language and meaning for which Wittgenstein's work was thought to provide the refutation.

For all the importance that aestheticians and philosophers of art claim for their theories, surprisingly little attention has been given to their logical details and the conditions that theories must satisfy if they are to provide the desired understanding of art and provide the answers to the questions that have been demanded from them. Very little heed has been paid to what we may call the logic or metholodogy of aesthetic theory construction and, consequently, no very clear picture has ever emerged of all those logical details that would have to be spelled out for any theory to be coherently formulated and unambiguously applied. The most systematic attempts to describe aesthetic theory construction are those of S. C. Pepper[6] and, to a lesser extent, Harold Osborne.[7] Each presents a 'theory' of aesthetic theories that share a number of common features.

By no means can Pepper be considered one of the great influences in twentieth century aesthetics; his views are largely derivative and would not merit detailed examination were it not for two things. He had a knack for laying out his positions so that the pictures they were based on were all on

[5] *Art* (London: Chatto & Windus, 1914), p. 7.

[6] *The Basis of Criticism in the Arts* (Cambridge, Mass.: Harvard University Press, 1948).

[7] *Aesthetics and Criticism* (New York: Philosophical Library, 1955).

the surface plain to see. If we follow Wittgenstein in thinking that part of the philosopher's job is to turn disguised nonsense into obvious nonsense, then for certain areas in the philosophy of art Pepper has done a big part of the job for us and through him we can more easily identify the confusions inherent in the tradition from which his position derives. Anyone who takes the idea of theory and definition in aesthetics seriously ought to look carefully at Pepper's work for the simple reason that it is virtually the only attempt to give anything approaching a systematic description of aesthetic theory construction. Through studying Pepper one can get a good sense of what the problems are and what one is up against in that kind of undertaking.

Neither Pepper's nor Osborne's account of theories is complete and we are left with a number of unanswered questions about both procedures and logical details. It is nevertheless possible, I believe, to extrapolate from what they do say, however meagre at times, to a model of aesthetic theory in which certain important logical relations can be made clear. Since it seems to me that so much of what has been said at one time or another about aesthetic theory is summed up in their work, it will be appropriate to restrict this examination mostly to their views despite the fact that the model of the theory to be extrapolated from them may not be endorsed by any particular philosopher who has undertaken to define art.

There are four questions about this kind of theory that must be asked. (1) What is an aesthetic theory or theory of art a theory of? (2) What questions is the theory intended to answer and what problems is it supposed to solve? (3) How is the theory to be constructed? (4) What is the logical structure of the completed theory?

Both Pepper and Osborne speak almost interchangeably of art and aesthetics and even occasionally of beauty as if there were no significant distinctions between these notions and no need to make any. In like manner I have referred so far indifferently to the philosophy of art and aesthetic theory. Pepper seeks a theory to characterize what he calls the 'aes-

thetic field' and expresses no doubt that whatever can be said about that will say just about all that needs saying about art as well. Both seem to use the word 'beauty' as a synonym for 'aesthetic value' without taking account that the word is often used to describe a somewhat restricted range of aesthetic character, e.g. the more lyrical and graceful aspects as contrasted to the powerful and the stark, rather than the whole of it. This lack of concern for any careful distinction between art and the aesthetic is understandable in the light of a certain tradition about the relation between the two. Aesthetic character, it is commonly supposed, can be found virtually anywhere in nature although, more often than not, in its natural occurrences it is attenuated if not adulterated. A work of art, on the other hand, is an artifact in which aesthetic character is deliberately concentrated and heightened. This way of thinking about the relation between art and the aesthetic has been questioned, as we all know, by the dadaists and more recently by the so-called conceptual artists who have sought to create works of 'art' in which aesthetic character is either minimized or declared to be irrelevant altogether. Whatever judgment is finally reached about the worth and significance of these movements, they have at least forced a reconsideration of the relation between art and aesthetics with the result that philosophers can no longer ignore the distinction or make facile transitions from talk of one to talk of the other in the absence of any explanations or justifications. For the time being it is enough to note that Pepper and Osborne confound the two and to point out that their theories are about something I shall in this chapter continue to call indifferently the artistic or aesthetic.

Pepper and Osborne expect of a theory of art and aesthetics that it do essentially three things: (1) it must determine what is and what is not an artistic/aesthetic fact, that is, a work of art; (2) it must determine standards for critical judgment; and (3) it must justify those standards. Pepper says that 'Sound criticism is the application of a sound philosophy to works of art' (*The Basis of Criticism*, p. 8). He implies by this remark

that criticism cannot really be undertaken without a proper philosophical theory of art and that such a theory is a logically necessary condition for good criticism. A similar view is expressed by Osborne when he says of the critic that 'Unless he knows what is and what is not a work of art, by what criterion a work of art is to be recognized, he has no standard of relevance; he will be at cross-purposes with himself . . .' (*Aesthetics and Criticism*, p. 40). It is, of course, a philosophical theory that is supposed to supply the criterion and standard. Osborne's stance here is even stronger than these lines suggest, for he goes on to say that a theory is required to make a critic's judgments of good and bad *meaningful*.

On Pepper's view a critical judgment is sound only if it is supported by the proper kind of theory; a theory thus seems logically prior to any particular judgment. While Osborne's position is consistent with Pepper's on this point, he does suggest another facet of the relation between theory and judgment. He contends that every description and critical evaluation of a work of art presupposes a theory of art or aesthetics. He goes on to say that 'a theory of art is *latent* in every act of appreciation, however spontaneous and direct, (ibid., p. 32). Similar views have been expressed by a number of other philosophers. Francis Sparshott, for example, puts it this way. 'One cannot describe a work of art without showing what one thinks important in it. Thus even a description presupposes a system of evaluation, and such a system when articulated and defended is an aesthetic theory.'[8] It remains to make clear what can be meant by this contention that a theory is presupposed by or latent in every critical judgment and just what the logical relation is between the demand that a judgment be supported by a theory and the claim that a theory is latent in every judgment.

The logical relation that is supposed to obtain between an

[8] *The Structure of Aesthetics* (Toronto: Univeristy of Toronto Press, 1963), p. 13.

aesthetic theory and the particular judgments it supports is one of those details that neither Pepper nor Osborne explain or demonstrate in their critical practice. It is never made clear whether a theory is deductive in its structure and particular judgments are to be understood as logical consequences of theoretical axioms or whether a theory is merely a kind of rule-of-thumb guide to what may prove fruitful critical practice or whether it is some third sort of thing. It is worth noting that we are never given an example of a fully developed and articulated theory in which the basic assumptions and relevant corollaries are specified and the procedures for deriving critical judgments explained The remarkable thing about this may not be the fact that these aspects of theories have never been detailed so much as the fact that they have never really been asked for. Traditional theorists as well as their critics apparently never thought that anything was missing. The construction of an aesthetic theory designed to distinguish art from what is not and provide criteria for critical judgment remains a tenuously defined program that has never actually been carried out.

The very notion of theory is, of course, vague enough, suggesting a continuum with a Hempelian model of a formal deductive system at one end and whatever kind of more or less systematic reflection at the other. This vagueness should not be allowed to encourage profitless dispute about what is and what is not a theory. It would not really be helpful, for example, to contend that those who reject the traditional enterprise of seeking an aesthetic theory are themselves offering a kind of theory. Although there is little philosophical gain in drawing boundaries for theories, there is none the less no reason to allow just anything to count as a theory. The important thing is to understand very clearly exactly what is going on logically in any particular piece of aesthetic 'theorizing'. The difficulty in doing this, however, is the one pointed out; there simply are not any developed examples of the kind of theory that Pepper and Osborne envisage to be understood.

Since there are no examples of an aesthetic theory with a fully articulated structure, it is in order to try out a couple of possible formulations. I shall begin with the assumption that a theory is latent in every critical judgment and for purposes of discussion offer 'This novel is good because of its tight plot structure' as a sample, if not a very imaginative one, of critical judgment. What is the theory latent in this? There are, presumably, two assumptions at work, that plot structure is an aesthetically relevant feature of novels and that it is a valuable or a 'good-making' feature. How, then, do these assumptions work and how are they related to the judgment that the novel is good? The assumptions about plot structure may be no more than very general guide posts, rules-of-thumb, for reading and appreciation, the sort of thing that might get said to undergraduates in any 'Introduction to the Novel' course:

> Plot structure is, of course, an important aspect of the novel and one of those things you must remember to look for when you read a novel. But you must also remember that novels can be organized in many ways and the kind of plot structure that you find in Jane Austen is not appropriate to Fielding or to Joyce. You must become familiar with the sorts of things that can be found in novels and then develop your own nose for what fits in one kind of literary circumstance and what fits in another.

Remarks like these are familiar enough[9] and if these are no more than commonplaces, others of the kind can embody fresh insights. What the remarks seem to reduce to is the observation that tight plot structure is a good thing in just those circumstances in which it is and is not in those other circumstances in which it is not. This last remark is saved from being a tautology because the reference to tight plot

[9] See, for example, R. Wellek and A. Warren, *Theory of Literature*, 3rd edn (New York; Harcourt, Brace & World, 1970), ch. 16, for a discussion of plot in just this vein.

structure calls attention to this as one of those circumstances in which it works and invites us to see how it works.

If this is all that is meant by a theory being latent in a critical judgment, exception can scarcely be taken although not much may be gained by denominating such remarks by themselves a theory. We can easily enough imagine them being connected with other relevant reflections about, say, the importance of character portrayal and development in the novel in representing human action in a way that would explain why a certain kind of plot structure does work in one literary context and not in another and we might be justified in calling the result a useful 'theory' of the novel. I take it that this was the sort of thing that Aristotle was doing in his analysis of tragic plots in Greek drama. This is not, however, the kind of thing I believe Osborne has in mind, as I shall show.

An alternative to the foregoing, rather loose way, of regarding theory is to construe the critical judgment as the conclusion of an argument that can be set out in logic text fashion.

This novel has a tight plot structure

Therefore, this novel is good.

In this guise the critic is represented as offering an enthymeme that can be converted into a valid argument by the addition of the major premise 'All novels with tight plot structure are good.' The theory that is latent in the judgment is, in this way of looking at the matter, the universal generalization that makes the critic's reason-giving into a valid syllogism by stating a logically sufficient condition for artistic/aesthetic value. Osborne's position, however, appears to be even stronger than this. He sets three demands that any proposed theory (definition) of art must satisfy.

(1) It must be applicable by anyone who adopts it to every object that person classifies as a work of art. (2) It must not be applicable to any object which a person who adopts it is unwilling to classify as a work of art. (3) It must be applied by

anyone who adopts it as his sole criterion for assessing the relative worth of different works of art. (*Aesthetics and Criticism*, p. 47)

The first demand is that a theory state the necessary conditions for something to be a work of art; the second demand is that the theory state a (the) sufficient condition(s) for art; and the third demand connects the definition with a criterion of value. This latter is a consequence of Osborne's view about the nature of definitions. He quotes with approval Collingwood's remark that the definition of a kind of thing is the definition of a good thing of that kind and then glosses that remark as entailing that every judgment of comparative value implies a definition.

These demands have an interesting consequence for Osborne's position which shows up in his discussion of realism and truth as artistic principles where he notes that verisimilitude is not a necessary condition for artistic excellence. He then makes the remark that 'if correspondence with real or possible actuality is not a necessary condition of artistic excellence, then most certainly it is not and cannot be of itself an *artistic* virtue . . .' (p. ibid., 93). Kennick[10] has pointed out the apparent *non sequitur* in Osborne's assumption that the only relevant conditions are necessary conditions. Kennick, however, has overlooked the third demand that Osborne imposes upon theories. Osborne's move is a *non sequitur* if taken as saying something about the nature of necessary conditions in general, but not if understood as a consequence of his own view about the peculiarity of aesthetic value and the role of definitions in assessing it. he may be mistaken, but not necessarily illogical, in requiring that anything that contributes to the value of a work of art be common to all works of art.

We can now understand Osborne's contention that a theory is latent in every critical judgment as the proposition

[10] 'Does Traditional Aesthetics Rest on a Mistake?', *Mind*, 67 (1958), p. 326.

that whenever some feature of a work of art is cited as a reason for that work being good, it is logically implied that the feature is a necessary condition for artistic value. Since every value-making feature is supposed to be a necessary condition, it must follow that the set of all necessary conditions, if there is more than one condition, constitutes the single sufficient condition for artistic/aesthetic value. All this entails, I believe, that Osborne has some sort of deductive model in mind for arriving at critical judgments.

Although Osborne says nothing about how an aesthetic theory is to be arrived at, Pepper describes in some detail how he believes a theory is to be constructed.[11] There are four steps in the process. (1) We must begin by acknowledging the necessity for a general metaphysical theory in terms of which all the facts of the world are to be understood. Pepper calls such a theory a world hypothesis.[12] (2) We note our ordinary pre-theoretical understanding of what is artistic/aesthetic and identify by ostension all those things that we are willing to call works of art (or beautiful). The set picked out by this act of ostension is called the 'common sense test definition'. (3) The members of this 'common sense' set are then described in terms of the categories and concepts of the controlling world hypothesis. (4) The 'aesthetic field' is then defined in terms of the descriptions provided by step (3) by picking out the properties common to all members of the aesthetic field.[13] The resulting definition is

[11] *The Basis of Criticism*, ch. 1, *passim*.

[12] Pepper's notion of a world hypothesis is developed in his *World Hypotheses* (Berkeley and Los Angeles: University of California Press, 1942). *The Basis of Criticism* is the application of the notion to aesthetics.

[13] In *The Basis of Criticism* Pepper does not make explicit that the definition is to be stated in terms of the features common to the members of the aesthetic field although he does state this explicitly in a later article, 'Evaluative Definitions in Art and Their Sanctions', *Journal of Aesthetics and Art Criticism*, 21 (1962) p. 203. Pepper does not use the terminology, but we can assume these common features to be necessary conditions and the set of all of them to be the sufficient conditions that demarcate art and the aesthetic.

assumed to have both a 'qualitative' and a 'quantitative' aspect. The former is intended to pick out what is to count as an artistic or aesthetic fact and the latter is to determine the criteria of aesthetic value.

Once the relevant concepts and categories in terms of which the theory is to be formulated have been selected, Pepper represents the task of arriving at the theory as an empirical one and goes so far as to describe it as an example of fitting an hypothesis to the facts.[14] As in other aspects of his procedure, he does not give us any details about how this is to be done or any examples of doing it, but I believe that he must have something like the following in mind. We notice several examples from the set established by the 'common sense test definition' that have some common property and we hypothesize that all members of the set have that property. The hypothesis is then tested against other examples from the set and extended or modified until we have a description that fits all cases. So far this procedure does seem properly empirical, but then it has to take a curious logical turn if it is to serve Pepper's purposes. The theoretical definition that results from all this is not intended to be simply a generalization about those things 'common sense' calls art, although it is at least that, but also is intended to refine and make precise that 'common sense' understanding and to settle questions about what is and what is not art that common sense must leave unresolved. It cannot, however, play both roles. A genuine empirical hypothesis can only describe or explain a class of phenomena identifiable on grounds that are independent of anything stated in the hypothesis itself and cannot itself formulate the identifying criteria of the very phenomena it seeks to describe or explain. It is precisely this latter job that Pepper's theoretical definition is also required to do.

There is much confusion in all this and it is partly the result of Pepper's, as well as other like-minded philosophers', views

[14] *The Basis of Criticism*, p. 30.

about our pre-theoretical, 'common sense', understanding of art. Pepper had to realize that there must be some vagueness in our common sense understanding of art, some fuzzy borderline where we are not sure whether this or that really is a work of art, otherwise there would be no need for a theoretical definition to make it more precise, but he seems to have no clear conception of the form that vagueness takes and where it shows up, nor how it affects our understanding and appreciation of art. Even a philosopher as astute as R. G. Collingwood is no more clear about this. In order to construct a theory of art Collingwood believes we first must be able to recognize art before we formulate a theoretical definition of it by investigating its relations to other things. He speaks of this just as if recognizing art is a straightforward affair where there are no baffling practical problems or, as some think, serious theoretical problems. Osborne, on the other hand, does admit that the domain of art can have vague boundaries, but where he locates those boundaries helps us to see the limitations in this kind of thinking. Osborne's examples of borderline cases are generally examples of things that may not be quite good enough to merit being called art, e.g. skyscrapers, trashy best sellers, and popularized versions of classical music (*Aesthetics and Criticism*, pp. 45–6). There are sometimes problems with these things, to be sure, and a definition of art that stipulates a criterion of aesthetic value would, of course, be expected to determine their value and, *a fortiori*, their artistic status. These problems, however, are all reasonably tractable; the disputed items are all, as they say, in the artistic ball park and are all recognizable candidates for art. I find it especially striking that Osborne and the others do not mention the point at which the really tough problems for both criticism and appreciation have actually arisen and which some recent philosophers believe generates some of the most serious philosophical questions about what art really is. I have in mind avant-garde movements such as impressionism and post-impressionism were in their day,

and dada and conceptual art have been more recently. A factor common to these movements is that they have seemed to challenge what had traditionally been thought of as relevant and valuable in art. If the location of the vagueness is shifted from the borderline that separates the traditionally good from the traditionally inferior to that other borderline between the traditional and the new and as yet unassimilated, the nature of Pepper's confusion becomes clear.

We may suppose that 'common sense' is incompetent to settle the real life dispute whether something like Marcel Duchamp's notorious *Fountain* is a work of art. Let us recall that this dispute cannot be whether Duchamp's piece is good enough to merit being called art because part of the dispute concerns what is relevant to making that judgment; avant-garde works repeatedly raise this question of relevance. A proper theoretical definition is supposed to determine the artistic status of *Fountain* for us, but given Pepper's procedure, it cannot possibly do so. The empirical generaliz-ation that forms the basis for the theoretical definition must be a function of the items included in the common sense test definition. One of the important aspects of *Fountain*, as well as of the other readymades, is sometimes said to be Duchamp's *declaration* that the thing is a work of art. If sympathy with this dadaist's antic of declaring things to be art is one of the factors influencing someone's common sense test definition, then the subsequent generalization derived from the set so picked out will certainly be quite different from one based on a test definition that does not include the readymades. It would appear that the question the theoretical definition is to solve is already in large part begged. Con-ceived as an empirical undertaking the whole procedure is broken-backed. There is an inescapable element of the arbitrary infecting the entire project.

The implication of arbitrariness built into all of this is given away by Osborne when he says that faced with competing definitions of art 'there can be no genuine conflict

of opinion whether this or that artifact is a work of art or not; it will be art for this man and non-art for the other, and legitimate argument is confined to discussing the linguistic convenience of using a criterion of this sort' (ibid., p. 46). This conclusion is totally unsatisfactory. I repeat the remark made in the Foreword that art is important to us. How we understand and appreciate a work of art has much to do with how we understand ourselves and the world we live in; our relations to art determine in part our relations to a culture and its traditions. Osborne's frank acknowledgement of the arbitrary and relativistic implications of the traditional search for definition must strike us as appalling. It is appalling not only because it trivializes as mere 'linguistic convenience' our concern for what is to be assimilated into our culture and traditions and thus made a part of our lives, but also for the very frankness with which it does it. This kind of theorizing is simply unable to give an account of what really is at stake in the matter of determining what is and what is not art.

Pepper's conception of how an aesthetic theory is to be constructed is hopelessly muddled, but what compounds the difficulty is that we are given no real indication what the completed theory is to look like once it has been constructed. In particular we do not know how to construe the connections that hold between the world hypothesis, the definition of the aesthetic field, and the particular critical judgments they are supposed, each in their turn, to support. Consequently we are not sure how it is that the definition supports critical judgments and how, in turn, the world hypothesis justifies the critical criteria stated in the definition. I have already pointed out that some of the things Osborne says about the relation between theory and critical judgments suggest that he has a deductive connection in mind. On the assumption that the crucial connections are deductive, I propose to extrapolate to the following representation of what a theory after Pepper's fashion could be like that makes clear the logical relations between the various elements of the theory and particular critical judgments. The representation makes use of an undefined property, or set of properties, A.

1	A statement of an appropriate world hypothesis demonstrating that A is a genuine value property	The truth of this is determined on whatever grounds, if any, are relevant to the truth of a metaphysical theory
2	(x) $(x$ is an artistic/ aesthetic fact *iff* $Ax)$	The qualitative aspect of the definition
3	(x) (y) $(x$ is better than y iff x is more A than $y)$	The quantitative aspect of the definition. (The theory requires every value judgment to be comparative

The application of the theory thus formulated to particular instances is obvious.

4	This object is A	Alleged empirical fact
5	This object is a work of art	2, 4
6	This work of art is good (i.e. better than most)	3, 4, 5

Step (1) calls for little serious discussion. Pepper believes that he has identified four relatively adequate world hypotheses which he calls mechanism, contextualism, organicism, and formism. He believes that any metaphysical theory, to the extent that it is at all adequate, can be assimilated to one of his four. This view surely does an injustice to metaphysics. Metaphysics may be a misbegotten enterprise but, for all that, is symptomatic of important underlying problems, puzzles, and confusions and any attempt to cast all its subtleties into a neat set of moulds can only turn attention away from the problems that get it all going. Pepper wants to use metaphysics to justify the critical criteria stated in the definition of art, that is, to show that property A really is artistically valuable. This is reminiscent of attempts to provide an ultimate justification for morality and may be just as fruitless. It is not at all evident that ordinary sorts of critical reasons admit of ultimate justification nor what such a justification would be like if they did. But then property A is not an ordinary sort of critical reason. What can be salvaged from the requirement that aesthetics be derived from metaphysics

is the reminder that works of art do, and I believe must, have connections with other aspects of life and the world. We do not, however, need metaphysics to tell us this and those connections, that want tracing detail, are not going to be discovered in that way.

The model of an aesthetic theory that I have extrapolated from the suggestions of Pepper and Osborne is a deductive system in which the definition of art is expressed as a pair of universally quantified sentences. Particular critical judgments are logical consequences of these definitions. On this model Osborne's notion that a theory is latent in every critical judgment becomes the hypothesis that for every pair of statements of the form (5) and (6) there is a trio of statements of the form (2), (3), and (4). A judgment is justified by a criterion by being deduced from it. It should be clear to anyone with the least familiarity with the arts that this theoretical representation is only too obviously at variance with the actual practice of reason-giving in most art criticism and discussion. A novel may be praised for its tight plot structure, a poem for its imagery, a painting for its space composition, but these usual sorts of critical reasons do not justify in the way set out by the theory and do not lend themselves to universal generalization; they are, instead, frequently hedged about with *ceterus paribus* clauses or are understood to be *defeasible*, e.g. we may say that tight plot structure makes a good novel unless . . . and recognize that the ellipses can be open ended. The kind of alliteration that gives Hopkins' poetry its peculiar appeal would not do at all for a tale of Apeneck Sweeney nor could a baroque painting be built around Bellini's organisation of space. Actual critical practice seems to be evidence against this deductive model as a correct description of criticism.

The issue really turns about the nature of property A. So far 'A' appears only as an undefined term in a partially interpreted formal system. It remains to ask what domain of properties 'A' can take for its interpretation and what the relation is between these properties and the usual sort of

properties that critics talk about in describing and evaluating works of art such as the ones mentioned in the preceding paragraph. Whatever it is that is selected to play the role of property A, it must be something of a sufficiently general nature that can be shared by all works of art in whatever form or medium. Such things as plot structure, imagery, alliteration, and space composition obviously cannot satisfy that condition.

Pepper offers four candidates for the role of property A, each associated with one of the four world hypotheses of mechanism, contextualism, organicism, and formism. These four are objectified pleasure' (Santayana's notion), 'voluntary vivid intuitions of quality', 'integration of feeling', and 'perceptions satisfying in themselves to the normal man'. Pepper once more fails to make clear the relation between whatever it is these expressions are supposed to refer to and particular aesthetic and artistic properties such as the ones already mentioned. Perhaps Hopkins' alliteration is to be thought of as the cause of a sensation of pleasure which then becomes objectified, or as an instance of a quality that is intuited voluntarily and vividly, or as an instance of something we normal folk find satisfying to perceive (or is alliteration itself a perception?), or as an instance of something that contributes (causally?) to an integration of feeling (or is it itself a feeling?). Not only is this relationship unclear, but the very intelligibility of these expressions is open to question. They are, after all, embedded in their respective 'world hypotheses' and must share in whatever conceptual confusion devolves from them. If these expressions are, as I believe them to be, unintelligible, then there is no relation to artistic particulars to be made clear. It is not to my purpose to detail the confusion inherent in Pepper's notions and make all that (thinly) disguised nonsense patent, although there is one feature common to all these expressions that must be noted.

All of these expressions purport to make reference to some mental event or aspect of a state of consciousness. This is not at all surprising. From its beginnings as an independent

branch of philosophy in the eighteenth century aesthetic theory was developed against a background of Cartesian dualism, British phenomenalism, and German idealism. Baumgarten had defined aesthetics as the science of perception and the British empiricists, as well as Kant, understood the problems of aesthetic description, taste, and judgment as demanding an investigation of psychological and mental processes. Attention was thus focused on psychological reactions to works of art rather than what the plain man would think of as the works themselves. The epistemology that was calling the tune for aesthetics argued against the plain man that the 'works themselves' were either accessible only through psychological responses or constituted by such responses. This led to the postulation of something called 'aesthetic experience' which became the focus of philosophical concern and the problem then became one of discovering the essential properties of this kind of experience. In the light of this tradition it is not at all surprising that by the twentieth century someone like John Dewey would write a book with the title *Art as Experience.* The concern with the particular characteristics of the various art forms is, on this view subordinated to the attempt to formulate the most general features of aesthetic experience. More recently Monroe Beardsley, for one, has argued that works of art produce aesthetic experiences and these experiences are all characterized by what he calls coherence and completeness, the common properties by virtue of which they are all aesthetic experiences.[15] The melodic and harmonic structure of a piece of music, the plot of a novel, the visual organization of a painting, and the like are all supposed to provide experiences which have in common the properties of coherence and completeness, Beardsley's candidates for property A. These properties of coherence and completeness may be thought to have an advantage over Pepper's rather idiosyncratic notions in being at least abstractions from genuine artistic properties.

[15] 'On Art and the Definitions of Art: A Symposium', *Journal of Aesthetics and Art Criticism* (1961) pp. 175–98.

The metaphysical and epistemological traditions from which philosophical aesthetics sprang have tended to find arguments convicing that works of art are not 'physical objects' and that their aesthetic properties are not 'physical' properties at all. There are basically two varieties of argument to this conclusion. One of them begins from certain considerations about the characteristics unique to literary and musical works that suggest they cannot plausibly be identified with any physical object or event such as a manuscript, printed page, or performance. The other species of argument contends that the aesthetic qualities that characterize works of art in terms of which we describe and identify them are incompatible with works of art being physical objects. A painting, for example, may be balanced or emotionally intense, but it is thought false to say that the 'physical object' consisting of pigment on canvas is either balanced or emotionally intense. As a result of these arguments philosophers of art have been led to postulate a special nonphysical 'aesthetic object' which is supposed to be the real work of art and the bearer of aesthetic qualities. This postulate became virtually a dogma of twentieth century aesthetics.[16]

This traditional aesthetic theorizing about the defining properties of art that I have been discussing was, therefore, almost from the first, essentially tied to questions about the kind of object a work of art is, where 'kind of object' was understood in the philosopher's sense of a reference to ontology and the range of possible kinds was dictated by the familiar metaphysical categories of materialism, dualism, idealism, and the like. Works of art could thus turn out to be 'physical objects', 'ideas in the mind', constructions out of 'sense data', or whatever other variety of entity these cate-

[16] A summary of these arguments can be found in Osborne, *Aesthetics and Criticism*, pp. 229ff. Pepper's most complete treatment of the 'aesthetic object' is in *The Work of Art* (Bloomington: Indiana University Press, 1955). For a discussion of the confusion in all this see my *The Expression of Emotion in the Visual Arts* (The Hague: M. Nijhoff, 1970) and 'The Literary Work of Art', in *Language and Aesthetics* (Lawrence/Manhattan/Wichita; The University Press of Kansas, 1973).

gories may sanction. Quite recently the whole matter of the ontology of art has been revived, but this time in a somewhat different fashion with the motivation coming to a large extent from those problems raised by the avant-garde and which had been ignored by the older generation of philosophers to which Pepper belonged.

Pepper would no doubt have argued that just as his four allegedly adequate world hypotheses comprehend everything of value in traditional metaphysics, so the theories of art associated with them comprehend everything worth taking account of in traditional aesthetic theory. Pepper does say that the aesthetic theory associated with the metaphysics of 'formism' assimilates whatever is of value in imitation theory and the theory of organicism rather obviously includes much of the expression theory. It may be thought another case of injustice to lump venerable theories such as imitation and expression together with Pepper's rather peculiar formulations and then declare the lot to be in the long run unintelligible. Here it is worth reminding ourselves that imitation theory, for example, has never been the philosophically innocent, perfectly intelligible, although false, generalization that all paintings are representational and all literature about men in action. Imitation theory has always been tied up with philosophical theories about the nature of reality and the nature of representation. Nor is the expression theory exhausted in the observation that romanticism encouraged us to have a new concern for the feelings and sensibility of the artist or that works of art frequently display expressive or physiognomic qualities. Theories of art as expression have always sought a philosophical explanation of the relation between artist, art, and audience and are inconceivable apart from general theories of language, communication, and philosophical psychology.

How other familiar theories of aesthetics such as empathy and significant form would be accommodated by one or another of Pepper's schemes is not really worth investigation, but there is no apparent logical difficulty in

plugging these notions into the formal system in place of property A whether or not they could be connected to some approved world hypothesis. Theories that seek to define art in terms of psychological impulses to play or unconscious wish fulfillment are of a rather different order. They were not developed in response to what seemed to be problems of practical criticism as were the others that Pepper and Osborne talked about and probably should not be forced into that logical mould. I will not be concerned in anything that follows with the philosophical problems that arise in trying to seek a general motivation for art.

It can go almost without saying that none of the proffered theories and definitions has been successful, certainly none has been generally accepted and each has been severely criticized. And I would add to this the observation already belabored in the preceding pages that no such theory has ever really been completely formulated. These facts by themselves do not, of course, demonstrate the futility of this theoretical enterprise although they have led some philosophers to suspect that the difficulty lies not so much in the shortcomings of any particular one of the theories as in that very futility. As already pointed out, the challenge to the philosophical enterprise of defining art that arose in the last three decades was based largely on Wittgenstein's *Philosophical Investigations*. To a philosopher already dissatisfied with traditional theories and definitions some of the things that Wittgenstein had to say about language, especially about the word 'game', could easily be thought to provide the insight that was to be the key to straightening out all the old misunderstandings.

This first chapter has yielded several results. It has yielded one possible model of the form of a theory of art or aesthetics. It has made clear that one important motivation behind what can be called the traditional search for definitions and theories of art is the altogether practical one of looking for criteria for identifying works of art and evaluating them. Such definitions and theories require that we be able to pick out a very general characteristic that can be a property of any

work of art in whatever medium. There are, needless to say, grave difficulties in determining what sort of property this can be. If there is a genuine problem about recognizing something as a work of art and distinguishing works of art from things that are not art, it probably arises with respect to new and avant-garde movements; traditional theory tended to ignore this aspect of art and its history. Some of these new movements in our century have called into question older assumptions about the relation between art and aesthetics and no theory can any longer afford to collapse the two into one another, but must, instead, clarify their relation to one another. Lastly, questions of definition, identification, and evaluation have been thought to be intimately tied to philosophical problems of ontology, problems about the kind of object a work of art is. All these topics will be discussed in subsequent chapters, but first we must turn to an examination of the challenge issued to traditional aesthetic theory by those who drew upon Wittgenstein.

2

The Attack on Theory and the Appeal to Wittgenstein

Early on in the *Investigations* Wittgenstein imagines several simplified situations in which a restricted range of words and expressions is employed. He calls these language-games. He uses the analogy between language and games to make at least two points about language. He wants to stress the connection between language and the human activity, form of life, in which it is embedded on the one hand and on the other he wishes to stress the different uses that words and expressions have, the different roles that they can play in human activity. The game analogy, however, is not intended to serve as a philosophical theory of language. Wittgenstein explicitly denies that there is an *essence* of language, something common to all things that we are willing to call language (§65). It is in order to make this contention clear that he examines the use of the word 'game'. This examination leads to the conclusion that there is no single feature common to all those things we call games and that they are, instead, linked together by a complex and open-ended set of overlapping similarities that he describes as 'family resemblances'. Wittgenstein warns us that it is a mistake to assume that all games must have something in common, else they would not all be called games. He admonishes us, rather, to 'look and see' whether there is, in fact, anything that they have in common (§66).

It is Wittgenstein's view that in many circumstances we can be helped to an understanding of how a word functions

in language – and in life – by reminding ourselves how the word is taught, say, to children. We do not teach children the word by giving them anything like a definition or a set of criteria they may use to identify games. Wittgenstein says that we do it by providing them with various examples of games and that they then learn to call other things games because they are similar in one respect or another to some of those sample games. 'How should we explain to someone what a game is? I imagine that we should describe *games* to him, and we might add: "This *and similar things* are called 'games'"(§69).

The application of these remarks about games to the problem of art has been thought to be obvious. If we do not need a theoretical definition of 'game' as a prior condition for identifying games, then perhaps we do not need such a definition of 'art' in order to distinguish art from what is not art. The word 'art' can be applied to an object because it bears some relevant resemblance to an agreed-upon paradigm, just as 'game' can be applied to an activity because it has a relevant resemblance to some paradigmatic game. Morris Weitz makes the connection thus:

> The problem of the nature of art is like that of the nature of games, at least in these respects: If we actually look and see what it is that we call 'art', we will find no common properties – only strands of similarities. Knowing what art is is not apprehending some manifest or latent essence but being able to recognize, describe, and explain those things we call 'art' in virtue of these similarities.[1]

The cogency of this move from games to art remains to be examined, but first it will be necessary to look more carefully at Wittgenstein's discussion of games; there are at least two observations about it that must be made.

[1] 'The Role of Theory in Aesthetics', *Journal of Aesthetics and Art Criticism*, (1956), p. 31.

Wittgenstein is certainly correct in warning against the demand that all games *must* have something in common in order to be called games. This is part of his attack on the theory that the meaning of a word is what it names and no philosophical theory of meaning can be allowed to lead us by the nose and dictate the form a philosophical conclusion is to take. Nevertheless, there is something in his advice that we 'look and see' whether there is anything in common that wants questioning. The question, Do all games have something in common? is asked as if its meaning is clear. I do not believe that the sense of such a question is always clear or that the question is necessarily intelligible. I want to express my doubts by the following considerations.

Wittgenstein draws our attention to two ways in which we can be said to understand a sentence. We understand a sentence when we know how to use it and also when we know what it is being used to do on some particular occasion of its utterance (§525). The question that asks what a group of things has in common, how they are similar or like one another, is one that we understand perfectly well in that we know how the question can be used. Nevertheless, it is one that has to be understood in a particular context, for the sense of the question and what constitutes an intelligible answer to it is a function of context. The question posed in abstraction from any particular circumstance and concern is simply another instance of language gone on holiday. The importance of context can be brought into focus by the reminder that there is another side to the logical coin of talk about things in common, similarities, and likenesses and that is talk about differences and what it is to have nothing in common. The context determines a range of relevant properties that are to count as candidates for similarities or differences. For example, in making up a guest list I may hesitate to invite John as an escort for Mary because they have nothing in common. Here the expression 'nothing in common' is intended to comprehend such things as tastes in food, drink, and music, political and religious opinions, and the like. It

would surely be a misunderstanding to insist that they really do have something in common for, after all, each has two legs and one head. And it would be equally a misunderstanding to suppose that it is only too obvious that Mary on the one hand and John's coati mundi on the other have nothing in common to the extent that suggests the coati mundi is High Church and doesn't disco. It is tempting to represent that legendary unfortunate who doesn't know a hawk from a handsaw as not knowing *the difference* between the two as if an intelligible account could be given of what that difference is. Nevertheless, there could be circumstances in which we look for connections between this hawk and that handsaw; perhaps they both belonged to the murdered man.[2]

If all games do have something in common, then it is surely intelligible to ask what that is and if all games have something in common, then any two games must have something in common and it should, therefore, be perfectly intelligible to ask about that. It should always be in order, then, to ask how game A is like game B. The foregoing remarks about the importance of context were intended to raise suspicions about the sense of that general kind of question and the following remarks are intended to confirm those suspicions. To do this let us first imagine, say, an Englishman who knows rugby well, but who has only a rather sketchy notion of American football, asking for an account of the similarities and differences between the American game and rugby. An appropriate reply would likely point out to him that the American game also involves running with the ball and trying to carry it over the opponent's goal line, how the American game permits forward passes, and how the scrimmage differs from the scrum. There are enough points of contact between the two games and we know enough about what is on the Englishman's mind to give us the sense of the question and allow us to know pretty well what the relevant similarities and differences are.

[2] See *The Case of the Handsawn Hawk.*

But suppose that we are asked how American football is like pachisi. The question has a queer sound and the most charitable explanation is that it arises from the misapprehension that pachisi is a kind of Hindu football. The kind of explanation we gave of the difference between American football and rugby won't do here. It is not in order to respond with anything like 'In American football a team is given four attempts to advance the ball ten yards, but in pachisi . . .' The proper response is to say 'But it's not that kind of game.' We must, rather, explain enough about the game to make clear the nature of the mistake. I am not at all sure what we could make of the question put by someone not under that kind of misapprehension. Would it be an answer to point out that both involve winning and losing? Perhaps, although a context would have to be specified in which that answer is appropriate. In the absence, however, of such a redeeming specification of context we might as well ask how a plum pudding is like the ocean. Are we really the wiser for fathoming that they both contain currents (or currants, if you prefer)? That the answer has to be a pun signals that we have to do with nonsense. These examples show that it will not always do to compare two games in search of similarities or differences. And if that kind of comparison is not always intelligible, then the intelligibility of the supposition that *all* games have something in common is put in question. This latter conclusion has an important implication: the intelligibility of the *denial* that all games have something in common is put in question.

When Wittgenstein talks about the various characteristics that may or may not be common to different games, he does not mention such details as whether the ball may be picked up and run with or how many squares a piece may be moved on a throw of the dice. He lists, instead, a very few characteristics of a much more general nature, e.g. amusement, winning and losing, competition, skill and luck. It is as though Wittgenstein was looking for a property G(ame) that stands above the details of particular games analogous to property

A(rt). Wittgenstein's candidates for property G, however, are familiar ones that we all understand and not philosopher's inventions whose homes are metaphysical theories. It is quite easy, in fact, to describe a context in which a number of different games can be compared in terms of such characteristics.

Imagine a school master who wishes to introduce a number of games into the education of his pupils. He wants games that will do various jobs such as develop skill in arithmetic, enhance physical conditioning, encourage competition between rivals or cooperation among partners, ones that are played by strict rules and require an official to supervise, and more informal ones that can be thought up by the children themselves in an idle hour, and so on. He makes a chart listing different games under the appropriate headings, Monopoly under 'Arithmetic' but not 'Physical Education', and so on. The question whether all games have something in common becomes in this context the question whether there is any single heading under which all the games are listed.

The moral to be drawn from all this is that if we are to 'look and see' whether all games have something in common, then there must be some point to, or purpose in, the looking that determines what is to count as a candidate for the thing in common. Without such a determination we don't know what we are looking for nor what would count as finding it. And, furthermore, without such a determination, were we to deny that all games have something in common, we would not know what we are denying. This kind of looking to see cannot be a contextless activity. The implications for the analogous question about art are immense.

The second observation begins with an impression that it is possible to get from one kind of reading of Wittgenstein that the primary use of the word 'game' is to identify and classify activities. From this point of view it might be thought that the main contribution that he has made to the philosophy of

language is his pointing out that identifying and classifying are not the rigorous exercises that they were hitherto thought to be. But this makes it appear that there is nothing really at stake in calling something a game or anything else for that matter, except possible alternative schemes of classification, and that in troublesome borderline cases one can say what one likes as long as one is clear about what is being said, that is, the extent to which it is the similarities or the dissimilarities to some selected paradigm that are being appealed to. This would be one with Osborne's contention mentioned in chapter 1 that choices between competing definitions of art really turn on matters of linguistic convenience. Nor would such a way of reading Wittgenstein make clear to anyone how the discussion of games can be part of the attack on the theory that the meaning of a word is what it names. One would be left only with the impression that 'game' is multiply ambiguous or, alternatively, intolerably vague. What would be confounded and obscured are the different uses of the word 'game', the different situations in which the word gets used, and the diverse points that can be served by using it.

The notion of 'use', as is well known, figures prominently in Wittgenstein's descriptions of language and diagnoses of philosophical problems. It would, however, be a mistake to suppose that 'use' is a technical term within Wittgenstein's philosophy of language and that there must be criteria for distinguishing different uses and that, if his views are sound, a neat catalogue of uses can be constructed to which various words and expressions can be nicely assigned. Wittgenstein does point out that there are different *kinds* of words and sentences, that is, words and sentences have different roles and uses in language, color words, for example, play rather different roles to number words; in his metaphor, they are stationed at different posts (*Investigations*, §§11, 17, 29). The classification of these various roles and uses is not something fixed and depends, instead, on our various purposes and upon our inclinations as well. How we pick out and disting-

uish uses will depend upon the particular philosophical problem to be investigated and the insight and philosophical acumen of the investigator. No general remarks about use will necessarily illuminate any particular philosophical problem.

Wittgenstein introduces his talk about use of words in connection with the very specific activity of buying apples. One asks the shopkeeper for five red apples. The shopkeeper goes to the drawer marked 'apples', matches the contents with a color sample, then repeats the numbers up to five, taking one apple for each number (§51). This description of the shopkeeper's rather simple-minded behavior is not intended as a reflection on his intelligence, but to serve the purposes of the example. Wittgenstein is making two points with the example. The first is to make clear that the words 'apple', 'red', and 'five' play quite different roles in the transaction and the second is to emphasize the realization that the words are embedded in human activity and draw their sense from it. It is this connection with activity that must be stressed if we are to understand the different uses of the word 'game' and, by analogy, 'art'. In §69 where he describes how the word 'game' is taught, by describing games to someone and then adding that these and similar things are called 'games', it is as if he forgets his own philosophical procedures and his account of that teaching, as a result, is misleading. We certainly do not teach 'game' to children by describing games to them; we teach them by teaching them *to play* games. In teaching children to play games we teach them, naturally, the rules of play and how to follow them, techniques of play, points of strategy, how to keep score, and so on. But other things are taught in addition: I am thinking of such things as the spirit in which the game is to be entered, notions of fair play and sportsmanship, and the etiquette, sometimes very elaborate and ritualized, that can govern the comportment of both players and spectators, all in all, a richer body of behavior and attitudes than is necessarily suggested by Wittgenstein's passing reference to amusement and competition.

What wants stressing is the fact that learning the word 'game' involves learning to play games and this in turn involves, in addition to learning what might be called the mechanics of games – e.g. rules, skills, and the like – entering into a very complex system of human relationships.

In his *Memoir* of Wittgenstein Malcolm relates an occasion upon which he, Mrs Malcolm, and Wittgenstein were taking a walk and Wittgenstein suggested that in their progress they enact the movements of the earth and moon about the sun.[3] Mrs Malcolm was the sun and walked straight ahead; Malcolm was the earth and trotted in a big circle about her; Wittgenstein was the moon and sprinted epicyclically around Malcolm. let us imagine two observers who have quite different reactions to these proceedings. One asks in a suspicious tone of voice, 'What are you doing?' He thinks perhaps he has to do with madmen or some sinister ritual. His suspicions can be disarmed by the reply, 'We are only playing a game.' The other observer, in quite a different tone, asks, 'Are you playing some kind of *game*?' Here the reply might well be, 'It's not really a game', where the intention is to point out that it is only something improvised upon the time. Calling it a game in one breath and denying it the next need not seem either inconsistent or odd if the point of using that word is kept in mind for here we do have different uses of the word. The word 'game' in such instances is not applied or withheld on the basis of similarities or the lack of them with some paradigm in order to achieve a classification, but is used, rather, to put the activity in certain light, e.g. to show it now as harmless rather than untoward or again as improvised and idle amusement rather than a contest of skill conducted according to rules.

These uses of 'game' are possible only because games are *played* and, likewise, it is only against a background of a complex set of human activities and relations that we can

[3] *Ludwig Wittgenstein: A Memoir* (London: Oxford University Press, 1958), pp. 51–2.

understand the following remarks that might get made of many an American college football game. 'This is no game; it's a slaughter!, or '. . . they're playing for blood!' or '. . . it's a business!' To say such things is to comment upon the one-sidedness of the contest, the viciousness of the play, or the motives of some of those involved, it is not to make an identification or classification of the activity, but is to characterize that activity in a certain way by putting it in a certain light. These comments are an invitation to focus our attention on particular aspects of what is going on that are characteristic, or in this case, uncharacteristic, of how many games are often played and thereby to arrive at a new understanding of the activity – not, of course, a new understanding of games, but of what is going on here and now.

The move from Wittgenstein's remarks about games to art and its definition turns out to have consequences unsuspected by philosophers who saw in those remarks the key to the refutation of general theories of art. In the first place, our discussion of games focused on the centrality of context for fixing the sense of talk about similarities and differences. The same is true of art and with a vengeance. It won't do to answer the question whether all works of art have something in common in the negative until the intelligibility of the claim being denied is determined. What would it be like if all works of art did have something in common? If all works of art have something in common, then any two works of art must have something in common and then the question, How is work A like work B? must always be in order. But when does it make sense to compare works of art and in terms of what characteristics?

In the art appreciation or art history classroom paintings are often compared and contrasted. At one time both Picasso and Braque painted a number of pictures using the cubist device of breaking up the figures into lines and planes. These paintings were very similar in subject matter, in the use of the same muted colors, and general style. A familiar object of

comparison is Manet's *Olympia* with its sixteenth century prototypes, Giorgione's *Sleeping Venus* and Titian's *Venus of Urbino*. The obvious similarity in the pose of the figure offers the occasion to call attention to differences in color, texture, space composition, and attitude toward the subject. Suppose, however, that we are asked to compare the Titian with something like Mondrian's *Broadway Boogie Woggie*. It is not immediately obvious what the basis of likeness or unlikeness is to be. The request might have been introduced as a rhetorical way of calling attention to the vast changes that have taken place in artistic style, technique, and interest in the last four hundred years, but that aside, it is not easy to see what sense the question could have.

If it is not always possible to make sense of looking for likenesses or differences within a single art form, then the search for likenesses across the boundaries of art forms can appear distinctly bizarre. Try asking how the Titian, for example, is like 'Sweeney Among the Nightingales', 'Pavan for a Dead Princess', or the *Taj Mahal* and that sense of the bizarre will surely register; one suspects, again, a riddle. There can, of course, be fruitful and significant comparisons among art forms. Paintings, statues, and buildings can obviously share common features of visual design; more than one contemporary facade has borrowed its geometry of rectangles from Mondrian. But of more theoretical interest are descriptions that speak of architecture as 'frozen music' and studies such as those of Wylie Sypher[4] that seek to develop sustained stylistic parallels between the arts of an historical period. What is the force of the musical metaphor for architecture? Rhythms in architecture are often spoken of by analogy with musical rhythm, but what is the likeness between the repeated elements of an arcade that are comprehended at a glance and the musical 'beat', that develops in time? And if, as Sypher tells us, unresolved tensions and contradictions are characteristic of mannerist poetry as well

[4] *Four Stages of Renaissance Style* (Garden City, N J: Doubleday, 1955).

as mannerist painting and architecture, we may be pardoned for wondering just what property is common to Michelangelo's anteroom to the Laurentian Library and the lines 'when thou has done, thou has not done, / For I have more . . . / And, having done that, Thou hast done / I feare no more.' If the response is to repeat 'unresolved tensions and contradictions', then we are owed an account of how poetic tension is like the tension in a visual design. This is not to challenge Sypher's comparison; it is, in fact, apt. The task, rather, is to show what kind of sense can be made of these comparisons and, whether in doing so, it is helpful to speak of common properties.

It won't do to seek the properties common to all works of art in the details of particular works of art just as it won't do to seek the essence of the game in the details of particular games. It is no more intelligible to suppose that rhyme scheme, chiaroscuro, or harmonic intervals could be candidates for the essence of art than it is to suppose that running with the ball could be a candidate for the essence of games. As we have seen, something of a far more general nature is wanted.

It is at this point that the theorist, finding himself frustrated in his search for definition, is tempted to call upon the notion of aesthetic experience that I mentioned in chapter 1. Let it be granted, someone might reason, that there are no properties common to all works of art and that the various art forms and media are diverse in nature, they are all, nevertheless, occasions of aesthetic experience and it just may be the case that all aesthetic experiences have common properties. Beardsley's coherence and completeness, for example. It was pointed out in the first chapter that most aesthetic theories are grounded in metaphysical and ontological theories ultimately descended from Descartes's dualism of mind and matter. Beardsley's position is no exception to this. His description of experience as coherent and complete presupposes a picture of experience as an entity or event in its own right that can exist logically distinct from the thing of

which it is the experience and this is essentially a Cartesian picture of experience. We know how to describe stories and paintings and symphonies as coherent and complete and the transfer of those descriptions to experiences forces upon us the picture of experience as the inner and ghostly, story, painting, or symphony. The difficulties with this way of picturing experience are well known – experiences, for example, become private objects – but none of that needs rehearsing here. This is why the details of any particular theory of aesthetic experience are not at this point really significant; it does not matter for our purposes whether experience is conceived of as a specific mode of *res cogitans* or as a slice of neutral monism's single whatever; I take them equally to be variation on a seventeenth century theme and to be equally unintelligible.

George Dickie, in a pair of articles, has offered an insightful criticism of the theory of aesthetic experience.[5] Dickie says that experiences cannot be intelligibly described as unified, coherent, or complete and that, in fact, most of the examples that Beardsley and other philosophers of art have offered of unified experience are really examples of objects with that property. When we become aware of the unity or coherence of a work of art we may speak of the experience of unity, but Dickie believes that innocent expression has been illegitimately inverted into the philosophically objectionable expression, 'the unity of experience'.

I believe that Dickie is right about this. The word 'experience' comes into our language at a number of places, but none of these places are a stop on the way to the Cartesian picture of experience that aestheticians rely upon. We often use the word 'experience' in reference to things we see and hear, situations in which we find ourselves, or our reactions to these. Thus I might relate the curious experience I had

[5] 'The Myth of the Aesthetic Attitude', *American Philosophical Quarterly*, (January 1964), and 'Beardsley's Phantom Aesthetic Experience', *The Journal of Philosophy*, 62 (1965).

yesterday when I was accosted and threatened by a man who mistook me for his wife's paramour. It could be described as a frightening or disturbing or even funny experience. In retrospect I might have noticed a pattern (unity, coherence) in my reaction. At first I was frightened, then became angry, and finally I ended up being amused by the man's posturing and the absurdity of it all. I could, in effect, tell a *story* about what happened and my reactions to it. Needless to say, this story of my curious experience would have nothing to do with any series of impressions or sense data or episodes occurring in a mental substratum. If it makes sense to speak of a unity to my experience, it is because these reactions can be made to figure in a story. The unity in question is the unity of a tale. There is, of course, much more to be done in describing the various uses of 'experience' and the roles it plays in language, and what the misunderstandings and misleading grammatical analogies are that have been the temptations that have led philosophers into the Cartesian confusions.[6] But it is the immediate consequences for aesthetic theory that are now in question.

If Dickie is correct and the alleged properties of aesthetic experience are really properties of the works of art experienced, then we are no nearer to any properties common to all works of art. Even if it be granted that all genuine works of art have some kind of unity or coherence, we still must ask how the unity of a poem is like that of a novel or of a painting, and how the unity of a string quartet is like that of a work of architecture. Brooks and Warren criticize Joyce Kilmer's poem 'Trees' for a lack of consistency in its use of

[6] Beardsley tries to defend himself against Dickie in part by denying that talk of the unity and coherence of experience is 'due to philosophers' high-handedness with plain language'. He does this by quoting some of Maslow's psychological conclusions. Ironically, however, Maslow's descriptions depend upon quasi-theoretical jargon – 'The person . . . feels more integrated' – borrowed from the very philosophical tradition Dickie identifies as the root of the problem.

the tree image.[7] On the other hand, Brooks very ingeniously is able to show that there really is a consistency and coherence in the apparently disparate images and figures of Donne's 'The Canonization'.[8] One kind of poetic unity and coherence thus, as these criticisms show, depends upon the use and development of images, metaphors, and other figures of speech. The coherence of a painting, by contrast, often is a function of the balance of visually perceived forces. Rudolph Arnheim has given us several painstaking examples of analyses of how this works. The view under consideration must be able to explain what there is in common between the visual organization of the planes of the wall, the chair, and the figure in Cézanne's *Mme Cézanne in a Yellow Chair*[9] and Donne's punning references and allusions to flies, candles, orgasms, and the phoenix. To be sure, in both cases there are these various elements that are intimately related to each other, but the elements of poetry are not those of painting and poetic relations are not pictorial relations; words and their meanings and connotations and rhyme and meter are not lines and colors and visual contrasts and spatial relations. Here I suggest is another instance in which the imputation of common properties to different art forms is unintelligible: it will not do to say – without a special context – that unity either is or is not common to both the poem and the painting. The poem is unified and the painting is unified – Brooks and Arnheim have shown us how each is put together, how each is to be understood and appreciated, and that is an important service, but how that showing is done and what is shown differ in the two cases. Directing our attention to verbal images and layers of meaning in a word is a different activity

[7] *Understanding Poetry* (New York: Holt, Rinehart, and Winston, 1960), pp. 288ff.

[8] 'The Language of Paradox', *The Well Wrought Urn* (New York: Harcourt, Brace, 1947).

[9] *Art and Visual Perception: The New Version* (Berkeley, Los Angeles, London: The University of California Press, 1974), pp. 37ff.

from pointing out relations of line, color, and mass. The susposition that unity is a property shared by both poem and painting is empty.[10] If anything is revealed here, it is that there is now a puzzle about the use of the word 'unified'.

This puzzle can be stated very simply. We use the same words, e.g. 'unity', 'coherence', 'unresolved tensions', etc., to describe many different things that do not necessarily have anything in common. In many instances it is not even intelligible to suppose that they could have anything in common. This may seem to rule out the possibility of even a Wittgensteinian 'family resemblance' between, say, the unity of a poem and that of a painting to justify or, at least, explain the common label since there do not seem to be any properties that can criss-cross and overlap. An alternative explanation is to suppose that these words are being used with different meanings or in different senses when referring to such different things. This move is made by Paul Ziff with respect to the word 'art' itself when he says that 'neither a poem, nor a novel, nor a musical composition can be said to be a work of art in *the same sense of the phrase* in which a painting or a statue or a vase can be said to be a work of art.'[11] The invocation of diverse senses of the phrase suggests that 'work of art' changes its meaning in each of its different applications, but that is surely a mistake. 'Art' is not a series of homonyms. The only justification for the claim that the word is not being used in the same sense is that it is being used to refer to things with rather different characteristics and that different reasons can be given for describing things as art. That is no more nor less than a reversion to the theory that the meaning of a word is what it denotes. Perhaps Ziff did not intend to equate his talk of sense with the concept of

[10] There is at least one context in which it makes sense to say that unity is common to both the poem and the painting, i.e. where we contrast them with other poems and paintings that are not unified. This case obviously has no connection with the search for definition.

[11] 'The Task of Defining of Work of Art', *The Philosophical Review*, 62 (1955), p. 66 (my italics).

meaning, but in that case to say that a word is being used in a different sense is to say merely that it is being used to refer to a different thing, and that is no explanation since it is the fact that words can apparently refer to things with nothing in common that gets the problem going in the first place. One crucial problem for the philosophy of art, then, is to explain how the same word, without changing its meaning, can be used to describe a range of things which have nothing in common. I will discuss these issues in more detail in chapter 7.

We may conclude that the search for property A is, indeed, fruitless. The reason, however, is not to be found in the fact that looking and seeing has failed to turn up the requisite common defining property nor in the corollary that any suggested definition is either too wide or too narrow, admitting too much that is not art or leaving out too much that is. The reason lies, instead, in the intelligibility of the hypothesis that there is a property common to all works of art and in terms of which art may be defined. This property cannot be any of the familiar artistic properties that we think of as characterizing particular works of art for no such property can be meaningfully predicated of all works of art in all media. Descriptions that give promise of being sufficiently general to fit all works of art, for example, 'unified' or 'coherent', turn out to apply on the basis of particular properties and the relations between them and, once again, we have nothing that can intelligibly designate a property common to all works of art. Any alternative seems to entail a retreat from descriptions derived from our understanding of art itself into notions derived from philosophical theories which must necessarily share in the conceptual confusions inherent in those theories.

The only philosopher to remark that there may be a problem about determining what is to count as a candidate for the defining property of art is Maurice Mandelbaum.[12]

[12] 'Family Resemblances and Generalization Concerning the Arts', *The American Philosophical Quarterly*, 2 (1965) pp. 219–228.

Mandelbaum, however, sees the problem quite differently than I do; for him it is not a matter of intelligibility, but rather of where to look for the defining property. He believes that Wittgenstein's notion of family resemblance is inadequate to explain the application of general words. He notes that in his description of games Wittgenstein refers only to characteristics that are 'directly exhibited' and on the basis of 'directly exhibited' similarities there are no grounds for distinguishing, say, fortune-telling with cards from some games of patience; something else must be needed. In the case of what he believes to be a real family resemblance there is a 'nonexhibited' link that connects all the family members, namely a genetic connection. In the case of games an analogous nonexhibited feature may be found, perhaps, in the purposes and intentions of those who invent and play games. The implication of all this for the philosophy of art is that there is no necessity that the defining properties of art be directly exhibited ones. The notion of a directly exhibited property, that is, something that can be seen or heard, doubtless has a certain vagueness in the best of circumstances, but in the hands of Mandelbaum and philosophers influenced by him, it is, I think, arbitrarily narrow. Visual balance and color harmonies are obvious examples of exhibited properties, but is the plot of a play or novel something that is directly exhibited or only pieced together from the incidents actually presented to us? Is not style something that can be seen in a painting? We surely can see the likeness between this painting and others from the same period. It may also be true that intentions can be seen in art, that we can sometimes see what an artist is trying to do. This is not the place to examine that in detail and it is not to the point to quibble about what is and what is not a directly exhibited property. Whatever they encompass, the directly exhibited properties of art do include at least a good portion of those things I have been calling the particulars of the various art forms. The defining properties of art may, on Mandelbaum's account, turn out to be

relational ones connecting works of art with the activities and intentions of artists.

Mandelbaum's article is important for two reasons. It has suggested a direction for aesthetic theorizing that has proved influential and it involves two fundamental misunderstandings of Wittgenstein. Clearing up these misunderstandings allows us to arrive at a much better idea of what Wittgenstein is doing and how his work has been, at least in part, misappropriated by recent aesthetic theory.

Mandelbaum's first misunderstanding is to suppose that the similarities gathered under the 'family resemblance' label must be directly exhibited ones. His only justification is the examples Wittgenstein mentions when he describes games. That is an altogether arbitrary limitation for Mandelbaum fails to note that Wittgenstein also applies the family resemblance metaphor to numbers. Granted that the idea of a directly exhibited property is a vague one, but regardless of where we draw the line delimiting exhibited properties, numerical properties must surely lie beyond it; what would, after all, be an exhibited property of a number? To suppose that the diverse mathematical entities that are called numbers are so called without reference to the theoretical concerns of mathematicians is simply bizarre. Mandelbaum's suggestion – that the common properties required for a definition may be found in the background activities and purposes to which games, art, or whatever is up for definition are related – is curiously ironic. In the case of art, the relevant intentions of artists can only be to produce works with appropriate artistic properties and these must be ultimately directly exhibited ones. If the requisite common properties cannot be found on the level of what is directly exhibited, neither can they be found at the level of intention where all the diversity of the first must be duplicated. There is every reason to believe that an examination of the background activities will reveal as great a multiplicity as is found at any other level. At any rate, there too we must 'look and see'. The important thing to

note, however, is that the existence of a Wittgensteinian family resemblance among a number of things has nothing to do with the nature of the properties of those things that are so related.

Wittgenstein's discussion of games, with its implications for language-games and hence for language, is designed as a first step toward breaking the hold of the reference theory of meaning. What Wittgenstein says at that point is not enough to dispose of that picture of meaning, but it is, nevertheless, a beginning. I have tried to show – and that independently of anything Mandelbaum may have had in mind – that what Wittgenstein says about games and how the word 'game' is taught is inadequate in the light of all the rest that he has to teach us about language and the background of human activity in which it must be embedded. But at the same time there is no reason to suppose that Wittgenstein thought he was providing an exhaustive account of the concept. What he offers is, I believe, best understood as a sample investigation intended to guide the reader in his own struggle with similar problems. It is with that in mind that I have offered my modifications and development of this remarks.

Mandelbaum's second misunderstanding concerns the role that the metaphor of a family resemblance plays in Wittgenstein's thinking. Mandelbaum believes that it is supposed to provide a criterion for the application of a general word to a particular instance. This is shown in his example of laying out cards to tell fortunes. On the basis of what is observed another person is led to believe that he is, instead, playing a game of patience. 'Will the resemblance between what you have seen me doing and the characteristics of card games with which you are familiar permit you to contradict me and say that I am indeed playing some sort of game?' ('Family Resemblances', p. 220). That the reply must be no is taken to demonstrate the inadequacy of the family resemblance account.

Mandelbaum seems to be thinking of this kind of case on the analogy of identifying members of a family where 'family

resemblance' is employed in reference to a blood-line.[13] Let it be the case that not all the Plantagenets look alike; they do not all have the same facial features, build, or gait. Here there are probably those overlappings and criss-crossing of resemblance that Wittgenstein found so characteristic of a family resemblance. It is not in terms of any of these, however, that we identify an individual as a Plantagenet although his looks can create a strong presumption that he is one. The criterion of Plantagenethood is, of course, the blood kinship and that is what allows us to distinguish the true scion from one who has fraudulently assumed the name. It is only because we have this criterion of family membership that we can undertake to map the various family resemblances. We can look for a 'family resemblance' among the members of a class only if we have a criterion of membership in the class and the family resemblance itself obviously cannot serve as that criterion. This is, I believe, an absolutely correct account of family resemblances of whatever stripe, but it is altogether wide of the mark as a criticism of Wittgenstein. Wittgenstein does not use the family resemblance model as a criterion for identifying individuals as members of a class, or as a rule for 'extending' a concept to cover new cases; it plays no kind of a justificatory role in his thinking. It belongs, rather, to a description of language as it is; it belongs to an account of what may be called the natural history of language. Thus, when Wittgenstein says 'Why do we call something a "number"? Well, perhaps because it has a – direct – relationship with several things that have hitherto been called numbers . . .' (*Investigations*, §67), emphasis has to be placed on the word 'we' for here he is describing a practice, what *we*, that is, mathematicians, have done and do. Over the centuries mathematicians have decided to call some newly discovered or invented mathematical entities numbers. Why? Some-

[13] Lars Aagaard-Mogensen has shown another irony in Mandelbaum's article when he pointed out that the notion of a family is itself a family resemblance concept ('The Definition of "Art"', *Dialogos*, 10 (1974), p. 43).

times because of similarities with things already called numbers. Why were just those similarities picked out as the salient ones?: We can imagine things having gone differently with people being struck by differences rather than similarities. The important thing in all this is that the practice of calling these other things numbers did not come into existence simply because there were similarities, but as the result of any number of theoretical interests on the part of mathematicians that led them to see these similarities as more important than those differences. (Nor should the role of mere inclination be overlooked here.)

To say that numbers, games, or works of art are linked by family resemblances is to say that if we examine the various things called by those names, i.e. if we examine our practice in using these words, we find no feature common to all, but instead various patterns of similarity. It is to say nothing about how any individual is identified as a member of its class nor what interests and concerns give point to bringing some new item into the fold or excluding it from the flock.

Mapping the family resemblances within the domain of numbers, games, or art is going to be rather different task than working within the blood lines of a social unit because we apparently do not have any independent criterion of membership that can be invoked in all cases. We call things numbers, games, and art for different and varying reasons. What we do have, however, is the fact that these things are *called* numbers, games, art – we do have the language and that means the practice of dealing with these things – and that is really quite enough to get the investigation going.

Of course I cannot contradict Mandelbaum when he tells me he is telling fortunes rather than playing a card game. Fortune-telling, after all, isn't a game although someone who is sceptical of the enterprise and cannot take it seriously may express that by calling it just a silly game. What must be seen, however, is that the question of whether fortune-telling is or is not a game is logically independent of anything Wittgenstein does with the family resemblance analogy.

3

Art Worlds and the Uses of 'Art'

One of the principal burdens of the last chapter was to show that the assumption that art may have defining properties is seriously confused – and not just false. If this is so, then whatever problems there are about identifying and evaluating works of art cannot expect any solution from that quarter. Moreover, the family resemblance metaphor borrowed from Wittgenstein now appears irrelevant to the task of identifying anything as art and the uncritical use of that notion has not yielded the results hoped from it. In this chapter I want to discuss some further essays at theorizing about the nature of art and begin to sketch a description of just what is the real problem about identifying art.

In the last chapter it was also said that Mandelbaum had indicated a new direction for aesthetic theorizing by suggesting that the defining property of games and, by implication, art, might be found in some 'nonexhibited' property that connects games and art with a background of game players' and artists' intentions and purposes. A point consistent with this suggestion was made by Arthur Danto when he said that what permits us to discriminate art from what is not art and in addition makes art possible is artistic theory and art history, which taken together Danto calls the artworld.[1] Thus both Mandelbaum and Danto agree that any adequate account of the difference between what is and what is not art

[1] 'The Artworld', *The Journal of Philosophy*, 61 (1964), pp. 571–584.

can only be given in terms of a background that is logically prior to any particular work of art. It was these ideas that were taken up and developed by George Dickie into what has come to be called the institutional theory of art. Dickie's theory is encapsulated in this definition:

> A work of art in the classificatory sense is (1) an artifact (2) a set of the aspects of which has had conferred upon it the status of candidate for appreciation by some person or persons acting on behalf of a certain social institution (the artworld).[2]

Most aestheticians and philosophers of art have assumed that there are two basic 'senses', or uses, of the phrase 'work of art', a classificatory sense and an evaluative sense. This assumption is implicit in Pepper's distinction between the qualitative and quantitative aspects of definition and is made explicitly by both Weitz and Dickie. This classificatory use is employed whenever we identify something as a work of art or distinguish a work of art from something else that is not art. Once this distinction between classification and evaluation has been drawn, we seem forced to ask how these processes are carried out; how do we classify and how do we evaluate? The answer of traditional theory is that classification requires a definition stating the necessary and sufficient conditions for the application of 'work of art'. Morris Weitz, by contrast, believes that what Wittgenstein says about games shows that classification does not have to be carried out in so rigorous a manner, but can be based on a looser 'family resemblance' model in which now this similarity, now that difference, guides our decision to apply or withhold the expression. Dickie's institutional definition is intended to answer only the classificatory question and he lines up with the traditional theorists in offering a set of necessary and sufficient criteria, albeit of a new sort, for art.

[2] *Art and the Aesthetic: An Institutional Analysis* (Ithaca and London: Cornell University Press, 1974), p. 34.

Pursuing a Wittgensteinian vein, W. E. Kennick said that 'we are able to separate those objects which are works of art from those which are not, because we know English.'[3] In saying this he was apparently echoing Wittgenstein's query 'How do I know that this color is red? – It would be an answer to say: "I have learnt English" ' (*Investigations*, §381). Kennick asks us to imagine a warehouse full of any number of things from which someone is to pick out all the works of art. He thinks this could be done with reasonable success despite the lack of a theoretical definition of art; such a definition, he believes, would only be confusing and get in the way of the process of selection.

Kennick's use of Wittgenstein, at this turn, plays him false. What makes having learnt English either an explanation or justification for calling something red? We can better understand this by looking at another kind of identification. Suppose that what is in question is, instead, the identification of a certain species of insect. Here it won't do to justify the identification with 'I have learnt English' although it can be an answer to reply, 'I have learnt entomology'. Why is being a native speaker of the language sufficient in the one case but not in the other and why should just that be sufficient at all? Being able to tell insects from one another is a rather specialized ability that few people bother to acquire, but, more importantly, the differences between the various species can be detailed and these differences serve as reasons and criteria for the specialist's identifications. Thus, 'I have learnt entomology' can be understood as the claim that one is such a specialist and stands ready to specify the necessary details should one's audience request them.

The ability to make basic color discriminations is not, of course, a speciality and save for the physiologically deficient and the weak-minded we all do it. Knowing our colors is such a basic part of our lives that we may be inclined to think

[3] 'Does Traditional Aesthetics Rest on a Mistake?', *Mind*, 67 (1958), p. 321.

that a person who doesn't know them doesn't know anything at all. It is not, however, merely the ubiquity of knowing our colors that is the key factor, although that is important. The logically telling factor is that there are no describable differences between the colors by virtue of which we can tell one from another. There is nothing about red that makes it different from blue in the way that there is something about this insect that makes it different from that one. Thus there are no reasons that I can cite for calling this color, seen in a good light, red. No answer can be given to the question how I know; or better, that question has no application in this case and we can remind the one who asks it of that by pointing out that this is what we call red, hence the appropriateness of the reply, 'I have learnt English'.

We may say of someone – a child perhaps – that he does not know the difference between red and blue, but it is wrong to suppose that we can say what that difference is as we can say what the difference is between two kinds of insect. To say that someone knows the difference is to say simply that he knows how to use color words, that he has mastered that part of the language.

Art may be more like entomology than it is like color and it is not always enough merely to be a native speaker in order to identify something as a work of art. Art is a remarkably complex cultural phenomenon – that is the truth behind the institutional theory – and there are varying degrees of expertise and specialization in our intercourse with it that connect with our reason-giving and specification of real differences.

There is something odd in asking someone to go about the world – for Kennick's warehouse just is the world – and pick out all the works of art just like that and with no further qualifications. I shall try to show later on what that oddness is. Dickie would find it odd as well, but for a rather different reason. Dickie believes that we very rarely use 'work of art' in the classificatory sense and I think he is right about that although the fact has implications that have not yet been spelled out. He goes on, however, to say that 'we generally

know immediately whether an object is a work of art, so that generally no one needs to say, by way of classification, "That is a work of art," . . .' (*Art and the Aesthetic*, p. 27). Let us note the oddity in the image of someone knowledgeable about art, let us say Bernard Berenson, for example, pointing to a Giotto panel and repeating that he knows it to be work of art. This would be like someone in ordinary circumstances insisting that he knows his name or G. E. Moore holding up his hand and intoning that he knows it is a hand. One frequently offered explanation for the curiousness of such remarks is that, although perfectly true, they are just not needed because they are taken for granted. This kind of explanation seems to impose a picture of knowledge and belief as states or enduring conditions or invites us to view them as like an epistemological music of the spheres, a sort of background noise always present, but unnoticed from long habituation and surprising only when brought to direct awareness.

The oddity in Berenson's imagined remark, however, is not that of a great man producing a painfully obvious truism when we were expecting an insight; it is, rather, grammatical or conceptual in nature. The word 'know' plays a role in countering doubts, establishing credentials, claiming access to special information, and the like. When our situation combines both Giotto and Berenson, however, there are no doubts to counter or credentials to establish and 'know' is left without a role to play; it has become like an idling wheel. It would require a very carefully contrived set of circumstances to give sense to either 'I know this is a work of art' or 'He knows it is a work of art'. Although we would not generally want to say that Berenson *knows* the Giotto is art, we can, nevertheless, speak of his *knowledge* of art which shows itself in the way that he looks at and talks about Giotto.[4] It may be more fruitful to turn from the question of what it is to know

[4] Witgenstein makes essentially this same point with respect to another topic in *On Certainty* (Oxford: Blackwell, 1969), §431.

that this thing is a work of art to the question of what it is to know art.

Here it will be useful to investigate some cases where mistakes are made in identifying something as a work of art. The examples that Pepper and Osborne would have to offer are instances of incompetent or tasteless work, paintings, poems, buildings that someone thought highly of although they really had little or no artistic value. Since the criteria of identification demanded by their theories are at the same time criteria of aesthetic value, they have to understand the classificatory sense collapsing into the evaluative sense. This intimate connection between definitional criteria and evaluation points to something important although the connection cannot be as intimate as Collingwood supposed when he said that the definition of a thing is the definition of a good thing of that kind. Criteria of evaluation do not fall so easily out of definitions. The dictionary tells us that an automobile is a self-propelled vehicle suitable for use on a street or roadway, but there is a vast distance between that statement and the evaluations of automobiles made in the motor magazines where the talk turns around engine displacement, horsepower, torque, fuel consumption, turning radius, g-forces, rear seat leg room, and a host of other particulars not hinted at in the dictionary formula. The gap between the dictionary statement and the generally accepted criteria of automotive excellence has to be filled by reference to a complex set of human interests comprising personal, social, economic and engineering considerations. There is, as it were, an entire *motorworld* behind all that.

There are mistakes about art, as I have suggested earlier, that philosophers have found more intriguing than those arising from poor taste or retarded sensibility. There are those critics who mocked the paintings shown in the first impressionist and post-impressionist exhibitions for pretending to the status of art. Danto constructs the example of the plain man who mistakes Rauschenberg's *The Bed* for a real

bed ('The Artworld', p. 575). The example is perhaps not a very good one. *The Bed* after all is encountered in a gallery and it does hang on the wall and is smeared with paint, which should suggest to the plainest of plain men that something is afoot. It would have been a more convincing story had he come across the thing in a corner of the lumber room. More plausibly, we can imagine a work consisting of various building materials, timber, concrete blocks, a sack of cement, strewn about the gallery floor. Upon entering that room our plain man can well be forgiven for failing to recognize a work of art, for such are the very things one expects to find in a room ready for remodeling. The same kind of mistake would no doubt be made by the museum porter who discovers the baggage delivered to the back door before the show. There is nothing in the material itself to hint of its ultimate destination.

The situation of our plain man and equally plain porter may remind us of the story of the gentleman (and that rather old-fashioned term is used deliberately) who is invited to dine at the home of a new acquaintance. In the course of the evening he addresses the lady of the house as Mrs Smith. He is later informed that he has made a mistake since the lady is Mr Smith's mistress and not his wife. He replies with aplomb born of breeding that it was not he who made the mistake.

At any rate, our plain gentleman and porter will have to be told that the stuff in question is art. This telling would seem to be a clear instance of the classificatory sense of the word and Dickie is surely correct in pointing out that such simple information-giving uses are not common. But let us take the story in which these examples figure one step further and ask what is pursuant upon receipt of the information. For the porter 'It is art' serves as notification that he is to truck the lot into the gallery rather than, say, leaving it for the builder's men. The porter's circumstances are clear and we know what motivates his question and comments. What are the circumstances of the plain gentlemen entering the museum by

the front door that underlie his questions and comments? Let us picture him as knowledgeable and discerning with respect to the history of art and thoroughly at home in twentieth century art; he knows and appreciates a wide range of periods and styles from Lascaux to abstract expressionism. He enters the gallery and thinks that some construction work is going on. When he is told that it is art instead, he is puzzled. That piece of information is not enough; he wonders how this can be art. His puzzlement arises out of his previous understanding of art. He is not put off by any lack of representation because he knows and enjoys abstract art, but this doesn't seem to have any of the characteristic virtues even of abstract art. There is no formal arrrangement worthy of being called a design, there are no interesting color relationships, there is not texture worthy of attention, nor is it apparently symbolic of anything and no doubt the artist or his critic tout would deny the relevance of all those things.

When this man wonders whether the business is art and uses the word 'art' in expressing his puzzlement, he is clearly not using the word in the classificatory sense; he is not, for example, disputing the information given him that it is part of the exhibition or that some agent of the artworld has been conferring status. Nor is he using the word in the evaluative sense. Of course he has not said that the thing is good, but, on the other hand, he has not said that it is bad either. His situation can profitably be compared to that of someone with a good sense of humor who does not see the point of some particular joke. He cannot say that it is a bad joke because that presupposes that he understood the point of the joke and then found that the point was not worth understanding. It is rather that he doesn't even know what there is in the story that is supposed to be funny. Many years ago there was a Peter Arno cartoon in the *New Yorker* showing two well past middle age couples in dinner dress on the sidewalk outside a Manhattan town house speaking through the window to a similar group inside. 'Come along,' they say, 'we're going to

the Trans-Luxe to hiss Roosevelt.'[5] Members of a younger generation are quite unmoved by this. Someone who doesn't see the point of the joke might not even know where to look for it. Is it in the fact that the people are rather old (as if hissing were a young man's sport)? that they are in dinner dress (one hisses only in tweeds)? that they want to hiss at the Trans-Luxe (Loewe's is the place for that)? and so on. The one who does not see the point knows that it is *supposed* to be a joke – thus the classificatory issue has been taken care of – but has yet performed no evaluation. When he asks what is funny about it or where the joke is, he is asking how the thing is to be understood, where the point is to be found, and what is relevant to its appreciation. In like manner the question about art in the previous case is a demand for an explanation of the thing as art and a plea to be shown what is relevant to an understanding and appreciation of it as art. Our plain man who wants to know whether it is art is using the word in a way that is captured by neither half of the classificatory/evaluative dichotomy.

The uncovering of this additional use of the phrase 'work of art' allows us to pose a series of questions about the nature of the institution of the artworld. Wittgenstein insists that language can be understood only against a background of human activity. Of the language of art he said:

> The words we call expressions of aesthetic judgment play a very complicated role, but a very definite role, in what we call the culture of a period. To describe their use or to describe

[5] President Roosevelt drew strong reactions from almost everyone. Large numbers adored him and others despised him, largely for what they took as his leftish tendencies. Some of the wealthy called him 'a traitor to his class'. Whenever he appeared in the newsreels at the movies he was applauded by part of the audience and booed and hissed by the other part. The Trans-Luxe was a theater in New York that showed only newsreels and other short subjects. In the thirties it would have been the place to go to see the latest doings of FDR.

what you mean by a cultured taste, you have to describe a culture.[6]

When Wittgenstein speaks of culture here, he does not have in mind that broad anthropological sense of the totality of a society's ways of doing, but rather what characterizes the educated class of Europeans who were concerned to cultivate art, good taste, and a certain style of living. To the extent that the 'culture of a period' takes in the activities of those who practice and appreciate art, it is tempting to identify what Wittgenstein is speaking of with the artworld of Danto and Dickie. It remains to be seen how nice the match really is.

Wittgenstein's point about culture is not primarily a sociological or historical one because the description of the culture is required to describe the *use* of certain words, that is, their meaning. In the *Brown Book* he says that to imagine a language is to imagine a culture (*Blue and Brown Books*, p. 134). These earlier thoughts about the relation of language to culture will be exchanged for remarks about the relation of language to forms of life in the *Philosophical Investigations* where imagining a language becomes imagining a form of life (§19). The notion of a form of life, like that of a language-game, is a notoriously difficult one and doubtless comprehends more than one kind of thing. Neither the idea of a language-game nor that of a form of life are given theoretical formulation by Wittgenstein. Neither expression is intended to have precise conditions of application; both are employed heuristically and invoked *ad hoc* in the treatment of particular difficulties on particular occasions. Whatever a form of life, is, it is something done, a set of activities or proclivities to act, that gives sense to our language and makes it possible; it is also something for which no further foundation or justification is to be sought.

[6] *Lectures and Conversations*, ed. C. Barrett (Oxford; Blackwell, 1966), p. 8.

Our use of language – our language-games – is embedded in activities and practices and apart from those there is no understanding of language. A form of life, however, seems to be something deeper and more basic than the conventional behaviour that makes intelligible such a four-sided exchange as 'Three hearts – Three no trump – Double – Pass'. We cannot understand the language of bridge apart from the activity of playing the game; the bidding, after all, is part of the game. Underlying the game there are yet more basic facts of human nature and human relationships. A form of life certainly includes natural reactions such as a child's cry when it is injured that makes possible the learning of the language-game in which the word 'pain' figures. It also includes that certain measure of agreement in judgments without which no language would be possible. It is a difference in form of life and not just cultural conventions that prevents us from understanding a talking lion (*Investigations*, p. 223e). We do not crouch in the tall grass of the High Veldt, switching our tails and licking our chops, while eyeing the stragglers from a herd of zebra: in addition to lacking the lion's physical equipment, we simply do not have the proclivity to do so. The fitting motto for so much of Wittgenstein's work is thus Goethe's *In Anfang war die Tat*.[7]

It is, I believe, a mistake to describe art as a form of life, as Richard Wollheim does.[8] Our artistic practices and institutions are partly conventional and certainly part of a culture, but do not by themselves constitute a form of life in Wittgen-

[7] These comments about forms of life owe much to John H. Whittaker, 'Language-Games and Forms of Life Unconfused', *Philosophical Investigations*, 1 (1978), and G. P. Baker and P. M. S. Hacker, *Wittgenstein: Understanding and Meaning* (Chicago: University of Chicago Press, 1980) pp. 136–7. Wittgenstein quotes the passage from Goethe in connection with a discussion of foundational issues in epistemology. I am indebted to Peter Winch for calling my attention to the appropriateness of Goethe's line for Wittgenstein's thought generally.

[8] *Art and its Objects* (New York, Evanston, London; Harper & Row, 1968).

stein's sense. They presuppose a form of life – a set of shared reactions, judgments, and the like – that make the conventions possible. If this is correct, then neither can we think of the artworld as itself a form of life; it seems, instead, more akin to Wittgenstein's 'culture' or possibly even a language-game(s).

If we were to elaborate the activities and practices in which our talk about art, the language of art, is embedded, the resulting descriptions might very well be like those given of the artworld. What does the artworld include? The name is a great deal more than a fashionable slogan for the New York establishment of studios and galleries, artists, critics, and dealers. Danto says it includes art history and theories. Dickie says it also takes in traditions that include the institutionalized behavior of artists, performers, and their audiences. The various traditions he speaks of as systems 'for the *presenting* of particular works of art' (*Art and the Aesthetic*, p. 31). It would be no great task to spell out as many of the details of the workings of Dickie's artworld as happen to be desired. The histories, traditions and conventions of the various art forms could be described, as could the training given to artists, the kind of education in art given to the general public, the economic status of artists, how works of art are commissioned, bought and sold, how museums and galleries operate, and so on. The trick is to discover in all this what, if anything, will shed light on the quandary in which our plain gentleman finds himself.

Neither Dickie nor Danto intend their accounts of the artworld to pass merely for cultural history and sociology. The notion plays a logical role for Dickie since it is from the artworld that criteria for the application of 'work of art' are obtained. Dickie does not, however, understand it as necessary to make our talk of art intelligible. Danto's view is at once more subtle and more puzzling than Dickie's as the following passage shows:

To see something as art demands nothing less than this, an atmosphere of artistic theory, a knowledge of the history of

art . . . Perhaps one *can* speak of what the world is like independently of any theories we may have regarding the world, though I am not sure that it is even meaningful to raise such a question, since our divisions and articulations of things into orbits and constellations presupposes a theory of some sort. But it is plain that there could not be an artworld without theory, for the artworld is logically dependent upon theory. It is essential to our study that we understand the nature of an art theory, which is so powerful a thing as to detach objects from the real world and make them a part of a different world, an *art* world, a world of interpreted things. What these consideration show is that there is an internal connection between the status of an artwork and the language with which artworks are identified as such.[9]

Danto believes that it is a theory that makes art and the artworld possible. This is puzzling for more than one reason. One of these reasons is that he also says that the artworld is made up in part of theories. But that aside, there is a more interesting reason to be puzzled by his talk of theories. There are a number of different kinds of things that we may be inclined to think of as artistic theories, an area about which there is much confusion generally. Renaissance perspective was based on scientific theories of optics and geometry and the impressionist painters appealed to physical and physiological theories of color and color perception. Boccioni's Futurist manifesto that 'The aim of scupture is the abstract reconstruction of the planes and volumes which determine form, not their figurative value'.[10] may be called a theory, and there are such things as Bell's theory of art as significant form and Santayana's theory of beauty as objectified pleasure.

One author has recently distinguished between *art theory*

[9] *The Transfiguration of the Commonplace* (Cambridge, Mass.: Harvard University Press, 1981), p. 135.

[10] *Technical Manifesto of Futurist Sculpture*, in *Modern Artists on Art*, ed. Robert L. Herbert (Englewood Cliffs, NJ: Prentice-Hall, 1965), p. 55.

and *aesthetics*.[11] Art theory is said to be the body of ideas formulated by artists in regard to their work in an effort to explain and further the appreciation of their work. Aesthetics is the body of theory produced by philosophers. The distinction turns out to be primarily a function of who does it. The major fault in this way of drawing the distinction is the failure to remark any logical difference within what passes for theory; there is, for example, no recognition of the difference between a philosophical generalization supported by arguments on the one hand and manifestos, statements of intentions, preferences, and the like on the other. Although geometrical optics no doubt made high renaissance painting possible, it is not the sort of thing that makes art in general possible. There seems to be a logical gap between the physics of color and impressionist practice and the theories probably lent more moral than logical support to those painters; Boccioni's manifesto is best understood as a proclamation of the intention to sculpt in a certain way and makes a kind of sense despite the fact that so many twentieth century manifestos border on the incoherent in their echoing of talk like Kandinsky's of the 'spiritual nature' of art; Morris Weitz suggests that Bell's theory can only be salvaged in the guise of an instruction for looking at paintings; and Santayana's theory is an epistemological confusion incapable of making anything possible.

It is not examples such as these, however, that Danto has in mind when he speaks of theory. In the first place, he speaks of all language as theory and if in fact it is, then necessarily whatever we say about art will be theoretical as well. I am not at all sure that it is helpful to think of the entirety of language as embodying theory about the world. Is it really plausible to suppose that when we call our chickens, buy groceries, or bid a hand at bridge we are invoking a theory about the nature of things in general? I am not,

[11] Stewart Buettner, *American Art Theory 1947–1970* (Ann Arbor: UMI Research Press, 1981).

however, concerned to argue that general case here. Be all that as it may, Danto believes that the artworld, at least, is logically dependent upon theory. A theory in art, it turns out, is what Danto calls an interpretation, for 'To interpret a work is to offer a theory as to what the work is about, what its subject is' (*The Transfiguration of the Commonplace*, p. 119). He then characterizes interpretation by saying it 'Consists in determining the relationship between a work of art and its material counterpart' (ibid., p. 113). This reference to the 'material counterpart' signals a move into ontology and a discussion of that must wait until chapter 5. For the time being it is enough to note that all of Danto's examples of interpretation, and hence 'theories', are examples of what we would ordinarily call artistically relevant descriptions and not theories at all; for instance, he says of Bruegel's painting, *The Fall of Icarus*, that this dab of paint is Icarus and that the plowman is indifferent to the tragedy.

I find it extraordinary that anyone would characterize such descriptions as theories, but I don't want to be understood as caviling about it and, again, setting all that aside, Danto's thesis comes to something like this. There is a precinct of our language – whether we should call it a language-game I deliberately leave an open question for now – in which we talk about art and the existence of art and the artworld is logically dependent upon that part of language. The key to understanding this dependence is his statement that there is an *internal connection* between art and the language of art. It is very interesting that Danto speaks of seeing something *as* art in that the 'seeing-as' locution immediately suggests the topic that plays such an important role for Wittgenstein. The locution is an important one for Danto and not merely a manner of speaking because of his views about the relation between works of art and what he calls their material counterparts, including the contention that a work of art can be visually indiscernible from its material counterpart. It is as if he is picturing arthood as a non-visual 'aspect' of an object. Wittgenstein talked about seeing-as in the course of elucidating

certain concepts of visual experience and although Danto uses 'seeing' in the broader sense of understanding in general, there are some interesting and important logical parallels between the two.

Wittgenstein said that in the dawning of an aspect, when something is seen as something else, what one sees is an internal relation with other objects (*Investigations*, p. 212e). This connects with his idea that the substratum of the experience of aspect perception is the mastery of a technique and this technique is usually one of using the appropriate language. It is only if someone can use the word 'duck' and identify ducks that he can be said to have the experience of seeing the ambiguous figure as a duck. For Wittgenstein seeing-as presupposes a language in which we talk about the furniture of the world and aspect perception then depends logically upon establishing a connection with some part of that furniture by means of that language; hence the internal relation.

Danto's position is in part analogous to Wittgenstein's. It is the mastery of a part of language, the ability to provide an 'interpretation', that is the logical condition for understanding something as art. But it is not just the understanding that the language makes possible, it is also art itself. And this is because Danto believes that art is the kind of product of human culture that exists only because it is possible to provide the kind of descriptions of it that he calls interpretations; hence the internal connection between art and the language of art.

Another puzzling feature of Danto's account is that it can appear to have got things the wrong way round. One would think that it is the theories, interpretations, and descriptions that depend upon art and that the art must be there first in order to be described, interpreted, and theorized about. Why isn't talk about art a contingent by-product of art instead of a logically necessary condition for it? We can imagine a tribe that draws and paints, plays music, and recites poetry, but keeps its talk about it all to a minimum. Instruction is carried out mostly by example along with occasional comments such

as 'make this line thicker'. 'Play it like this', and so on. There are no schools of criticism, no reviews in the papers, and certainly no art history. People nevertheless take it all very seriously and are most attentive to what they see and hear; they react with gestures and facial expressions, and sometimes shift their preferences with their moods.

Danto's position seems to entail that we cannot call the practices and products of these people art because they do not have a concept of art manifested in the right sort of talk about what they do. This may strike us as needlessly arbitrary, however, since what they do is so much like what we do and it seems obvious that we would have little difficulty in joining in a great deal of their activity. There is yet something correct in Danto's thesis: there are some facets of art and our dealings with it for which description and interpretation are essential elements and not merely contingent additions. It would be without meaning, for example, to say that someone finds Bruegel's plowman indifferent to the tragedy unless that person were prepared to offer the appropriate descriptions. But at the same time something is missing from Danto's account and our imaginative example allows us to see what it is. It allows us to see that the artworld is not at all like a Wittgensteinian form of life and it makes clear that it is not even very much like a language-game. The artworld as he pictures it is entirely a linguistic entity made up of all the things we say, the theories, interpretations, and descriptions of art available to us. Inasmuch as Danto describes the artworld as a linguistic entity nothing has been said about how the language connects with the activities of artists and the reactions of their audience nor how – nor whether – these theories (interpretations, descriptions) are grounded in these activities and draw their sense from them. Suppose our tribesmen neither corrected nor encourage their learners and that they were expressionless in front of what they saw and heard or that any reactions were disconnected from the reactions characteristic of the rest of their lives. Then all justification for speaking of their art would certainly be removed.

I have no desire to disagree with that part of Danto's thesis

that maintains that the materials for the interpretation and description of works of art are drawn from an artworld background of knowledge of art history and artistic intentions; on the contrary, I endorse it. Nevertheless, the question remains how all this works in any particular case and exactly what it is from the artworld that our plain gentleman must draw upon in order to understand the stuff in the gallery as art. It was, after all, his knowledge of art history that generated the perplexity for him in the first place.

Suppose we approach the problem of the joke with some of Danto's views in mind. If someone does not understand the Arno cartoon to be a joke or does not see the point of the joke, it is not at all apparent how a *theory* can help him although he may need an interpretation. It is difficult to imagine someone who does not even understand that it is supposed to be a joke unless we imagine someone who has no concept of jokes at all, perhaps the product of a serious minded tribe that punishes the natural laughter of its children. Our only recourse then would be to turn him back into a child and start all over again. In the more usual sort of case, however, to help someone see the point of the Arno cartoon we would probably have to recreate for him an entire sociopolitical context now almost vanished. The joke turns upon a familiar species of human foible and the explanation must make clear the circumstances in which that kind of folly is operating. We could, following Danto, call the explanation an interpretation.

With this kind of explanation there is always the danger that the appreciation of the joke will be rather academic. The explanatory footnotes cannot provide the bite that comes from having lived through that particular episode of the American past. And even with the best interpretations there is no guarantee that the point of the joke will register. What is required is not only an interpretation, but also a reaction; it must strike one as funny. It is the idea of such a reaction that so far seems missing from Danto's account of art and is another indication of an important difference between the artworld and a form of life.

Not all jokes, of course, turn upon the exploitation of foibles. There are what might be called other principles of humor as well. Recall the story of the man who rushes into the doctor's office and exclaims breathlessly 'Doctor, I've got Bright's disease – and he's got mine!'[12] The humor here depends instead upon a conceptual ploy. There are a number of ways of getting someone to see the point of a joke; sometimes it is a matter of filling in a background and sometimes it is a matter of pointing out the kind of joke it is. None of that, needless to say, suggests anything at all about theory.

Just as there are different kinds of jokes so there are different kinds of art, not all paintings are representational, not all poetry uses rhyme or meter, not all music is based on the same tonalities. What is important here is not theories, but what artists do, how we understand, appreciate, and respond to their work. The importance of practice can be brought out by once again reminding ourselves how the crucial language is taught. The word 'game' is not taught by descriptions and explanations but rather by teaching children to play games, and the word 'art' is not taught by describing works of art and adding that these and similar things are called 'art' but by teaching children to appreciate art. We show children pictures, we read to them, we play music for them, and then we encourage them to draw pictures, write poems, and play music for themselves. We teach them, eventually, about different periods and styles, that the impressionists must be approached differently from the quattrocento, that one reads Donne and Eliot differently from Tennyson, and that we must not expect the same things from Hindemith that we do from Haydn.

It is no doubt unfortunate that the education of children in art is neither as systematic nor widespread as we may wish and the understanding of the concept grounded in this train-

[12] I am indebted to John Cook who, I believe, was the first to get philosophical mileage out of that one. Cook attributes the joke to Perelman. ['Wittgenstein on Privacy', *The Philosophical Review*, 74 (1965), p. 302.]

ing, or the lack of it, may often be impaired. This may lead to problems, but not necessarily philosophical ones. What must be insisted upon, however, is the centrality of artistic practice, of painting, writing, composing, and the like, on the one hand and the appreciative practices of looking, reading, and listening on the other for understanding talk about art and the disputes and doubts that can arise about the artistic status of things.

It is this centrality of both artistic and appreciative practice that makes the claim, referred to in chapter 1, that particular aesthetic descriptions and judgements imply general theories of art or aesthetics appear in a very bizarre light. This can be seen in the remarks that Maurice Mandelbaum makes about Paul Ziff's description of Poussin's *Rape of the Sabine Women*, Ziff talks about the sensuous features of the painting, its design, and the fact that it is a representation of a mythological scene.[13] Mandelbaum then makes the curious remark that in focusing attention on the features that he does, Ziff 'is making an implicit appeal to what is at least a minimal aesthetic theory, that is, he is supposing that neither weight nor insurable value need be mentioned when we list the characteristics which lead us to say . . . it is a work of art'.[14] I see no reason whatsoever to believe that Ziff is *supposing* anything; his description of the painting is based on our ordinary and traditional ways of looking at paintings. There is no theory here, implicit or otherwise; there is only what we do. The absurdity of imposing a theory shows up when we make the analogous claim that a card player is appealing to at least a minimal theory of bridge when he opens with a bid of two spades, having the honor count to do so, rather than calling for the running back to carry the ball on a wide sweep. There is absolutely no temptation to suppose that

[13] 'The Task of Defining a Work of Art', *The Philosophical Review*, 62 (1953), pp. 60–1.
[14] 'Family Resemblances and Generalizations Concerning the Arts', *The American Philosophical Quarterly*, 2 (1965), p. 224.

there is a theory of bridge at work on him and anyone who wondered why he did the one rather than the other would be guilty of a dreadful confusion. We would have to explain that bridge and American football are two different games played in altogether different ways. Likewise we do well to remind ourselves that there are ways of understanding and enjoying paintings, and our activities in those regards are of a different kind from the ones we engage in when it is a matter of commercial transactions in art where weight and insurable value can become relevant.

Like the word 'game', the word 'art' has many uses. In the last chapter we saw that it is the fact that games are played that makes possible so many of those uses. The implications of this for art are obvious. The word 'art' and all its relatives are learned in connection with learning to look, read, and listen – in a word, along with the development of aesthetic sensitivity and appreciation – and it is the many facets of these activities that give the word its many uses. A finely wrought ship model can be called a work of art by way of comment upon the craftsmanship manifested in it, although it would never occur to an art historian to speak of it in his scholarly studies. One painter may dismiss another as no artist at all, but only a mere illustrator, while finding nothing amiss in his listing his occupation as that of artist. Bruno Walter tells us that early in his life 'I considered dance music perfectly proper for purpose of entertainment, but my boyishly serious mind was absolutely opposed to mixing art with amusement.'[15] In these examples, applying or withholding the word 'art' or 'artist' is not a way of identifying or even classifying things, but rather serves as a way of directing attention to certain features of them so that they may be made to appear in a certain light. It is important to note that 'art' is used in each of these examples to mark a specific contrast, e.g. skillfully as opposed to clumsily done, having something to say, some vision of things to get across,

[15] *Theme and Variation* (New York: A A. Knopf, 1947), p. 32.

as opposed to executing designs no matter how skillful, pleasing, or decorative, and as serious as opposed to merely diverting.

The classificatory/evaluative distinction is clearly inadequate to do justice to the complex role that the word 'art' plays in our language. Moreover, it is misleading to speak of *the* classificatory sense as if classification were a single activity serving a single end. One instance of classification has already been imagined in the case of the museum porter who is to transport the material into the gallery. As another instance consider the celebrated Brancusi affair. Was Brancusi's *Bird in Space* a work of art or only a piece of raw metal on which import duties were to be levied? The judge decided that the *Bird* was indeed a work of art. Here something was at issue and something depended upon the judge's application of the expression 'work of art' and we have a pretty clear idea of the considerations relevant to the decision. The government had argued that Brancusi was not known as an artist and that the *Bird* did not look like a piece of sculpture. Brancusi's lawyers countered that he was well known as an artist in Europe, that the *Bird* had been crafted by hand with an artistic purpose in mind, and that the past decades had seen important changes in artistic practice that the government was unaware of. It may be worth adding that in addition to the immediate legal and economic issues at stake, the decision apparently had some effect, in the United States at least, of encouraging certain artistic trends and hastening their public acceptance.

The point about classification that I want to make can be seen more clearly with the aid of another imagined example. Suppose that acting for a commercial agent I am given the job of inventorying the estate of a recently deceased and wealthy *parvenu* for the purpose of selling it all off. I am given the categories into which the personal property must all go, 'furniture', 'kitchenware', 'silverware', and so forth. One of the categories is 'works of art'. I have no trouble in picking out quite a number of things to be tagged 'art' – paintings, tapestries, sculpture – no matter how execrable the

taste. Is it significant that books would probably have their own category although I may well have to sort them into 'literature', 'reference', and the like? But what about the life-size statue of the Nubian slave girl in the front hall by the staircase, the one with the lamp on her head and the clock in her belly? Is she a work of art, a piece of furniture, or a miscellaneous? I have to make a decision here and my decision will most probably not be guided by any considerations of aesthetic theory, but rather by what I know of the tastes and wishes of the dealers I represent and of those of their prospective customers. If the lot is to be sold off in Miami Beach, we could represent her as 'work of art', in San Francisco, she may go as 'conversation piece', but in Philadelphia it may be best to leave her discretely unmentioned.

The thrust of all these examples is directed at bringing home the necessity of a context in which the word 'art' must function. When we 'classify' an object as art we must have something in mind, some point to make, some contrast to mark, some job to do, and in the absence of such a context 'art' is but another idling wheel. Thus we can see what is amiss in Kennick sending his chap into the warehouse to pick out all the works of art. Kennick has specified no context for this instruction and hence no use for the word 'art'. Is the fellow being tested for his knowledge of art history, is he on assignment for a museum, or are we interested in learning something about his taste? We don't know. Kennick is right to say that no aesthetic theory is going to help him, but he fails to indicate what will help him, namely his background knowledge of art and some sense of what he is supposed to be about in his assigned task. What makes Kennick's example plausible to many people is that they tend to supply a context for the task and imagine the fellow as engaged in building a collection for a museum, decorating his house, or something of the sort. Without some such assumed context Kennick has given us only another example of language gone on holiday.

There are doubtless many difficulties with the institutional theory of art. The analogy between the 'artworld' and what

we think of as a social institution may be imperfect and the notion of 'conferring status' may strike one as much too ritualistic for anything that actually goes on in the world of art. Nevertheless, by recognizing the existence of an artworld – some kind of complex of historical traditions, conventions, and, perhaps, even theories, that underlies our talk of art and judgments about it – the institutional theory has directed attention to something of the utmost import-ance, although I do not believe that the theory has been able to pick out from all that background just precisely what it is that is crucial for the problems the theory is designed to solve. Nor has it been able in any satisfactory detail to show how the idea of an artworld functions in actual cases where the artistic status of something is in question.

It is now time to return to the doubts and puzzlement of the plain gentleman in the gallery. It is not enough to 'clas-sify' the stuff before him as art. The information that it is intended to be art does not touch his question because he wants to know how the thing is to be understood and apprec-iated. Until he knows this the classificatory 'this is art' can mean nothing to him. How can he be taught to understand the work? In the next chapter I want to examine an historical example of this kind of puzzlement and how it was relieved.

4

The Shock of the New

A persistent feature of the last hundred and more years of art history has been the seasonal recurrence of what Ian Dunlop has labeled *The Shock of the New*.[1] On any number of occasions during this period the artworld has been shocked by the appearance of avant garde movements that have seemed to challenge artistic traditions and prevailing conceptions of art. One thinks immediately of the impact made by the first impressionist showings, the fauves, the post-impressionist, the surrealists, and so on. Professional critics and casual gallerygoers alike have been disturbed and puzzled by these new developments that they did not know what to make of. The new works did not seem to accommodate themselves to what art was thought to be like and frequently the motives of the artists were themselves impugned. This sort of thing is still very much with us and has been especially exacerbated by a number of movements of the very recent past including some manifestations of pop art, minimal art, arte povera, conceptual art, and the like. One need only think of Andy Warhol's *Brillo Box*, Claes Oldenburg's *Placid Civic Monument*, the hole he had dug in Central Park behind the Metropolitan Museum and then filled in again or the piece that Robert Barry offered for Lucy Lippard's Seattle World's Fair show which consisted simply of the remark 'All the things

[1] *The Shock of the New* (New York, St Louis, San Francisco: American Heritage Press, 1972).

I know but of which I am not at the moment thinking –
1:36 P.M.; 15 June 1969, New York', not to mention the
examples, both real and imagined, of the last chapter.

When faced with this sort of thing the plight of our plain
gentleman, described in chapter 3 evokes sympathy. But
what exactly is his plight? It is not that he thinks the work
before him is bad; after all, he doesn't know what is relevant
to the assessment of its worth and in this respect he is like the
man who doesn't see the point of the joke and doesn't know
where to look for it. His first reaction might be to dismiss the
business out of hand as a kind of nonsense or as a prank or
joke, and not a very good one at that. But he is reluctant to
thus dismiss it out of hand. A great many allegedly serious
people do take it seriously and he thinks of those traditional
critics who proved to be the laughing stock of later
generations for making mock of the impressionists, the post-
impressionists and all the others we now rank among the
modern masters. He has grounds for his reluctance.

How can he be brought to understand this new material
and be shown that there is something to it after all or, as may
be, verify his original suspicions? We can approach this task
and at the same time get a clearer view of our man's situation
by examining in some detail an actual case of new works of
art shocking the artworld and producing what may be
described as a crisis in criticism and appreciation. The case I
want to examine is that of those painters for whom Roger
Fry coined the name 'Post-Impressionist' in 1910. This case is
instructive because we now have an advantageous historical
perspective from which to view it and also because Fry's
critical defense of those painters is an excellent example of
how a new movement can be sympathetically understood
and judged.

Roger Fry was well known in Edwardian Britain as an art
historian and critic and was popular as a public lecturer on the
arts. He also had a modest reputation as a painter in his own
right. In 1910 he organized the first exhibition of post-
impressionist painting at the Grafton Gallery in London. The

exhibition included works by Manet, Cézanne, Gauguin, Van Gogh, Vlaminck, Derain, Seurat, Signac, Matisse, Rouault, and Picasso, to name only the more important. The great majority of these works were new both to British artists as well as to the British public. Critical and public reaction was generally one of outrage. When they were not simply laughed at, the paintings were called indecent and pornographic. The tendency was for critics to regard it all as destructive of artistic tradition and of the artistic values so laboriously developed from the renaissance on. It was especially puzzling that a man such as Roger Fry who could write and lecture eloquently on the likes of Bellini and Botticelli could at the same time perpetrate a thing like the Grafton show.

The critical reaction to the exhibition is made comprehensible by the state of the arts and artistic taste at that time, that is, by the culture of the period, the Edwardian artworld. This state of things has been described for us in some detail.[2] The 'old masters' of the high renaissance were still much admired and the popular academic painters of the nineteenth century, Alma-Tadema, Leighton, and Landseer, for example, were thought of as carrying on that tradition. Some artists and collectors had begun to make their peace with impressionism and if the impressionists were not exactly in vogue, at least they were no longer despised. Whatever group of painters passed for avant garde in Britain, it was a pretty tame crowd; there was nothing that could properly be called bohemia where radical ideas were fermenting. Although a number of British painters had studied in France, they had confined themselves to the more reputable *ateliers*, and had apparently not penetrated into *la vie bohème* whence came the makings of the Grafton show.

[2] See Dunlop's chapter on the post-impressionists; Virginia Woolf, *Roger Fry: A Biography* (London Hogarth Press, 1940); and Frances Spaulding, *Roger Fry: Art and Life* (Berkeley and Los Angeles: University of California Press, 1980).

Against this background it is easy to understand the reception of the post-impressionist and why neither critics nor public knew what to make of them. There was no problem in describing and evaluating a new painting done in the famililar traditions. Here one knew what to look for, literary and historical content, drawing, space composition, perspective, color, atmospheric rendering, and so on and there was no great problem in telling the painter who had learned his lessons from the inept who couldn't make it all come off. With the post-impressionists, however, none of the familiar categories seemed to apply. No wonder they were seen as either hopelessly unskilled and doing very badly what the academic painters did very well or as deliberately, and perhaps even maliciously, kicking over all that was of value.

In an article in *The Nation*[3] Fry defended the post-impressionists in the following way. He admitted that although 'they were in revolt against the photographic vision of the nineteenth century, and even against the tempered realism of the last four hundred years', nevertheless they are the most traditional of recent artists. They represent a rather successful attempt to get behind 'the too elaborate pictorial apparatus which the Renaissance established in painting. In short, they are the true Pre-Raphaelites.' He then went on to develop this point.

> We think of Giotto as a preparation for a Titianesque climax, forgetting that with every piece of representational mechanism which the artist acquired, he both gained new possibilities of expression and lost other possibilities. When you draw like Tintoretto, you can no longer draw like Giotto, or even Piero della Francesca. You have lost the power of expression which the bare recital of elementary facts of mass, gesture, and movement gave, and you have gained whatever a more intricate linear system and chiaroscuro may provide. (p. 332)

[3] 'The Grafton Gallery – I', *The Nation* (London, Nov. 19, 1910), pp. 31ff.

Fry's argument is in essence a rejection of the view of art history associated with Vasari that understands Giotto as doing in a crude and clumsy beginner's way what Leonardo, Michaelanglo, and Titian did superbly well. With such a picture of art history in mind it is also possible to see Cézanne and the others as doing very badly what the nineteenth century academics did very skillfully. There are, however, other ways to look at Giotto; he has his own values of form, design, and expression that tended to get submerged in the later development of renaissance techniques of representation. Now, Fry tells us, don't look at Cézanne as you look at the nineteenth century academics; see him, instead, as doing the kind of thing that Giotto was doing. (Fry also compares Cézanne to Mantegna and Piero.) To understand the post-impressionists the reference point must be Giotto rather than Raphael.

I have spoken of Fry's *argument*, but something wants saying about that use of the word. Fry's conclusions about Cézanne and the other post-impressionists could no doubt be accommodated as a formal exercise by some such scheme as that set out in chapter 1 with his basic 'assumptions' about artistic value made explicit and all the rest. But the force of what Fry has to tell us about post-impressionism does not depend upon any relation of entailment by previously accepted premises. That Cézanne is good and worth looking at is not arrived at deductively – and it is certainly not rendered inductively probable by any marshalling of evidence either. What Fry is actually doing is showing us how to look at Cézanne so that we will see his value for ourselves. He helps us to do this by pointing out likenesses between his work and aspects of the artistic tradition with which we are already familiar despite those aspects having been neglected in the then prevalent view of art history.

This kind of pointing out is double-edged in an interesting way. For if Fry can show us that Cézanne is like Giotto, then surely we can also see that Giotto is like Cézanne with the result that the kind of formal values common to the two are

brought much more forcefully to our attention and this neg-
lected aspect of the tradition can henceforth become another
focus of appreciative and critical awareness. Something
rather similar had been suggested sometime earlier by Degas
when he exclaimed 'O Giotto! teach me to see Paris, and you,
Paris, teach me to see Giotto.'[4] In such ways the tradition is
thus modified and expanded.

Very much the same kind of aesthetic commerce between
the current and the past is instanced in an example drawn
from literary criticism. In a brief essay on Kafka, Jorge Luis
Borges calls attention to the existence of Kafkaesque themes
in earlier writers. He then goes on to conclude that:

> Kafka's idiosyncrasy, in greater or less degree, is present in
> each of these writings, but if Kafka had not written we would
> not perceive it; that is to say, it would not exist. The poem
> 'Fears and Scruples' by Robert Browning is like a prophecy of
> Kafka's stories, but our reading of Kafka refines and changes
> our reading of the poem perceptibly . . . The fact is that each
> writer creates his precursors. His work modifies our
> conception of the past, as it will modify the future.[5]

Although it is surely an exaggeration to say that Cézanne
created Giotto, as if we had to have seen Cézanne before we
could appreciate Giotto, nevertheless there is a point here
well taken. The work of Cézanne and his contemporaries of
the late nineteenth and early twentieth century has indeed
modified our conception of art history and artistic tradition.
With the move toward abstraction and expressionism,
Byzantine art and primitive art, for example, as well as a
unique figure such as El Greco, cannot possibly look the
same to us. The new developments are sometimes, to be
sure, the result of the influence of a tradition, but they need

[4] 'Shop Talk, in Elizabeth Gilmore Holt, *From the Classicists to the
Impressionists* vol. III of *A Documentary History of Art* (Garden City NJ:
Doubleday, 1966), p. 404.

[5] 'Kafka and his Precursors', in his *Other Inquisitions* (Austin:
University of Texas Press, 1964), p. 108.

not be linked to that tradition merely by historical ties; sometimes it is the new works themselves that help mark out just what that tradition is.

The major accomplishment of Fry's critical work was to show the artistic public how to look at the new painting. His importance lies not so much in any theory he developed, but in the critical and appreciative practice that he encouraged. It is in the light of all this that we can gain a different understanding of what is going on logically in the theory of art as 'significant form' that Clive Bell worked out as a result of his experience with and his thought about post-impressionism largely under the influence of Roger Fry. If the theory is taken as an attempt to explain the meaning of the word 'art' or to lay down the necessary and sufficient conditions for its application, the result is the sheerest nonsense. It is better understood, I believe, as an expression of how Bell and Fry looked at the post-impressionists and as an instrument in the critical and interpretive labor that they took up on their behalf in the context of Edwardian taste. This allows us to appreciate Morris Weitz's apt characterization of the theory.

> What gives it its aesthetic importance is what lies behind the formula: In an age in which literary and representational elements have become paramount in painting, return to the plastic ones since these are indigenous to painting. Thus, the role of the theory is not to define anything but to use the definitional form, almost epigrammatically, to pinpoint a crucial recommendation to turn our attention once again to the plastic elements in painting.[6]

There is a pattern in this history of Fry and the post-impressionists that now needs to be made explicit. This pattern is composed of four elements. (1) There is the culture of the period, the background of artistic life, traditions, and

[6] 'The Role of Theory in Aesthetics', p. 35.

practices, the artworld, against which works of art are understood, described, and evaluated. (2) Something is offered as a work of art that apparently cannot be accommodated by the tradition and that cannot be described and evaluated in terms of familiar categories and standards, with the result that the critics as well as the general public are puzzled, if not outraged in addition. (3) The new work is defended by the demonstration of a connection, however unsuspected, with some aspect of the familiar tradition. The connection is established by showing the likeness that is to be seen between the new and the already familiar. The demonstration thus provides a way to understand and assess the new work. (4) The result of all this is that the relevant aspect of the tradition is given an importance it did not have previously and the tradition is thereby modified and enlarged. It remains to be seen whether the conceptual pattern revealed in the criticism of Roger Fry has any application to the critical and appreciative concerns that surround Oldenburg's *Monument*, Barry's 'All the things I know . . .', or any of the other puzzling examples we have introduced.

There is one feature of our present day artistic life that is quite different from that of Britain in 1910. We are now habituated to artistic change and aesthetic experimentation and new artistic movements are the order of the day. We are no longer disturbed simply because something is new and unlike what we are familiar with; in this respect we are undoubtedly much more tolerant and open than the Edwardians. We are also much more sophisticated with respect to art history; we are aware of a vast historical and contemporary range of artistic styles and intentions and we know that these can make quite different demands on our appreciative faculties. Put in another way, this means that we have a wider and richer vocabulary for artistic description at our disposal than did that older generation that Fry had to contend with. Not only can we talk about the traditional values of representation and draftsmanship, but also about the formal values that Fry called our attention to and abstract values

of color and texture as well, not to mention more recent styles and movements such as cubism, expressionism, and surrealism that provide us with additional ways to categorize and described both twentieth century art and that of the past.

I have already suggested that puzzlement in the face of a new kind of art is marked by not knowing how to describe the things in question and this inability to describe is logically one with not knowing how to appreciate the work, not knowing how to look at the new painting, read the new poetry, listen to the new music and so on. I want to bring out the importance of this now. We know how to describe a Raphael as, say, a madonna and as an example of high renaissance space composition. Fry's British public made the mistake of trying to describe a Cézanne or Matisse as an example of academic composition. They looked at Cézanne and Matisse as if they were trying to do the same kinds of thing as the academic painters such as Leighton and Alma-Tadema were doing and it is thus not at all surprising that they had to describe them as making singularly inept essays in that direction. How, then, is our plain gentleman to describe Oldenburg, Barry, or any of our other curiosities? Presumably it won't do – despite the obvious temptation – merely to say that Oldenburg has flung a spadeful of dirt in the face of a gullible public, but what is *Placid Civic Monument* other than a filled-in hole in the ground?

Let us note the problems in giving a satisfactory answer to that last question. In the first place, the thing is strikingly devoid of aesthetic properties. When it was still just a hole in the ground before it was filled in, it wasn't much to look at. It was of no interest as a formal design and after it was filled whatever possibilities there may have been in that direction were effectively closed off; now there is nothing to see at all. Oldenburg tells us that the thing includes all that is related to the event of digging and filling the hole, but did not happen at the spot of the event, such as the deliberations of the Park Board. The whole park and its connections are supposed to enter into it and he also tells us that it is open to any interest-

ing interpretation.[7] A work of art is not the sort of thing we think of as open to just *any* interpretation, interesting or otherwise. In fact, the way that Oldenburg talks about *Monument* makes it perilously close to being a starting point for an exercise in free association. Typically a work of art is a focus where, by means of its form and organization certain attitudes, beliefs, feelings, or expressive features are concentrated to the exclusion of others. In Giotto's Arena Chapel *Deposition* the limp and ashen body of the dead Christ is the dramatic center of the composition. The attitudes of the mourners are concentrated there and the barren and desiccated landscape in the background reinforces the whole atmosphere of the painting. The painting is about suffering, death, and sorrow and is not about any number of other aspects of human experience. That other notable hole in the ground, Ophelia's grave, is the cockpit of Hamlet's agony and the ironies and tensions found there mirror those in the castle and do not connect with just anything that happens to be going on in Denmark. Such remarks as these are commonplaces about art, but are commonplaces that remind us that not just any description or interpretation can be true of, or relevant to, a work of art, or anything else, for that matter. The subject of any interpretation is the subject of no interpretation. The object of this kind of critical generosity has no value; anything whatsoever would do just as well.

The kind of move that Fry made in defense of post-impressionism is not available to anyone wishing to defend and explain something like *Placid Civic Monument*. Fry's critical maneuvering took place within a context of aesthetic concerns; he was concerned with the aesthetic properties of visual art and our perception of those properties. The notion of an aesthetic property is vague enough, but fortunately not hopelessly so. I am convinced that a theoretical definition of the aesthetic is out of the question and have no desire even to offer any general characterization of it short of a definition; it

[7]Barbara Haskell, *Claes Oldenburg: Object into Monument* (Pasadena, Calif.: Pasadena Art Museum, 1971), p. 62.

is enough for our purposes to have a catalogue of illustrative examples. Under the heading of aesthetic qualities we can include such things as design and composition, space, line, mass, color, and subject matter in the visual arts; plot structure, character development, rhyme scheme, imagery, and metaphor in literature; melody, harmony, and tonality in music, and so on. These are all the things that I earlier referred to as the particulars of the various art forms and that Mandelbaum would doubtless include among the exhibited properties of art. There are also other properties that can be called aesthetic that one may hesitate to describe as 'directly exhibited'; I am thinking of properties that are the result of certain relations between works of art such as style, allusion, pastiche, and parody. Exactly where the line is drawn between the aesthetic and the non-aesthetic properties of art is of no great matter for the present issue. Be that as it may, Fry can be understood as advising the British public, in effect, to pay more attention to certain of those properties – the formal ones – and less attention to certain others – the ones having to do with subject matter. An influential strain within the conceptual art movement to which Oldenburg's *Monument* belongs, by contrast, has declared the entire range of the aesthetic to be irrelevant, a declaration manifested in the critical slogans of the seventies that spoke of the 'dematerialization' of the art object and of the 'deaesthetization' of art.

The conceptual art of the latter sixties and the early seventies was a rather diffuse movement about which it may be dangerous to generalize. It is regarded by many as the spiritual descendant of Marcel Duchamp and his readymades. Ted Cohen had criticized Dickie's institutional definition of a work of art as a candidate for appreciation by offering the example of Duchamp's notorious *Fountain* as a work of art that cannot be appreciated.[8] Dickie responded to this with the counter-contention that *Fountain* does indeed have many

[8] 'The Possibility of Art: Remarks on a Proposal by Dickie', *The Philosophical Review*, 82 1973), p. 78.

qualities that can be appreciated, 'its gleaming white surface',[9] for example. Dickie is quite right about this and Cohen is, I think, mistaken. Like almost any other object in the world the utensil has some aesthetic character although the thing is by no means a triumph of industrial design. The dispute, however, is altogether beside the point as it bears on the status of *Fountain* as art. In a conversation in 1967 Duchamp said of his readymades that:

> I had to be careful to avoid the 'look' [of being art]. It's very difficult to choose an object, because after two weeks you either love it or hate it. You have to become so indifferent that you have no aesthetic feeling. The choice of Readymades is always founded on visual indifference and a total lack of good or bad taste.[10]

Can we take Duchamp as a reliable guide to his own work? Perhaps we are not justified in doing so, but whether we are or not, the important thing for our present concern is the persistence of the belief that art can be disconnected from all consideration of aesthetics.

In recent years at least two reasons have been offered for this radical distinction between art and aesthetics. One is a professed surfeit of objects. Douglas Huebler expressed this when he said that 'The world is full of objects, more or less interesting; I do not wish to add any more.'[11] Something more like an argument was presented by Joseph Kossuth when he said that 'It is necessary to separate aesthetics from art because aesthetics deal with opinions on perception of the world in general.'[12] If there is an argument in this, it is that

[9] *Art and the Aesthetic: An Institutional Analysis* (Ithaca and London: Cornell University Press, 1974), p. 42

[10] Pierre Cabanne, *The Brothers Duchamp* (Boston: New York Graphic Society, 1976), p. 141.

[11] Quoted by Lucy R. Lippard, *Six Years: The Dematerialization of the Art Object from 1966 to 1972* (New York and Washington: Praeger Publishers, 1973), p. 74.

[12] 'Art after Philosophy', *Studio International* 178 (Nov. 1969), p. 134.

since other things have aesthetic character in addition to works of art, aesthetic character has nothing to do with art. The argument as it stands is a transparent *non sequitur* and only points out the truism that aesthetics is a wider notion than art; i.e. having aesthetic character cannot be a sufficient condition for art; it shows neither that aesthetics is unnecessary to art nor that it is irrelevant to art.

Virtually all description and discussion of art has traditionally been carried on in terms of the aesthetic properties of art. It is the repudiation of aesthetic character as irrelevant to art that is largely responsible for generating the puzzlement of our plain gentleman. This repudiation, in effect, deprives him of his artistic vocabulary and puts him quite literally at a loss for words for he has been deprived of the entire set of concepts in terms of which he knows how to talk about and understand art. And this allows us to see very clearly how the pattern manifested in Roger Fry's defense and justification of post-impressionism can have no application in the task of educating the public to the appreciation of conceptual art since Fry was concerned to demonstrate *aesthetic* connections between the new and the old. It is also worth noting in passing that if readymades and conceptual art are indeed to be recognized as genuine art forms, then they are counter-examples to Dickie's institutional theory. Dickie's definition describes a work of art as something offered for appreciation, but it is clear from his discussion that the appreciation Dickie refers to is the appreciation of the aesthetic character of things and where aesthetic character has been repudiated there is no room for its appreciation. The institutional theory cannot comprehend conceptual art.

There are four themes that run through much of the thinking and writing of conceptual artists and their critic touts that it is important to call attention to. The first of these is the rejection of the aesthetic that we have been discussing. Having disconnected aesthetics from art as beside the point, conceptual art claims that the important thing is, instead of objects and the looks of objects, i.e. their aesthetic character,

the concept of idea behind it all. The word 'concept', however, seems to be used in more than one way in the writings of those that think of themselves as conceptual artists. Sometimes the word is used to suggest that the work of art is itself a 'concept', some kind of imaginary, hypothetical, or theoretical object such as Barry's 'All the things I know . . .' rather than anything tangible hanging on the wall or standing on a pedestal. Kosuth seems to have had this sense of concept in mind when he exhibited a series of photostats of the dictionary definition of water for he explained what he was about with the statement 'I was interested in just representing the *idea* of water.'[13] Kosuth's remark suggests that he believes that there is something called 'the idea of water' that can be identified and thought about in independence of any context in which either the word 'idea' or 'water' may have a use. We may be tempted to ponder the merits of, say, a new 'idea for conserving water', but I can only assume the artist would disclaim any interest in that on the grounds that he wants to entertain only the idea of water *simpliciter*. Needless to add, we are still owed an account of what that might be.

Kosuth, however, also has another view of the matter in which he understands the notion of the artist's concepts to refer to his intentions. Speaking of the work of Donald Judd, he says

> One could say that if one of Judd's box forms was seen filled with debris, seen placed in an industrial setting, or even merely sitting on a street corner, it would not be identified as art. It follows then that understanding and consideration of it as an artwork is necessary a priori to viewing it in order to 'see' it as a work of art. Advance information about the concept of art and about the artist's concept is necessary to the appreciation and understanding of contemporary art.[14]

It is by no means clear, I should point out, how it follows

[13] Arthur Rose, 'Four Interviews with Barry, Huebler, Kosuth, and Weiner', *Arts Magazine* (Feb. 1968), p. 23.
[14] 'Art after Philosophy', p. 137.

that the key to identifying it as art is information about the artist's concepts, that is, intentions. But setting that difficulty aside, according to him it is the intention that makes something a work of art and not the nature of the object itself, if, indeed, there is an object at all. Kosuth is thus led to conclude that the only value in, say, a cubist painting is the idea of cubism and not the painting itself. He likens such a painting in a museum to Lindbergh's *Spirit of St Louis* in the Smithonian Museum; it is now no more than an historical curiousity.

For all the importance conceptual art attaches to concepts, ideas, and intentions the literature of the movement is singularly lacking in descriptions of conceptual artists' intentions and, furthermore, from the way these intentions are talked about one suspects that conceptual art is confused about the very idea of an intention. If this latter contention is true, it may explain why so few details are forthcoming about particular intentions. An investigation of this will help us see the issues in a clearer light.

The notion of an intention belongs to a family of notions that include such things as plans, designs, projects, schemes, purposes, and motives. It is not necessary at this stage in the discussion to pause to sort out the many differences in import and implication of these words, that, for example, 'motive' often suggest something ulterior and 'scheme' something untoward. What I do want to insist upon as central is that the description of an intention is one with the description of the thing intended. The intention, the concept, the plan behind the *Spirit of St Louis*, conceived by Lindbergh and the engineers at Ryan, was to build an aircraft capable of flying the Atlantic and 'aircraft capable of flying the Atlantic' is a description eminently true of the *Spirit of St Louis*. Likewise, the intention of the cubist artist was doubtless to represent the girl and the mandolin as a series of interestingly interrelated planes and that is just what the painting is.

Conceptual artists have written as if it were possible to 'dematerialize' and hence 'deaestheticize' art by skimming off the work of art itself and leaving the intention behind,

performing, as it were, a Cheshire cat kind of operation. Skimming off the cat to leave the grin behind is a transparent piece of nonsense and the idea of an intention essentially disconnected from the deed intended is also a piece of nonsense although not quite so transparent. An intention is an intention to do something and our understanding of intentions is logically linked to our understanding of carrying them out. This is shown in the fact that the only way to describe an intention is by means of the description of the thing intended. To be sure, many intentions, especially good ones, are never carried out and for a variety of reasons are frustrated or abortive and it is this that doubtless contributes to the belief that the conceptual distance between intention and execution is greater than it in fact is. Many plans and projects are never executed; indeed, many plans were never intended to be executed. We think of the projects assigned to architectural students as school exercises and proposals for various works that are no more than flights of fancy. We must remember, however, that our understanding of these unachieved proposals, plans, and projects is really parasitic upon our understanding of the standard case of the carried-out intention. In all these other instances there is a reason the project was not 'actually undertaken, e.g. there was no money, it was badly conceived, the selection committee didn't like it, it was only a schooling exercise for those who will later carry their designs to completion, and so on. What conceptual art is asking us to entertain, by contrast, is the idea of an intention that is essentially severed from any execution. To speak of an intention whose nature it is never to be acted upon can only be incoherent.[15]

There is an additional difficulty. Kosuth says that the only value in a cubist painting is the idea of cubism. But what is

[15] Lawrence Weiner appended the following to the description of a number of his 'works': '1. The artist may construct the piece. 2. The piece may not be fabricated. 3. The piece need not be built.' He later added 'As to construction, please remember . . . there is no correct way to construct the piece as there is no incorrect way to construct it.' (Quoted by Lucy R. Lippard, *Six Years*, pp. 73–4).

that idea? It is, no doubt, the idea to use paint in a certain way, to represent objects as interrelated planes, to construct just these color combinations, in a word, to paint in the fashion that we know as cubism. Kousuth's notion of a concept or intention thus trades upon our previous familiarity with artistic intentions. Traditionally artistic intentions have all been *aesthetic* intentions where the modifier 'aesthetic' goes proxy for all those properties and relations I have been calling the particulars of the various art forms. If we are to take the proposal to deaesthetize art seriously, we must be prepared to understand the concept of an artistic intention that is not an aesthetic intention and I must confess to being at a loss to know what such an intention might be.

Kosuth may well be correct in pointing out that Lindbergh's plane is now merely an historic curiosity and important only for its concept. That is to say, we would not use it now, even if it were in flying condition, for translantic travel; the thing is obsolete and the job it was designed to do is done much better by the jets although we cannot deny its pioneering influence and its importance as a portent of things to come. The assimilation of our understanding and appreciation of art to that of technological development is the saddening part of all of this. It is almost as if Kosuth had reverted to Vasari's picture of art history that represented Giotto as a primitive Titian (the *Spirit of St Louis* as a primitive 747, cubism as primitive conceptual art) or perhaps Kosuth was so engrossed in his own preoccupations that he was unable to admit the value in anything that did not have a direct influence on his own work. The attitudes manifested by Kosuth are perfectly possible ones; there is nothing incoherent or logically awry in taking such a stance toward cubism or any other movement or particular work of art; in this respect it is not like the idea of a concept or intention just discussed. This stance is not something to be shown to be wrong, but is, instead, something to be deplored. It is simply too bad that there are people who cannot enjoy and appreciate a work of art in the way that so many of us do.

The third feature of conceptual art to be noted is the idea

that something can be declared a work of art. This idea seems to have had its beginnings with Duchamp and his ready-mades. Duchamp took ordinary objects, a bottle rack, snow shovel, a urinal and entered them in exhibitions declaring them to be works of art. The conceptual artists are fond of repeating the slogan that art is whatever an artists says is art or is whatever is presented in an art 'ambience', a museum, studio, or theater. This aspect of conceptual art is obviously consonant with that part of Dickie's institutional theory that speaks of conferring status on things on behalf of the artworld. I would assume that Duchamp's entering of *Fountain* in the exhibition was a paradigm case of status conferral.

Some perspective can perhaps be gotten on this aspect of conceptual art by means of a parable. In his *Memoir* of Wittgenstein Malcolm tells how Wittgenstein and he took frequent long walks that usually involved intense and exhausting discussion, although on occasion Wittgenstein could display a playful countenance. On one of these occasions he 'gave' Malcolm each tree that they passed with the reservation that Malcolm was not to cut it down or do anything with it, or prevent the previous owners from doing anything with it, but with these reservations it was henceforth Malcolm's. Wittgenstein is, of course, offering a gentle conceptual joke. It is the kind of joke that consists in uttering an expression solemnly just as if it had a job to do except that it is uttered in the absence of all the usual conditions of application or in such a way that those conditions are effectively stripped away. In the hands of someone like Wittgenstein, however, we are not left simply with the absurdity of an utterance hopelessly out of place, for the joke also serves as a reminder of what the role of the expression really is. One does not make a gift simply by saying 'This is yours' or in circumstances where all rights of ownership were set aside.

The application of the parable should be obvious. A work of art is not created simply be designating anything whatever while saying 'This is my work of art'. We may be tempted to conclude on the basis of this that much of conceptual art is an

extended conceptual joke, but I think it would be a mistake to suppose this is how it is intended. There was more than plenty of the jokester in Duchamp as his fascination with puns, if nothing else, makes clear. It has been suggested that his *Fountain* be understood as a gesture – of cocking a snook at an overly pompous establishment of galleries, critics, and juries, I suppose – but such a gesture is at best a one-off exercise that doesn't wear well with repetition. Nor are his puns essentially conceptual; 'LHOOQ' is clever, but merely irreverent and doesn't direct attention to the logic of anything. The writing of recent conceptual artists gives no hint that they understand themselves as making jokes; the almost comic seriousness with which they pursue, unsyntactically, lame conclusions belies that possibility.

From another point of view, however, we can understand this facet of recent activity by analogy with Wittgenstein giving trees to Malcolm. This performative side of the business can be taken as an unwitting conceptual joke that serves to remind us who look at it all from the outside what art really is, or at least where that part of the landscape is in which it is to be found, by calling attention to what it is not and in this light much of the conceptual art movement thus appears as an intellectual confusion unintentionally engaged in showing itself up for what it is.

The fourth unit in this rather depressing march past is an attempt on the part of more than one conceptual artist to imagine an analogy between contemporary art and analytical philosophy. Traditional philosophy, so this story goes, sought to describe the world; contemporary analytical philosophy, by contrast, seeks only to analyse concepts and, hence, offers only analytical propositions and tautologies that have no descriptive content. Likewise, traditional art was about the world; it represented the world and even when it was abstract and non-representational it still traded in the aesthetic character found in the world. Contemporary art, that is, conceptual art, on the other hand, in its rejection of the aesthetic is not about the world at all. A work of art,

instead, is like an analytic proposition about the nature of art. Every work of art is thus a definition of art and Kosuth remarks that 'Being an artist now means to question the nature of art'.[16]

What Kosuth has in mind by questioning the nature of art is not altogether clear, but may possibly be spelled out in this way. Artists have continually questioned and challenged the conventions and limitations of their media. Here we think of the development of perspective rendering during the fifteenth century, of Gainsborough challenging Reynold's strictures on color, of the pointillists constructing forms out of spots of color, of Kandinsky abandoning the last vestiges of representation for pure abstraction, or of more recent artists incorporating three-dimenional elements into the canvas so that the distinction between painting and sculpture becomes blurred. But these challenges to the conventions and traditions of painting are not what Kosuth thinks of when he speaks of questioning the nature of art. Painting and sculpture are both forms of art and to work with them in no matter how radical a way is to accept the traditional concept of art. The new work that questions art itself is neither painting nor sculpture and we are invited, I believe, to suppose that this must be conceptual art which eschews the object and, *a fortiori*, the aesthetic.

Wittgenstein is said to have asked whether one can play chess without the queen and in the same spirit we should ask whether one can make a work of art without the aesthetic. It is tempting to suppose that Wittgenstein's query invites us to an exercise in the logic of family resemblances – how different can we make the game before we can no longer call

[16] 'Four Interviews', p. 23. Terry Atkinson, 'From an Art & Language Point of View', *Art Language*, 1 (Feb. 1970) pp. 25–60 has also asserted that there is an analogy between the work of some conceptual artists and what he calls 'The British Philosophical Method'. His account, however, borders on the incoherent and references to philosophers are introduced randomly and with little apparent point. Harold Rosenberg, *The De-definition of Art* (New York: Collier Book, 1972) cites Robert Smithson as believing that art today must become 'speculative philosophy' (p. 60).

it chess? – but that would be a mistake. It overlooks any point there may be in using the word. We get out the chess set and discover that the queens are missing, but decide to play anyway. A master sharpens his pupils' sense of strategy and tactics by making them play practice games without the queen. One of the parties to the game with the incomplete set is dissatisfied with the resulting game and grumbles that without the queen it's just not chess and there is justification for that complaint. It is easy enough to imagine stripping away one by one characteristic features of some work of art selected as a paradigm, *sfumato*, space composition, even representation, and the result will still be art, but to take away the art object itself and leave only the idea (whatever that means) may be going too far. If it is going too far, it is not merely because there are too few properties in common with the paradigm, but because what has been stripped away are all those things that seem to give point to calling something a work of art, such things as beauty, a celebration of some aspect of our life, a view of the world, and so on.

The analogy between art and analytical philosophy is, of course, impossibly lame. The analyses and explications sought by analytical philosophers were attempts to unpack and clarify familiar although troublesome concepts and were hence either correct and consisted of analytical propositions or were incorrect and consisted of contradictions. The conceptual artist, by contrast, is not setting out to clarify and elucidate an already familiar concept of art, but rather is undertaking to question the nature of art and challenge the familiar concept. If we try to make something of the contention that every work of art is really a definition of art we find that the analogy is not with analytic propositions, but instead is with stipulative definitions or, possibly, with persuasive definitions. The alleged analogy with philosophy thus brings us back to the points discussed earlier about declaring things to be works of art and conferring status upon them. It is also one with the slogan that a work of art is whatever an artist says it is.

It is difficult to escape the conclusion that this is nothing

but pure Humpty-Dumptyism, another instance of the view that words can mean anything that one wants them to mean. If this is so, then no sense at all has been given to the notion of questioning the nature of art as an undertaking to be distinguished from challenging or flouting the various conventions or traditions within particular art forms.

In so pointing out the confusions in both the thinking and practice that surrounds conceptual art I am not simply out to direct a few last kicks at a dying horse, if it isn't one that is dead already. A clear view of what has gone astray in these spheres will help us to a clearer view of just what the problems are in the appreciation and evaluation of real works of art whether it be with respect to new movements where the conventions and traditions of an art form are being genuinely challenged or with respect to more familiar materials. Meanwhile we must turn our attention to more recent theoretical attempts to resolve the puzzlement of our plain gentleman.

5

The Return to Theory and the New Ontology

The plight of our plain gentleman arises from the fact that a number of things are presented to him as art that do not look like art and do not seem to have any of the characteristics traditionally thought of as typically artistic. Indeed, many of the things seem to be those ordinary sorts of things that we would be altogether disinclined to describe as art, construction materials, a Brillo box, a hole in the ground. If the contention that these things really are art is to be made good, then there must be a way of describing them as something more than just construction materials, Brillo boxes, and holes in the ground. This point is presupposed by Harold Rosenberg in his critical admonition that:

> Since the eye and the analogies it discovers in common sense experience cannot be trusted, the first rule in discussing modern art is that a painting or sculpture must never be described as resembling (or being) an object that is not a work of art; a sculpture consisting of a red plank must under no circumstances be identified as a red plank, a set of Plexiglass cubes as a type of store fixture.[1]

Danto provides us with a budget of curious examples designed to illustrate this problem about description. He imagines an artist who exhibits a mirror of an ordinary sort while denying that it makes any allusion to the hoary meta-

[1] *The De-definition of Art* (New York: Collier Books, 1972), p. 57.

phor for art. Its being a mirror is of no importance; it might just as well have been a breadbasket like the one on the breakfast table. There is a duplicate of the Manhattan Telephone Directory which is represented as a novel or, alternatively, a piece of sculpture. To this budget he adds a number of examples of supposedly identical objects which are claimed to be different works of art. There is a series of canvases consisting of identical squares of red paint done by various hands with the titles *Israelites Crossing the Red Sea, Kierkegaard's Mood, Red Square, Untitled*, and so on. There are two paintings in which a black line horizontally bisects a white rectangle. One is called *Newton's First Law* and the other *Newton's Third Law*. And strangest of all are the two indiscernible, but distinct *Don Quixotes* that Danto borrows from Borges' *jeu d'esprit* of literary criticism 'Pierre Menard, Author of Don Quixote'.[2]

Reflection on these curiosities leads Danto to make two assumptions. The first is that a work of art can be identical in all its physical and perceptual particulars to an object that is not a work of art. The second is that two distinct works of art can be identical in all their physical and perceptual particulars. Although the prime examples of these possibilities are, of course, Duchamp's readymades and their descendants, imagined or real, the possibility is intended to hold for traditional works of art as well. He imagines a duplicate of Rembrandt's *Polish Rider*, resulting from random paint splattering, which may not be a work of art and he challenges Kennick's reliance on the knowledge of English in picking out the art in the warehouse by imagining a counter warehouse stuffed with objects perceptually indistinguishable from those in the other. The only difference between the two facilities is that everything stored with Kennick & Co. that is

[2] A discussion of the use to which Danto puts Borges' joke and the questions he believes the story raises for the ontology of literature, as well as art in general, deserves a chapter to itself. I have dealt with this in some detail in 'Danto and the Ontology of Literature', *Journal of Aesthetics and Art Criticism*, 40 (1982) pp. 293–299.

a work of art is matched by something in the counter-warehouse that is not a work of art and conversely. These two assumptions generate Danto's problem which is to identify that element or ingredient which must be, perforce, neither physical nor perceptual that makes something a work of art or individuates one work from another. Danto wants to ask what kind of object a work of art is and how it differs from what he calls a 'mere real thing'. This question he takes to be one of ontology.

As already pointed out, ontological issues have played an important role in much of twentieth century philosophy of art. The most frequent response to the ontological question about the kind of object a work of art is, is to deny that works of art are essentially physical objects and to identify them instead with some kind of phenomenal object or mental construct. There have been traditionally two major motives for this kind of ontology: in the first place aesthetic properties of works of art that we perceive and appreciate are thought to be inconsistent with their being properties of physical objects and secondly it seems impossible to identify a work of literature or music with any particular physical object or physical event. These have already been mentioned in chapter 1 in connection with 'aesthetic object' theories.

We must again remind ourselves that the philosophical roots for these ontological maneuvers are firmly grounded in the Cartesian dualism of mind and body. Descartes's conclusion that *res cogitans* and *res extensa* have no properties in common requires that minds (persons) and bodies be described in altogether different vocabularies with the consequence that no statement about a mind entails any statment about a body and conversely. The connection between the two is wholly contingent. If we substitute for 'mind' or 'person' ('Descartes himself') the notion of 'work of art', we find that mind/body dualism is nicely paralleled by the dualism of aesthetic object/physical object and artwork/real thing. The new ontology represented by Danto, and Joseph Margolis as well, differs from earlier twentieth century

philosophical theory in at least two respects. In the first place its immediate occasion was the critical problems posed by the work of Duchamp and the conceptural artists, areas of activity either unknown to or ignored by earlier theorists. In the second place neither Danto nor Margolis would accept any phenomenalistic solution to the ontological problem. This has to follow from their denial that works of art are identified or individuated by means of their perceptual qualities. Nevertheless the philosophical impetus behind this new ontology is just as thoroughly Cartesian as any that generated the older ontology. It is the picture of the contingency of the artwork/real thing relation that creates the illusion of intelligibility in the permutations and combinations that Danto recognises with respect to the two. The only possibility that perhaps he does not entertain is that of disembodied works of art, but can't we imagine some works of conceptual art playing that role?

Danto finds that an analogue to the ontological question in art is provided by Wittgenstein's query, 'What is left over if I substract the fact that my arm goes up from the fact that I raise my arm?'[3] The analogous question for art is obvious: ' . . . what is left over when we subtract the red square of canvas from "Red Square"?' (*The Transfiguration of the Commonplace*, p. 5) or when we subtract Rosenberg's red plank from the piece of sculpture it composes or Oldenberg's hole in the ground from *Placid Civic Monument*? Danto believes that Wittgenstein's answer to his problem in ontological arithmetic is 'zero'. He believes that this answer is mistaken and that it is wrong to identify an action with a bodily movement and, *mutatis mutandis*, a work of art with a mere real thing. Danto does see in this view he attributes to Wittgenstein a laudable attempt to escape from the traditional dualism that identifies the ontological remainder with something mental, an intention, act of will, or other event in a

[3] *Investigations*, §621. Cited by Danto, *The Transfiguration of the Commonplace* (Cambridge, Mass.: Harvard University Press, 1981), p. 4.

Cartesian soul substance. The parallel of this latter view in aesthetics, as already indicated, is the theory that the real work of art, the 'aesthetic object', is something phenomenal. Danto also objects to the theory that he attributes to followers of Wittgenstein that an action is a bodily movement that falls under a rule. He represents the institutional theory as the analogue of this in the philosophy of art. The possible ontological positions in the philosophy of art do indeed seem to be neatly parallel to traditional theories of philosophical psychology. If Wittgenstein and his followers are behaviorists in the face of classical dualism and idealism, then Dickie and his institutional theory play the role of behaviorist against Pepper, Collingwood and their tradition.

In a similar vein Joseph Margolis has called attention to Strawson's distinction between P-predicates that describe persons and M-predicates that describe bodies as a parallel to the ontology of art. He says:

> What is extraordinarily suggestive about Strawson's maneuver, as far as the philosophy of art is concerned, is simply that it is a consequence of Strawson's theory that *persons and physical bodies cannot be distinguished from one another in any purely perceptual way* . . .[4]

Actions are more than bodily movements, persons are more than physical bodies, and in like manner works of art are more than mere real things, yet Danto and Margolis are one in agreeing that these pairs are all perceptually indistinguishable from one another. How, then, does a mere real thing become a work of art? Danto phrases the question in terms of the colorful metaphor of *Transfiguration*, hence the title of his book, and wants to know how an ordinary object, a red

[4] *Art and Philosophy* (Atlantic Highlands, NJ: Humanities Press, 1980), p. 3. Danto also refers to Strawson's distinction between P- and M-predicates and remarks that the relation between a work of art and its 'material substrate' is as intricate as that between mind and body (*The Transfiguration of the Commonplace*, p. 104).

plank, a hole in the ground, a Brillo box, can become transfigured into a work of art. Wherein, asks Danto, lies the logic of such a feat? (p. 7).

Before we inquire into the wherein of a feat, however, we should make sure that there is a feat to inquire into. Danto assumes unquestioningly that his budget of imagined curiosities is, indeed, a list of works of art, that the mirror and telephone directory are works of art and that the identical squares of red canvas and the two *Don Quixotes* are distinct works of art. And, naturally, he assumes unquestioningly that certain actual inhabitants of the artworld such as Andy Warhol's *Brillo Box* are works of art. Danto is assuming that the readymades of Duchamp and the products of the conceptualists are works of art. One would think, however, that this assumption is one that wants arguing for; I know of no demand arising either out of logic or out of the history of art and its practices of appreciation requiring these things to be accepted as art or as distinct works of art. It is, after all, the contention that these things are art that is responsible for our plain gentleman's puzzlement. Danto may be in danger of begging the very question that generates the inquiry. In any event, it may be worth noting that if we refuse to accord these things the status of art or to accept them as distinct works of art, then it may be very difficult to get one kind of philosophical parade going.

Both Margolis and Danto answer the ontological question in rather similar ways. Both maintain that a work of art is something more than a 'mere real thing' or 'physical object', but deny that this something more is any additional entity or substance. In this they differ from traditional aesthetic ontology that tended to identify the 'something more' with a mental or phenomenal component. The something more is, instead, provided by some kind of social or cultural background. Margolis describes a work of art as a 'culturally emergent entity' and says that 'works of art are the projects of culturally informed labor and physical objects are not. So seen, works of art must possess properties that physical objects, *qua* physical objects do not and cannot possess' (*Art*

and Philosophy, p. 22). These properties of art that physical objects cannot possess are intentional ones such as design, expression, symbolism, representation, meaning, style, and the like. For Danto a work of art is the kind of object that requires an interpretation and 'interpretation' is also an intentional notion; a world of interpretation is a world of meaning. Artistic interpretations are provided by the theories that constitute the artworld and the problem for Danto, then, is to specify the differentia that distinguish an artistic interpretation from other kinds.

I want now to sketch briefly how Danto narrows the range of interpretations to isolate the artistic ones that are intended to account for the feat of transfiguration before returning to a more detailed discussion of the ontological issues that are supposed to be involved in the philosophy of art. Danto postulates an important connection between art and philosophy. Art and philosophy can arise within a society only when that society begins to make a distinction between appearance and reality. That distinction, which is the very stuff of philosophy, also permits works of art to be thought of as representations of things instead of the magical incarnations of things that primitive thought takes them to be. Art, like language, has the semantic function of representing the world. But if art has a semantic function, so do a host of other things that are not art and thus additional differentia are required for a fuller account of art. Those additional differentia are found in the way a work of art presents what it represents. As Danto puts it in *The Transfiguration of the Commonplace*:

> Any representation not an artwork can be matched by one that is one, the difference lying in the fact that the artwork uses the way the nonartwork presents its content to make a point about how that content is presented. (p. 146)

And again:

> works of art, in categorical contrast with mere representations, use the means of representation in a way that is not

exhaustively specified when one has exhaustively specified what is being represented. This is a use which transcends semantic considerations . . . (pp. 147–8)

The point that a work of art makes about how it presents its content and that is not exhaustively specified in a description of that content is said to be the province of rhetoric, style, and expression, three concepts that Danto believes are essential for the understanding of art.

The key to understanding these concepts of rhetoric, style, and expression turns out, Danto believes, to be the concept of metaphor. A metaphor, we are told, 'presents its subject and presents the way in which it does present it' (ibid., p. 189). He illustrates his account with the metaphor 'men are pigs', which presents its subject, men, by way of the piggish associations of being unmannered, selfish, and generally disgusting. The subject is thereby seen, as it were, under that aspect or through the filter of porcine connotations.

Danto's next move is to think of a work of art as a metaphor; he offers several interesting examples of works of art described in this way. Roy Lichtenstein did a painting representing Erle Loran's diagram of the composition of Cézanne's *Portrait of Mme Cézanne*. Lichtenstein's painting can therefore be described as 'Portrait of Mme Cézanne as a diagram'. Rembrandt painted a portrait of his wife as Bathsheba and, in doing so, Danto tells us, he saw her with love. We cannot see her in the painting as Rembrandt saw her, that is, with love. Rather, the portrait presents her *as seen with love*. There are interesting and insightful ways to describe paintings, but what is the application of this device of construing art as a metaphor to such things as Warhol's *Brillo Box* that get Danto's problem going?

The work of art, *Brillo Box*, is to be distinguished from the ordinary supermarket variety of Brillo box which is perceptually indistinguishable from it by the former's being a metaphor. 'The work vindicates its claim to be art by propounding a brash metaphor: the brillo-box-as-work-of-

art' (Danto, ibid., p. 208). But how are we to understand this metaphor? I believe there is a problem here and we can see what that problem is by reminding ourselves of what is involved in understanding the other examples of metaphors that Danto offers us. We can admit sometimes the aptness of the feminist sneer that men are pigs because we are aware of the grosser habits of pigs and can see how men can do those things too. Similarly with the portrait of Rembrandt's wife; we know what it is to look upon someone with love and are thereby enabled to understand the painting described in that way. With *Brillo Box*, however, we stumble. We have an understanding of art derived from a certain amount of education and experience. This education and experience has acquainted us with a wide range of artistic characteristics. We have, for example, learned something about design, composition, color relations, representation, expression, melody, harmonic structure, meter, metaphor, and any number of other artistic properties that we can all add to the list. None of this need involve us in any attempt to construct a philosophical theory or definition of art; no such theory is needed for it is enough in these instances to be acquainted with a sufficiently wide range of things characteristic of art. Against this background of education and experience it is clear why *Brillo Box* presents a problem. Our situation is now precisely that of our plain gentleman. We encounter the thing in the gallery and are told it is supposed to be a work of art. We are puzzled because it doesn't have any of the properties characteristic of art. Its aesthetic qualities of shape and color are minimal and are no different from those of the 'real thing'. There is nothing of interest in that direction and, like Duchamp's readymades, the aesthetics of the thing would doubtless be discounted as irrelevant by the artist and the critics that promote his work. The thing is not like a statue or sculpture of a Brillo box, as if there would be any point in one of those; it is neither expressive nor symbolic, and we can continue eliminating items on anyone's list of typical artistic properties.

We are supposed to be relieved of our puzzlement by

learning that it is to be understood as a metaphor: the Brillo-box-as-work-of-art. This, I submit, does not relieve the puzzlement; it merely duplicates it at another level. The puzzlement arose because the thing was represented as art and yet we could find nothing in it characteristic of art. To understand it as that metaphor, however, requires that we understand it under the aspect of art, that we be able to find artness in it just as that other metaphor enabled us to find piggishness in men. If we were unable to do it in the first instance, we are no better prepared to do it now. And this is why I believe that Danto has not provided an answer to the original question and that we are still owed an 'Apologia for the Brillo Box as Art'.

Something has gone wrong in Danto's enterprise and I think we can see what it is by going back to his treatment of Wittgenstein's piece of ontological arithmetic and to Margolis' use of Strawson's distinction between P-predicates and M-predicates that are supposed to provide analogies for art. What is left over if I substract the fact that my arm goes up from the fact that I raise my arm? In saying that Wittgenstein believes that there is nothing left over Danto is accepting uncritically the widely held, but mistaken, notion that Wittgenstein is a behaviorist.[5] In fact, one goes wrong from the first if one supposes that Wittgenstein meant the question to have an answer, at least a general answer. The question is intended, rather, to encourage us to sort out the language-games and make clear the circumstances in which it is appropriate to talk about things that might be called bodily movements and to distinguish them from the various things that people do, i.e. actions. It has been assumed, and no doubt also uncritically, that the world of human behavior divides rather nicely into bodily movements on the one hand and actions on the other. That division naturally suggests all

[5] That Wittgenstein is not a behaviorist is made abundantly clear by John Cook in 'Human Beings', in Peter Winch, ed., *Studies in the Philosophy of Wittgenstein* (New York: Humanities Press, 1969).

the familar questions about the relation between the two including the possibility that they are really identical. The ultimate source of this assumption is, of course, the whole Cartesian syndrome and the many variations on that theme by Descartes that have been played in the history of modern philosophy.

I want to pick out two considerations that can contribute to the supposition that actions and bodily movements can be identical. The first stems from the temptation to believe that in the greater number of things people do there is a component of bodily movements and the second is that at least some of these movements can occasionally happen involuntarily as the result of tics, spasms, pushes, and the like so that we can sometimes be in doubt whether an eye movement, say, was a wink or only a blink.

It will be very important for the discussion of the philosophy of art to follow to insist on the highly problematic nature of the idea of bodily movement. It is not at all clear what is to count as a description of a bodily movement nor how and in what circumstances the notion is properly applied. Until that can be gotten straight it is no clearer what it means either to affirm or to deny that an action just is a bodily movement. Assume that 'his arm dropped' is a description of a bodily movement (I deliberately invert Wittgenstein's example) and 'he dropped his arm' is a description of an action. If we are disposed to take a stand on whether an action is identical to a bodily movement, then we are tempted to ask whether the two descriptions are descriptions of the same event. Let us suppose that I am to describe the start of a race and I report that the starter's arm dropped and the runners were off. I could just as well have said that the starter dropped his arm. In this context the two descriptions are equivalent and merely different ways of reporting the same event. P. C. Wren's *beau sabreur* witnesses a punishment drill in which troopers are made to hold their sabers at arm's length for an extended period of time. Now one of the arms drops. Did the man drop his arm or did it drop from

fatigue? In this context the two descriptions are not equivalent and which one is true makes a difference, to the sergeant in charge of the punishment squad for one.

These examples cannot yield a pattern of description intended to pick out 'bodily movements' from actions. In the case of the trooper any question must concern whether he did it deliberately or voluntarily. Finding out whether he did is a matter of finding out more about the man himself and is not at all a matter of philosophy. This is the point of Wittgenstein's remark that:

> What is voluntary is certain movements with their normal *surrounding* of intention, learning, trying, acting. Movements of which it makes sense to say that they are sometimes voluntary and sometimes involuntary are movements in a special surrounding.[6]

I know that my friend was winking at me from across the room and not just blinking; after all, he looked directly at me, we had been talking about that situation earlier, and so on. These are the surroundings that determine the character of the eye movement *in that instance*. The distinction between action and bodily movement that the philosophy of action has sought to establish and trade on is not the distinction between voluntary and involuntary movements.

The kind of movement that can sometimes be involuntary is not the sort of thing that we are called on to describe with any great frequency. We may speak of such movements when we cannot tell what someone is doing – for example, 'he is lying on his back moving his legs so'. We do not know whether he is exercising or just being foolish. Even so, we say that *he* is moving his legs; 'his legs are moving' suggests he is perhaps injured and his legs are twitching. It would, by contrast, require very special circumstances to make sense of saying of that man walking down the street that his legs are moving.

[6] *Zettel* (Oxford: Blackwell, 1967), §577.

Another way in which we might talk of 'bodily move-
ment' comes from the side of the gymnast, his trainer, and
the sports physiologist who are all concerned with the physi-
ology and the geometry of how our bodies move and how
those movements can be made more supple and graceful and
athletic performance thereby improved. It is in this
connection that we think of Muybridge's pioneering photo-
graphs that revealed so much about the details of how limbs
move when we walk, run, and climb stairs.

One conclusion that I wish to draw from these various
examples is that it won't do to talk of 'bodily movements'
simpliciter independently of any context or surrounding to
give that talk sense. It follows from this that it is without
sense also to think of 'bodily movement' as a component of
action and then wonder whether it constitutes the whole of
action or whether an action is a bodily movement plus some-
thing else.

I have suggested two kinds of context in which we can talk
about bodily movements, but neither can support the
philosophical weight that Danto and Margolis want to put
upon bodily movements. One is that just mentioned of the
physiologist interested in the mechanisms of athletic per-
formance. He knows he is studying the movements of men
in action and the question of the difference between move-
ment and action simply does not arise for him; indeed, there
is no room for such a question. The second is that of involun-
tary lapses, slips, and stumbles. In both kinds of
circumstance the description of the movement makes clear
what is going on: 'when he puts the shot his legs assume this
alignment', or 'when he hit the banana skin his legs flew out
from under him'. In the first case there is no problem about
getting from a movement to an action; there was never any
question of it being anything other than an action and hence
nothing to get from or to. Consequently there can be nothing
like a 'transfiguration' of the motion into an action to serve
Danto as an analogy for art.

There may be room, however, for a 'transfiguration' in the

second kind of circumstance. The circus aerialist loses his grip on the trapeze bar and we gasp as he plunges to certain doom when suddenly he is pulled up by a safety line and he twirls gracefully over our heads as we sigh with relief and applaud his artistry. The whole thing now looks different to us. It is no doubt worth noticing that could we watch him more closely we would be aware of his concentration and how he times his swing and lets go at just the right moment. That being so, we would no longer be inclined to suppose that a genuine accident and the trick were perceptually indistinguishable just as the comedian's pratfall and the decline of the uncle on the banana skin never were. So neither is this an analogy for artistic 'transfiguration'.

This brief excursus into the relation between bodily movements and action is intended to suggest, if not to demonstrate, that there simply is no ontological question, as that term has been understood in traditional philosophy, about action. The question 'What is left over . . .?' is bogus and it is my contention that Wittgenstein's aim in posing it was to show it as bogus. The posing of the question is not an invitation to answer it, but to sort out our language and to replace ontology by grammer, i.e. a description of how the relevant part of language is used. As he says, 'Grammar tells us what kind of object anything is' (*Investigations*, §393).

If the ontological issue proves to be bogus with respect to bodily movements and actions, we can still understand those occasional practical difficulties that can make it appear that there is an issue. When it comes to the ontological issue about bodies and persons that Margolis borrows from Strawson, however, there aren't even these occasional practical difficulties, e.g. about involuntary movements, to lend a measure of plausibility to the question. Margolis says that Strawson's theory entails that persons and bodies cannot be distinguished from one another in any purely perceptual way. This remark is puzzling because it suggests that we are sometimes called upon to distinguish a person from a body and may have trouble doing it or may even confuse one with the other. To be sure, the root of the matter is still Cartesian,

but one is very hard put to imagine a situation in which it is intelligible to wonder whether that is Jones or only his body, which, I take it, is not at all like wondering whether that poor chap lying there is dead or alive. We can, of course, at times confine our attention to the biology and physiology of the body, but we always remember that it is the workings of the *human* body that is being studied and we can put what we have learned to use in diagnosing and treating Jones' ailments.

That a person is something more than a mere physical thing may appear to be supported by the occasional moral admonition not to treat people merely as things. That is, indeed, good advice, but we do well to remind ourselves of the true scope of the admonition rather than taking it in a certain literal sense. The admonition warns, among other things, not to treat the serving wench only as a sex object and that means to be attentive to her wishes, be careful of the consequences, and all that. One can treat her with disrespect and abuse her and use her only because she is a person; a mere thing would not do in her stead, a telephone pole or shoulder of veal, for example. What it is to treat someone as a genuine *thing* comes out in the black joke in which the neighbourhood boys ask Mrs Smith whether Johnny can come out to play. 'But you know Johnny has no arms or legs', she replies. 'We know that,' the boys say, 'we just want to use him for second base.'

People certainly do have a number of properties such as dimension and weight that are shared by other things, but, once again, it is only by ignoring any context in which these things figure that there can be a temptation to raise the ontological question. The point of determining a person's height or weight depends upon such human concerns and practices as buying him a new suit of clothes or establishing his eligibility for military service. Even when we measure him for his coffin or for his chains it is because he is a human being and by doing so it is human customs we are observing and human institutions we are serving.

Whatever motivation there is to find a philosophical

problem in any of this can be grounded only in Cartesian dualism. The clearest and most devastating diagnosis of the confusion inherent in Descartes's mind–body distinction is offered by John Cook[7] who argues that Descartes's attempt to drive a wedge between himself and his body is vitiated by his failure to specify any use for the word 'body' such that the body can be intelligibly contrasted with Descartes himself; as a result the wedge never gets driven. The same difficulty, I believe, infects the account Margolis borrows from Strawson; no use is established for 'body' that can contrast intelligibly with 'person' and, consequently, the contention that a person is 'something more' than a body is left without any clear sense.

The work of art/real thing distinction is generated out of a carefully chosen set of examples, the readymades and the results of the antics, both real and fancied, of more recent practitioners. Danto's strategy in the use of these examples would seem to be the following. (1) Assume the members of that set of examples are works of art. (2) From that assumption generate the ontological problem about artworks and real things. (3) Develop a theory to explain the differences between the two; a theory which isolates the artistic ingredient that is left over when the ontological subtraction is performed. (4) The members of the initial set are then claimed to possess that artistic ingredient. (5) The status of those things as art is thereby supposed to be vindicated. This strategy, however, is plainly question begging. If the things in question are works of art, then there does indeed seem to be a problem of some kind; whether it is 'ontological' or not is another question. If these things are not works of art, then there is no problem, ontological or otherwise – or better: if there is such a problem, it can't be got going out of those examples. At any rate, whatever problem there may be and whatever solution it may have cannot be the result of the

[7] 'Human Beings'.

assumption that the questionable items are art; that would have to be established independently.

Can any version of the ontological problem be stated with respect to traditional art where there is no question whether some particular item is art? Can we locate there an intelligible artwork/real thing distinction? So far we have proceeded as if the notion of the 'real thing' that is supposed to stand in contrast to the work of art is unproblematical, but since the person/body ontology is vitiated by the failure to specify any use for the word 'body', we may suspect a corresponding difficulty in the ontology of art. The expression 'real thing' as a counter to 'artwork' has several relatives. There are 'mere things', 'material substrates', 'physical objects', and even a 'dab of paint'. It is not at all clear how these expressions are to be understood. Margolis speaks of a sculptor carving a statue from a block of marble and says that the work will exhibit both physical properties of the marble and representational properties and adds that 'works of art are the products of culturally informed labor and physical objects are not' (*Art and Philosophy*, p.22). Is the physical object in question here the *block* of marble? If so, it is just as much a product of culturally informed labor, the quarryman's art, as is the statue, a product of the sculptor's art. If the artwork/physical object distinction is intended, as this example seems to suggest it is, to distinguish between the work of art and the materials from which it is made, then we have to note that the artist's materials rarely satisfy the conditions Margolis specifies for being physical objects. The painter's canvas and pigments and the sculptor's materials, be they bronze or Structolite, are all products of culturally informed labor. By this account a physical object can only be a mass of unprocessed raw material found in nature and very little of that makes its way into art; even the potter rarely uses clay directly from the ground without at least some screening. The artist more often than not is engaged in exhibiting properties of manufactured and processed materials.

Consider Duchamp's *Fountain*. What is to count as the real

thing to which the work of art stands in contrast? Is it the urinal Duchamp appropriated; is it the porcelain from which it is made, or is it perhaps the chemical compounds that comprise porcelain? Is one of these the real thing and another the material substrate or do those expressions denote the same thing? As examples of real things Danto offers us the Manhattan Telephone Directory, a Brillo box, a square of red paint, and so on. Examples are often quite enough when it is a matter of reminders about expressions that have well established uses in our language, but 'real thing', 'physical object', and the like are introduced here as technical terms within the philosophy of art and so far have no established use in the language. Danto gives us no general instructions for the use of these expressions and, consequently, for picking out real things, although the demand that a real thing be perceptually indistinguishable from a work of art may be thought a criterion. This criterion can seem plausible with regard to the budget of curiosities that gets Danto's inquiry going, on the assumption those things are works of art. It remains to be seen whether any sense can be made of this in regard to noncontroversial cases of traditional art.

What are we to say of the accidental *Polish Rider* that is perceptually indistinguishable from Rembrandt's? At first it may be mistaken for the Rembrandt itself or thought to be a duplicate that we didn't know the master had painted. But now we learn its curious history and . . . : here we can imagine more than one sequel. It may now be scorned as art and relegated to some seedy museum of curiosities and exhibited next to the two-headed calf. Some, however, may find it just as satisfying and as deep as the real Rembrandt and be more than pleased to hang it properly and contemplate it. I believe it is profitable to compare this situation with that of Wittgenstein's chair that disappears and then reappears randomly (*Investigations*, §80). No place in our language and our practice has been prepared for that contingency and as a result there is no correct way of describing and dealing with the anomalous phenomenon. It cannot, thus, be merely assumed

that the accidental Rembrandt is not a work of art or cannot be treated as one. Should such strange duplicates start showing up with some frequency, there would doubtless be reason for making a decision about how they shall be described and dealt with, a decision introducing a set of new moves into the language-game. What that decision would be, however, cannot be determined ahead of time.

No matter how wildly unlikely such an accidental masterpiece would be, it still remains something that can be imagined despite there being no place in the language prepared for determining its artistic status. The counterwarehouse that contains duplicates of everything in Kennick's warehouse, but with their artistic status reversed, is a different matter altogether. The provenance of these things is not specified and we don't know whether they are more accidental products, works upon which non-artists have non-conferred status, works whose status has been withdrawn, or . . . , and here one has not the slightest idea what possibilities to entertain. Since Kennick's warehouse is simply the world, Danto is then asking us to imagine a world in which all our notions about art and, I think, perforce, all our notions about everything else, are turned upside down and I frankly submit we have no notion of what we are being asked to imagine.

When it comes to dabs of paint in place of real things or physical objects we come closer to a point where there may be a genuine issue. In discussing Bruegel's painting *The Fall of Icarus* Danto twice remarks that a dab of paint is Icarus or his legs (*The Transfiguration of the Commonplace*, pp. 115, 126). This is an odd way of identifying the figure. Seen very close to it may appear to be only a dab of paint, but from a bit farther back it is clearly legs. 'This dab is a human figure' seems appropriate in talking about something like Monet's *Gare St Lazare* where the impressionist technique blurs the human figures in the background into the architectural furniture of the station. But Bruegel is not an impressionist and his forms are clearly delineated. The natural response to the Bruegel is to identify these *legs* as belonging to Icarus.

As already mentioned in chapter 3 Danto believes that every artistically relevant description is an interpretation that results from a theory. Just as the observation terms of science are often said to be theory-laden, so every artistic description is theory-laden. There is no artistically relevant neutral description of a work of art. 'To seek a neutral description is to see the work *as a thing* and hence not as an artwork . . .' (ibid., p. 124). It is not at all clear, however, what such a neutral description is. One is reminded of the behaviorist's program of constructing all the relevant descriptions of human action out of 'colorless bodily movements', a program that was never carried out. Perhaps the most fruitful way of trying to make some sense of this is to begin by noting that to see a work as a thing is to *fail* to see it as art and thus connect the notion of a real thing, physical object, neutral description, and the like, with the ways works of art can be misunderstood. There are, needless to say, many ways works of art can be misunderstood.

Many cases of misunderstanding or failing to understand a work of art involve one or more aspects or facets of the work; one is unaware of the inconography or symbolism, formal relations of design pass one by, the flavor of a literary trope is missed, one fails to hear this passage as a variation on a preceding theme, and so on. Despite all these failures one still knows one is in the presence of paintings, poems, and music and the artwork/real thing distinction cannot get going out of examples like these. We must find plausible examples of mistaking a work of art for something else. To begin with, we must set aside the original question-begging set of examples with which Danto begins and find our own items in more traditional art. We must also set aside the person from the altogether alien culture who has no concept of art at all; his shortcomings tell us nothing about art, he doesn't have a concept of the steam locomotive either. And the same applies to the child who has yet to acquire the concept. In the same basket we can put the bumpkin who, being ignorant of the theater, remonstrates with the villain.

One possibility is the *trompe l'oeil* painting that deceives us into believing we are in the presence of the real thing (where 'real thing' stands in contrast to 'picture of the thing'). But this is of no theoretical interest; such illusions are not characteristic of art and a closer look or another angle quickly undeceives us. Of no theoretical interest either is Ruskin's chiding of Whistler for flinging a pot of paint in the face of a gullible public. He was no more the victim of an ontological mistake than was Hamlet when he spoke of lugging the guts into the neighboring room.

One difficulty in trying to isolate the right kind of example is the failure to specify the use of the word 'art' that is to stand against 'real thing'. If we consider the evaluative use of 'art', then it is quite possible to imagine someone generally insensitive to artistic values not recognizing a picture, a verse, or a tune as art; he simply doesn't see its value. This, however, can't be what Danto is after. The philistine recognizes the thing as at least a picture, verse, or tune and to do that is supposed to require an interpretation.

The thesis that all artistically relevant descriptions are interpretations requires that there is something that is interpreted and is identified under a description that differs from the interpretation. The proper understanding of Bruegel's painting requires that the figure of Icarus be interpreted as the dramatic focus of the composition. That interpretation requires that the legs be interpreted as the plummeting Icarus. And that in its turn must rest on the interpretation of the dab of paint as legs. This sequence of interpretings-as must come to an end somewhere and wherever that is we presumably have the real thing and the neutral description. It is true that to understand Bruegel's composition we must see everything in relation to the figure of the fallen Icarus and that does presuppose the identification of the legs as belonging to that rash and inexperienced traveller. My earlier remarks were intended to suggest that it is a mistake to push this back to dabs of paint. In this instance we don't interpret anything as legs; they are legs from the beginning. With the

Bruegel the line of interpretation comes to rest with the conventionally and clearly delineated figures of ships, plowman, and landscape details.[8] It is in the impressionist painting where it is intelligible to puzzle about what a dab of paint is supposed to be.

Nowhere in any of this do we reach something that can unequivocally be described as the real thing and, consequently, the artwork/real thing distinction remains unclear and, what is more important, totally unhelpful for understanding the concept of art or for clarifying any of the problems about the description and appreciation of art that we have been puzzling over. The solution to none of these problems is to be found in ontology.

If no solution to our problem is to be found in ontology, that is, by invoking some artwork/real thing distinction, then no solution is to be found in the alleged artistic differentia that distinguishes the two. For Danto that differentia is art's semantic function. This imputed semantic character of art is nevertheless worth talking about because we can thereby get a clearer and firmer view of what it is that distinguishes Rembrandts and Bruegels from *Brillo Boxes*.

Danto thinks of art as like language in having a semantic character, in being about the world, and also like language in being an appropriate subject for philosophy. Wittgenstein's *Tractatus* is offered as a paradigm of what is typical of philosophical theories: language is pictured as standing to one side, the world as standing to the other, and the two connected by the one's mirroring of the other. Language as physical reality, sounds and printed marks, is of course part of the world, but in its role as mirror of the world it stands apart from the world. Given this picture of things, philosophy is said to occupy itself with the space between language

[8] It may be objected that the reference to conventional pictures begs all the questions and that our conventional understandings of pictures itself rests upon a host of tacit interpretations. I shall consider this possible objection in the next chapter.

and the world. Against the earlier *Tractatus* view Danto thinks it is possible to summarize Wittgenstein's later theory of language and the world as the contention that 'natural language does not represent reality at all, it has a use but not a descriptive meaning . . .' (ibid., p. 82).

The attempt to find a common denominator of art in its semantic character, I shall argue, is just as fruitless as the attempt to find it among more traditional candidates. The actor represents the character he is playing, in Danto's parlance his performance is *about* that character. How are we to understand this semantic notion of 'aboutness'? I suppose we would have to explain it with a general account of what acting is, what the traditions and practices of the theater are, and so on. It is doubtful that we have a semantic notion of aboutness ready at hand in terms of which we can understand the theater; it is more likely the other way around. If we are to make sense of the semantic concept, it must be in terms of the already familiar practices of acting. It is also doubtful that the relation of the actor to the character he plays is very much like that of the portrait to the person whose portrait it is where the latter relation has to be explained in terms of the practices and traditions of painting. And similar remarks will hold for whatever semantic character we attribute to poetry, music, or other art forms. All the problems about locating properties common and peculiar to works of art that troubled other attempts to define art spring up all over again with regard to the concept of semantic function. There is just as much reason to describe it as a family resemblance concept as any of the others we have discussed.

There is yet a further difficulty in this assimilation of art to language by way of shared semantic character. Danto's picture of language as something set apart from the world cannot do justice to the role that language plays in life. This comes out in his account of Wittgenstein's later views about language, i.e. that language has a use, but neither represents nor describes. Wittgenstein does not say that language has *a* use; it has, rather, innumerably many different uses and

among these are representing and describing. And then we must add that there are many different things that can count as descriptions (*Investigations*, §§23, 24). To this view of language as standing apart from the world should be opposed Wittgenstein's view of language as human activity rooted in a form of life and, therefore, an intimate part of the world. Language enters the world, that is, human life, in a much deeper way than physical marks and sounds enter the world. The former picture is an instance of something idle and doing no work in the world; it is a picture of language gone on holiday. And to the view of philosophy as occupying itself with the space between language and the world we should oppose Wittgenstein's view of philosophy as closing that gap by bringing words back from their metaphysical to their everyday use.

To the extent that art is supposed to be like language, might we be justified in speaking of art gone on holiday? Perhaps we might. Meaning is supposed to be given to an expression by assigning it a semantic function. What that function is can be a matter of indifference; it is only important that there be a function. By parity of reasoning the semantic function that converts a mere thing into an artwork can also be a matter of indifference. I believe it is like this with *Brillo Box*: Brillo-box-as-work-of-art or *Brillo-Box*-as-altogether-pointless, it is all the same. For it to count as art it is quite enough to know that it has been assigned a semantic function. Danto does not – always – find art a matter of indifference; that is clear from the way he writes about Bruegel and Rembrandt, but there is nothing in his theory to indicate why it shouldn't be that way. I offer no alternative theory of art, but do take a stand on the unargued foundation that art is important in our lives and cannot be a matter of indifference and that any theory permitting it to be otherwise has to be mistaken.

The foregoing allows us to see the essential inappropriateness of Danto's Transfiguration metaphor. The Gospel account of the Transfiguration follows the story of Peter's confession that Jesus is the Christ and is usually read in

connection with it. Albert Schweitzer boldly proposed that the order of events had been reversed and that the confession followed upon the Transfiguration; this way of reading the narrative makes one kind of sense of it. At any rate, the two do seem to belong together. As Peter said, we 'were eyewitnesses of his majesty', which may be a reference to the Transfiguration, but could just as well refer to the entire ministry; however it is taken, it is all of a piece. The Transfiguration was not just a curious event eliciting 'Ohs!' and 'Ahs!' and then forgotten. It made a difference in the lives of those chosen disciples; it had to make a difference or it was no Transfiguration. The relation between those disciples and Jesus was now different. The matter is not exhausted in the report that 'his face did shine as the sun, and his raiment was white as the light', but is essentially connected with the further description that 'Thou are the Christ, the Son of the Living God', and the subsequent religious vocation of the Apostles.

From one point of view it is blasphemy to suppose that art has the same kind of importance in human life as the Christian revelation, but the point of introducing the remarks about religion is to indicate that art is also important and can make a difference in life. It is obvious what one would be missing by taking Peter's report of the Transfiguration as merely the report of a Curious Unexplained Phenomenon. What would one be missing if one took *Polish Rider* merely as a picture of a man on a horse (not, surely, merely as a dab of paint) or *Crime and Punishment* as a kind of detective story (not, surely, merely as marks on paper)? We can respond in the obvious terms of painterly and literary skill, of design, composition, color relations, and plot structure, but in addition we want to talk about depth and mystery, the conflicts within the human soul and a view of life and human relationships.

Whoever misses what is important in the Rembrandt is lacking in something. He may lack aesthetic sensitivity and be indifferent to compositional relationships. But 'Nice design' and 'Clever plot' are somehow inappropriate as com-

ments on Rembrandt or Dostoevsky. As Wittgenstein reminded us, we don't talk of appreciating the *tremendous* things in art.[9] The composition and plot structure are the sorts of things we can appreciate; the human significance, however, must move us. What, then, would one be missing if one took *Brillo Box* merely as . . . a Brillo box? *Placid Civic Monument* merely as a hole in the ground? Rosenberg's sculpture merely as a red plank? It is not that one would be lacking in appreciation for there is no aesthetic character to appreciate. Nor would one be lacking any normal reaction to something of abiding human significance. Is the only thing that it is possible to miss a pointless metaphor? If that is so, then the Transfiguration metaphor is blasphemy at more than one level – an event of the deepest human importance becomes a metaphor for the philosopher's theoretical notion of acquiring semantic content! This is indeed art, as well as language, gone on holiday.

We are now in a position to resolve the problem that has generated the discussion in the preceding chapters and that lies behind the puzzlement of our plain gentleman. We are tempted to pose the problem in this way: What is the difference between works of art and things that are not works of art? or, more simply: How is something identified as art? Put in this fashion the question does not take into account the different uses of 'art' nor is any context specified to give the question sense. Perhaps the only kind of circumstance in which there is a serious problem about identifying and recognizing something as art is that exemplified by our plain gentleman puzzled, if not shocked, by the new. His puzzlement is not to be relieved by any definition or theory, whether in terms of 'exhibited' properties or an artworld

[9] *Lectures and Conversations*, ed. C. Barrett (Oxford: Blackwell, 1966), p. 8.

background of intentions, interpretations, or semantic functions. To suppose that it can be so relieved is to make two mistakes. It is to make false assumptions about the intelligibility of a class of definitions and theories and it is to misunderstand the nature of the problem which is a practical and not a theoretical one.

For our plain gentleman to identify the puzzling thing as art he must come to understand and appreciate it – by analogy with the joke he must, as it were, get the point – even if this involves the realization that the thing is not very good, that the effect aimed for is not brought off, or that the point was not worth the getting, for this in itself is a form of appreciation. In this kind of case the identifying of something as art is one with its appreciation. The problem of bringing our plain gentlemen to make the identification is, therefore, practical in that he must be brought to do certain things and to react in certain ways; to see things in appropriate ways and in appropriate connections, to like and to judge and possibly be moved emotionally.

The only way to do this, I believe, is the way that Roger Fry taught us to see the post-impressionists, that is, by making connections between the new and puzzling and the old and familiar. The connections that Fry made and the appreciation and reactions that he sought thereby to evoke were all *aesthetic* in that broad sense I have talked about. So many of the things that have been represented as art in recent times have, to belabor a point already made, been deliberately divorced from the aesthetic. Fry's procedure for producing appreciation obviously won't work for them. Indeed, the very idea of appreciation seems thereby ruled out of play. This being so, our plain gentleman is never going to identify these things as art in any but that most trivial sense sanctioned by the Institutional theory. If this is how it is, so be it. I have no desire to close off any possibilities of appreciative or critical insight and whether something can be brought into the artistic fold can, after all, only be decided on a case-by-case basis. At the very least, however, I do firmly

believe that the divorce of art from the aesthetic was a disaster.

It may be supposed that what I have said entails at least an element of theory in that having aesthetic character is a necessary condition for art. I would have no objection to this as long as we remember that at the very most it only points the general direction in which art is to be found and that there are so many different aesthetic characteristics no one of which or set of which is necessary. I offer no knock-down argument to the conclusion that the readymades and our other curiosities are not works of art; I don't believe there can be such an argument. Instead, I think, the onus is on their partisans to show us that they are, that is, to show us how to appreciate them and what it is about them that should move us. It is for this reason that I believe I would prefer my remarks not to be taken as a kind of minimal theory, but as the expression of a practical stance and their logic construed as that of a manifesto: Since I find little or nothing worth attending to in one direction and things of the greatest value in that other direction, I choose to go in that other direction. Moreover, I find it very difficult to imagine what it would be like to go in the one direction and have all those things for my familiars; to what ways of thinking and doing would I be commiting myself and what form of life would have to lie behind it all?

To declare, as I have done, that it is pointless to try to conceive of art apart from any possible aesthetic character is to invite questions about the nature of aesthetic character and its value. I have been insisting all along that there are many different aesthetic qualities, many different particulars, that characterize art and play a role in appreciation and discussion of art. There are qualities of organisation, design, composition, balance, plot structure, thematic and harmonic structure; there are expressive and emotional qualities; there are qualities of style; and so on. There are a number of traditional philosophical problems about these qualities, the place that they occupy in the world, and our knowledge and

awareness of them. Since the aesthetics of art is so significant to us, it is important that we think clearly about it and I want to argue that the clearest thinking that we can do is in terms of some of Wittgenstein's ideas. The next two chapters will be an attempt to do some of that clear thinking about aesthetics. In these final chapters I will do three things: (1) state the traditional problems about aesthetic quality, (2) explain some of Wittgenstein's views about perception and meaning, and (3) show how the application of his views can solve those traditional problems. It is to this task that I now turn.

6

Aesthetics and the Complexity of Perception

When Baumgarten coined the word 'aesthetics' he defined it as the science of perception, a science that was intended to explain our understanding and appreciation of art and poetry. Although this stipulative definition was not wholly arbitrary given the word's Greek root, he was mistaken to suppose that our traffic with art involves anything like a science, at least in our contemporary understanding of science. He was right, however, to focus his new discipline upon perception and to seek to find there the key to so much that is important about art. In the same tradition Heinrich Wölfflin described the task of the art historian as reckoning with the stages and development of what he called modes of vision. This way of thinking about the subject invites us to construct a parallel description of the historian of music as reckoning with the stages and development of hearing. Another to stress the importance of perception was that pioneer of art history and connoisseurship, Giovanni Morelli, who noted that:

> among those who study art we find that there are some who have eyes to see, and there are others whom the most powerful of glasses would not benefit in the slightest degree, because there are practically two kinds of sight – physical and mental.[1]

Morelli's distinction between kinds of sight is important in

[1] *Italian Painters*, 2 vols (London: John Murray, 1900), vol. 1, p. 44.

reminding us that in art it is not enough to talk about just perception without some sorting out of its species. Morelli was of course interested in that kind he called mental, the kind which could not be improved by correcting lenses. It remains to make explicit exactly what the distinction is that he has in mind and in just what ways it is important for aesthetics and the understanding of art.

This concern with the development of visual perception and, by analogy, auditory perception is natural for people such as Wölfflin and Morelli who were working in the history of the visual arts of drawing, painting, sculpture, and architecture, but Baumgarten had restricted his concern almost entirely to poetry and it is not at all obvious that beyond a certain point perception has much to do with poetry in any interesting way. While the sounds of the words of a poem, their rhymes and rhythms, are themselves of undeniable significance, that significance is usually thought to be secondary to other things such as the meaning of the words. Baumgarten was able to make perception of central importance by his definition of poetry as sensate discourse composed of sensate representations,[2] by which latter expression he seems to have meant imagery. It is as if he thought of reading a poem as like looking at a series of pictures. By this definitional maneuver he assimilated the aesthetic character of poetry to that of the visual art of painting and to that end he even borrowed Horace's *ut pictura poesis*, an adage that, had it not already existed, the eighteenth century would have had to invent. While imagery is clearly important, like sound and meter it is not all there is to poetry and cannot be the basis for any general theory of it. If the aesthetic character of poetry is to be one with that of the visual arts, the connection is going to have to be made in more subtle and unexpected ways. I certainly would not argue for any general theory of the aesthetics of poetry and

[2] *Reflections on Poetry*, tr. Karl Aschenbrenner and William B. Holther (Berkeley and Los Angeles: University of California Press, 1954), §§4–9.

much less for any broader program seeking to bring both poetry and the visual arts under some still wider common theory. Nevertheless, I do believe that there are interesting connections between the two that are both subtle and unexpected as I try to show in the next chapter.

Baumgarten's desire to develop a science of perception under the name of aesthetics was a natural outgrowth of traditional epistemological interests. Within Baumgarten's tradition the aim of philosophy was conceived as the search for theoretical knowledge of the world and in support of this aim it was necessary to conduct an investigation into those 'higher' cognitive faculties that were supposed to be responsible for that knowledge; this investigation was called logic. Given Baumgarten's assumption that there is another form of knowledge that is acquired in our commerce with art and poetry, sensate knowledge, it likewise seemed necessary that an investigation be conducted into those supposedly 'lower' faculties of perception responsible for that, as it were, form of knowledge; that investigation may as well be called aesthetics.

Since Baumgarten's time, however, the epistemological question about art and poetry has taken a different turn. The interest is no longer in a general classification of knowledge that locates art in some relation, be it one of parity or one of subservience, to the theoretical sciences, but has focused instead on the nature of the relevant properties of art and the nature of our knowledge and awareness of them. The modern problem about aesthetic qualities and aesthetic perception is implicit in Hume's declaration that beauty is no quality in things themselves and Kant's subsequent emendation that nevertheless judgements of taste demand universal acquiescence. If we let the word 'beauty' stand as a general representative of any aesthetic description whatsoever, then Hume's thesis is that no object in the world, no thing itself, possesses any aesthetic character. The expression 'things themselves' is a stumbling block to understanding what is being claimed. We are tempted to fall back upon 'physical

object', 'material substrate', and their kin as equivalent expressions, that is, upon all of those expressions that figure in the ontology of art for the problem seems inextricably bound up with ontology. The modern argument for Hume's thesis is the following. A work of art, a painting, say, posses-ses several different types of aesthetic properties. These include representational features, spatial and dynamic prop-erties, and properties associated with the emotional and motivational life of people. The painting considered as a piece of canvas covered with pigments, however, does not have those properties and, as a consequence, the aesthetic descriptions either seem false, as in the case of the spatial and dynamic properties, or categorically out of order, as in the case of emotional properties. On the assumption that the aesthetic descriptions are, in fact, true of the painting, we are driven to the conclusion that a painting is not a physical object, not a thing itself, or at least not a piece of canvas. Once again it must be noted that the argument is plausible only if the assumption that a painting either is or is not identical with a piece of canvas is intelligible.

What holds for paintings can be assumed to hold for other art forms as well and if a work of art is not a physical object, then the sequel to the thinking represented in the foregoing argument usually identifies the real work of art with a mental entity or event of some sort and locates aesthetic character in consciousness. Thus are generated theories of art as illusion, as total imaginative experience, as empathic 'projection' of feelings, or sensory perception 'fused' with bodily feeling, and so on. There are many difficulties with theories like these. Words such as 'empathy' and 'fusion' are intended to refer to psychological mechanisms that are postulated to operate upon our feelings although no intelligible account of those mechanisms can be given. In addition such theories lead us back into ontology. I do not intend to pursue the general question of 'the ontological status of the work of art', and the confusions inherent in all that, beyond what was said in the last chapter. I am interested only in the nature of the

aesthetic qualities themselves and the attendant problems about aesthetic perception.

As already pointed out in the last chapter, the whole issue of the ontology of art is set within a broad Cartesian framework. One salient feature of this framework is the privacy of consciousness: mental events and processes are private objects and the language in which they are reported and described is, perforce, a private language. Since the modern argument to the Humean conclusion leads to the location of aesthetic properties in Cartesian consciousness, it follows that aesthetic properties are private objects and that the language of art, i.e. the language of aesthetic description and art criticism, is a private language. This view of things traps us in the traditional 'other minds' problem: it entails that we can never know whether any two people are aware of the same aesthetic qualities nor can we even know what their aesthetic descriptions mean. On these grounds the Kantian demand for universality in judgments is impossible to meet; indeed, it is unintelligible. The task before us, then, is to provide an account of aesthetic properties and aesthetic perception that will make clear why these things have been found puzzling and that will resolve the puzzles while rejecting the philosophically disastrous private object picture of perception. This task can be carried out, I believe, by a development and application of material drawn from part II, section xi of the *Philosophical Investigations*. This section of the *Investigations* is an extraordinarily rich and complex one and has very significant connections with other parts of Wittgenstein's work, yet, surprisingly enough, has not been the subject of thorough study. I want to call attention to several of the topics discussed in the section and to some of the connections between them in order to show their importance for aesthetics. By doing so I hope to bring to light a number of significant and helpful points that seem to have been overlooked.

Wittgenstein begins his investigation of seeing by directing our attention to the experience of noticing a likeness between

two faces; such an object of sight as a likeness he calls an aspect. Wittgenstein does not very often make use of anything like a technical vocabulary or introduce distinctions that are necessarily intended to apply to and illuminate anything beyond the particular case under discussion. In section xi, perhaps more than anywhere else, he seems to back off from his usual practice and at this point makes what I shall hedge as a quasi-technical distinction between the report of the experience of an aspect and the report of what he calls a perception. The report of a perception is the report that an object of a determinate kind is seen. Thus 'I see the face' usually reports a perception while 'I see the likeness' reports an aspect. A perception need only require good eyesight; aspects, on the other hand, dawn and can be missed even though the object itself is clearly seen. He goes on to talk about aspects of ambiguous figures such as the duck-rabbit, aspects of organization such as appear when one sees a figure in a puzzle picture, and aspects that require imagination such as those of the triangle that become this or that depending upon the setting we imagine for it. He then introduces the notion of aspect-blindness and entertains the possibility that there are people who cannot see aspects or experience a change of aspect. This possibility suggests to him an important connection between perceiving aspects and what he calls experiencing the meaning of a word which, in turn, permits him to bring in the crucial concept of words having secondary senses. The discussion then modulates into further remarks about mental privacy and forms of life and concludes on the matter of understanding another person. The order in which these topics are addressed is not, I think, of any great significance since no one of them is more basic than any other. A number of the same topics are covered in part II of the *Brown Book* although in a different order which underscores their interdependence in Wittgenstein's thinking rather than the logical priority of some one of them.

Wittgenstein's interest in seeing goes back at least to the *Tractatus*, and *Investigations* II, xi is, in part, another facet of

his reaction to and criticism of his earlier views. Wittgenstein begins the 1914–16 *Notebooks* with the enigmatic statement that logic must take care of itself, a statement which is repeated several times and turns up again in the *Tractatus* (5.473). Logic must be understood in this context as including not only relations of entailment and deducibility among propositions, but also the very structure of propositions themselves and the abstract form they are supposed to share with states of affairs that make it possible for them to express a sense and thereby, in *Tractatus* fashion, represent the world. In a word, logic comprehends all the essentials of the picture theory of propositions. The condition that logic must take care of itself is the contention that explanations and justifications are not needed — indeed none are possible – for how propositions can express sense and picture the world; how they do that is one of those things that can be shown, but cannot be said. Since propositions are pictures, what is true of logic is true of pictures, and we can conclude that pictures must take care of themselves and just as, in a certain sense, we cannot make mistakes in logic, so we cannot make mistakes about pictures. What a picture represents and how it represents it must be shown in the picture and neither requires nor is capable of explanation.

Wittgenstein introduces what may be intended as an exception to this at *Tractatus* 5.5423 in the form of an ambiguous drawing of a cube that can be seen in two different ways. Since the drawing represents a cube in two different attitudes, it would appear to be a picture that cannot take care of itself and about which we cannot unequivocally say what it represents. Along with the drawing goes this passage:

> To perceive a complex means to perceive that its constituents are related to one another in such and such a way. This no doubt also explains why there are two possible ways of seeing the figure . . . For we really see two different facts.

The passage is puzzling. It is not at all clear how the reference

to perceiving complexes is supposed to explain what he will later call aspect perception. Nor is it obvious what he has in mind when he speaks of seeing different facts. In *Tractatus* terminology a fact is a determinate arrangement of objects and can contain no ambiguity. If we consider the drawing to be a fact, then it must be the fact that these printed lines are related to one another in just these ways. Conceived in that way the drawing is just one fact and not two. What I believe to be Wittgenstein's view of the matter can be explained in the following way.

The *Tractatus* makes an important distinction between a propositional sign and a proposition. A proposition is a propositional sign in use. This notion of use, however, must not be permitted to suggest the later one of the *Investigations* for Wittgenstein was not at this time talking about the role an expression plays in some language-game as part of human activity and a form of life. The use of the sign is as a projection of a possible state of affairs. The idea of a projection has its home in drafting and cartography and the assimilation of language to these activities may strike us as out of place since when we read, write, speak and listen nothing like them seems to be going on. Wittgenstein, nevertheless, says that the method of projection is to think of the sense of the proposition (3.11) and thereby connects his view with the traditional philosophical one that language is the expression of thought.

In the *Tractatus* Wittgenstein gives no account of what thought or thinking is, but we may assume his position is represented in the 1919 letter to Russell in which he explained that a thought is made up of psychical constituents corresponding to the words of language.[3] A thought, then, is just as much a picture of a possible state of affairs as a proposition and we can understand how a propositional sign is converted into a proposition when, by means of the consti-

[3] *Notebooks* 1914–1916, ed. G. H. von Wright and G. E. M. Anscombe (Oxford: Blackwell, 1961), pp. 129–30.

tuents of the thought-picture, we correlate the names that make up the sentence with objects in the world. We may imagine the projection of the sign upon the world accomplished by setting up something akin to a line of sight from the thought through the signs and onto the world, a kind of aiming, as it were, of the signs at the world.

Thoughts, then, are mental pictures and, like all pictures, must take care of themselves and thus there can never be a question of what a thought is a thought of. A similar account can, I believe, be given for seeing. Wittgenstein says that propositions containing intensional verbs such as 'A believes that p' are of the form '"p" says p' and involve a correlation of facts by means of a correlation of their objects (5.542). The facts correlated are (1) a thought, that is, a psychical fact composed of psychical objects and (2) a propositional sign composed of name-tokens. 'A sees p' can be construed analogously if instead of '"p" *says p*' we substitute '"p" is the *visual experience* of p'. (The extent to which the verb 'to see' shares in the intensional properties of 'to believe' remains to be investigated.) The visual experience, the perception itself, is a mental picture, a psychical reproduction or model, of what is seen.

We can now understand Wittgenstein's solution of the problem about the ambiguous drawing. The drawing can be a projection onto a plane surface of two different three-dimensional forms, or one form in two different attitudes, and the drawing can thus be used to represent two different states of affairs. Wittgenstein, however, speaks not of *using* the drawing, but of *seeing* it in different ways. In the *Tractatus* scheme of things to make a state of affairs, be it a drawing or sentence-token, into a picture and use it as a projection of another state of affairs, it must be thought, 'thought out' – that is, there must be a mental picture with the same structure that correlates sign and world. In the present case the accompanying mental picture cannot be merely a duplicate of the drawing on paper for that would reproduce at the psychical level all the ambiguity of the first. The psychical fact

must instead be conceived as a kind of three-dimentional model of one of the physical cubes, even if we have to conceive it as a kind of ectoplasmic model.[4] It is clear that there must be two such mental cubes corresponding to the two physical attitudes. When we see the drawing what we *see* is one or the other of the mental cubes. The change in the way we see the drawing can be explained by the alternation in consciousness of the mental cubes.

The explanation of the two ways of seeing in 5.5423 is now clear. The two facts that are seen are the two different psychical facts, that is, the mental cubes as articulations of psychical constitutents. The drawing is thus not an exception to the thesis that pictures must take care of themselves because the drawing is not a proper *Tractatus* picture, but is like a propositional sign that must be projected onto the world and made into a picture by a thought. In the later terminology of the *Investigations* these thoughts and mental pictures are private objects, and the price the *Tractatus* pays for saving the picture theory from unacceptable ambiguity is this retreat to private objects. Language takes refuge in pictures, and the ultimate refuge of pictures is the private picture.

This picture of visual experience as private object entails that the perception of different aspects is in fact the perception of different objects. The experience of seeing the alternation of the two aspects of the ambiguous drawings of the cube is thereby assimilated to seeing first one and then another of the two unambiguous drawings of cubes in different attitudes. By this maneuver the concept of aspect perception, the concept of seeing something in different

[4] There are several passages in the *Investigations* that I take to be criticisms of this kind of view and that invite us to believe that Wittgenstein is once more taking after his own earlier theories. For example, '"What I really *see* must surely be what is produced in me by the influence of the object" – Then what is produced in me is a sort of copy, . . . almost like a *materialization*' (p. 199e), and 'Here one would like to say: the visual impression of what is seen three-dimensionally is three-dimensional; with the schematic cube, for instance, it is a cube' (p. 202e).

ways, is ruled out of the language, or at least not recognized. Another way of putting this is to say that from the point of view of the *Tractatus*, and the Cartesian tradition I believe it is rooted in, the verb 'to see' has only one use. This was precisely the view shared by and the maneuver adopted not only by many philosophers of art in order to explain problematic features of aesthetic qualities and aesthetic perception, but also by the Gestalt psychologists in their overriding concern to explore and explain the phenomena of aspect perception.[5]

Wittgenstein begins section xi of part II by pointing out that 'to see' has a second use as well; in fact he will go onto show us that it has many uses. He reminds use more than once of the complexity of the concept and warns us away both from oversimplification and overly nice classification. He illustrates the second use of 'see' with the example of seeing a likeness between two faces and then almost immediately opens his attack on the private object picture as an explanation of that use. While the picture of alternating private images has a certain plausibility and is surely philosophically tempting as an explanation of ambiguous figures such as the cube or duck-rabbit, there is no plausibility in thinking of a *likeness* as another object, private or otherwise, in addition to the faces. Perhaps what we have to picture instead is two images merging into one by contrast with one dividing into two. Wittgenstein caps the attack on the intelligibility of the private object picture with this advice. 'Always get rid of the idea of the private object in this way: assume that it constantly changes, but that you do not notice the change because your memory constantly deceives you' (*Investigations*, p. 207e). The argument implicit in this advice can be made explicit in the following tale. Suppose there is a person who has neither the word 'duck' nor 'rabbit' in his vocabulary. He has in his possession a picture and he says

[5] These contentions are documented in my *The Expression of Emotion in the Visual Arts* (The Hague: Nijhoff, 1970).

that those creatures on the pond are just like his picture. We are tempted to suppose that referring to his picture stands for him in place of mentioning ducks. Let us suppose, however, that this picture is a 'private object' in the sense that no one else is permitted to look at it. He is shown the ambiguous figure and exclaims that it is just like his picture and, consequently, just like those things on the pond. Perhaps he also has a 'private' rabbit picture and sometimes says that the ambiguous picture can look like that other picture, too. Unknown to him a trickster is continually exchanging his pictures for others, but the man, having a very bad memory, never notices the change. Note that he deals with the ambiguous figure essentially as the rest of us do. Despite his not using the word 'duck' (or 'rabbit') he makes the appropriate comparisons with real ducks and rabbits and we have no difficulty telling which aspect he is seeing. The 'private' pictures play no role in any of this and, indeed, in these circumstances there is no role they can play. His expression 'looks like my first picture' does not serve to refer to the picture at all, but function just like the ordinary 'is a duck'. The moral of this tale for the philosophically private object is obvious. Our 'reports' and 'memories' of them can never be checked and for all we know are forever mistaken. There is nothing for them to do (cf. *Investigations*, §§271 and 293).

The picture theory of the *Tractatus* requires that every propositional sign, drawing, diagram, and the like be 'thought out' in order to be made into a proper picture; every picture must be accompanied by an underwriting thought if we are to understand it and know what it is a picture of. (Whether this thought is a private object is not presently germane.) The propositional sign 'The cat is on the mat' can say what it usually does only when interpreted as referring to this cat and that mat. Under another intrepretation it could say that the dog is under the table or express any situation of the form 'xRy'. Any picture can represent any state of affairs whose logical form it shares; every picture is to that extent indeterminate until interpreted

by thought. A result of this species of interpretation is that 'In a proposition a thought finds an expression that can be perceived by the senses' (3.1). Take this latter statement about perceiving the expression of thought together with the remark that 'A proposition is not a blend of words (just as a theme in music is not a blend of notes)' (3.141). A musical theme is not a blend of notes since in order to hear the theme we must hear the notes ordered in appropriate relations. The juxtaposition of 3.1 and 3.141 thus suggests that understanding a sentence, perceiving its sense, or a picture, is like seeing an aspect of organization and that all seeing (and meaning) is seeing-as. The *Tractatus*, of course, contains neither the means of articulating that thesis nor of making it intelligible.

In the *Investigations* Wittgenstein is at great pains to map the conceptual relations between interpreting and seeing. He shows another cube slightly different from the one in the *Tractatus* and imagines it appearing on different pages of a text book where each time it represents a different object, a box, three boards, a wire frame (p. 193e). At each place the text supplies the interpretation, e.g. 'let abcd be the front of the box to be constructed . . .' This is a perfectly straightforward use of 'interpretation' and such an interpretation instructs us in the use of the drawing. But the figure can also be seen in different ways and the description in the text can determine how we see it. This leads Wittgenstein to ask how it is possible to see something according to an interpretation.

Wittgenstein's answer to this question involves two moves. The first is to distinguish instances of seeing from instances of merely interpreting. To interpret is to form an hypothesis (p. 212e). A more complex example helps in the explanation of this. Imagine someone using a technical drawing to assemble a mechanism. The drawing presents to him merely a jumble or blend of lines and he must figure out which part of the drawing corresponds to which of the machine parts. He constructs a series of hypotheses, e.g. this line probably represents this surface and this broken line must be this key slot, etc. He then tries to mate the pieces and

either confirms or disconfirms his hypothesis. By contrast there is the other technician who doesn't have to do this kind of figuring out because he sees the drawing right from the first as a coherent representation. This is shown in the ease with which he uses and describes the drawing without any of the hesitancy of the other man.

The second move is to point out that seeing-as is subject to the will (p. 212e) and that when it is a matter of seeing aspects of ambiguous figures such as the cube and duck-rabbit or aspects of organization as in the case of the machine drawing it makes sense to tell someone to see the figure this way, take these lines for ears, this hatching for the section at this point, and so on. This is one feature that distinguishes the concept of seeing-as from that of simply seeing an object. A description that in one circumstance is the result of an interpretation, that is, of figuring out and hypothesizing, in another circumstance is a result of how something is seen and can serve as an instruction for seeing. The description in the text not only tells us how to use the drawing, but can also tell us how to see it.

In the light of all this we can understand talk about indiscernible but distinct works of art from quite a different perspective. The titles of Danto's pair of imaginary paintings, *Newton's First Law* and *Newton's Third Law*, provide interpretations of the paintings that enable us to see them differently. Actually it doesn't make any difference whether there are two canvases or only one. We can see it now as a point tracing a path across space or again as two masses impinging upon one another. Under the different interpretations the canvas(es) looks quite different; we have quite a different visual experience of it, and the contention that they are visually indiscernible can only appear to be the result of a philosophical prejudice that fails to take account of the complexity of the concept of seeing and emphasizes once again that Mandelbaum's notion of a directly exhibited property along with this notion of visual identity, its near kin, is much too narrow. The 'ontological' question about what

distinguishes the two perceptually indiscernible works of art is now seen to rest on the false assumption that they are perceptually indiscernible. The question, therefore, is not what distinguishes them, but how it is possible that the same thing can be seen in different ways and this question is answered by an examination of our language and not by any theory. Consequently nothing is served by speaking of the two canvases as distinct works of art. It comes to the same thing to say that there is one work with two aspects; that is why it doesn't make any difference whether there is one canvas or two. Ontology, whether of the traditional Cartesian private object variety or the new sort of Danto and Margolis, is of no help in the explanation of aspect perception.

Wittgenstein's explanation of aspect perception is that the experience rests upon the mastery of a technique (*Investigations*, p. 213e). The technique in question is the ability to provide appropriate descriptions of the objects under consideration, make appropriate comparisons with other things, use the drawing in certain ways, and the like. In order to see the duck aspect of the duck-rabbit one must be able to do such things as described these lines as the bill, the dot as the eye looking toward the left, or the figure as being like other duck pictures. This explanation of the ground of an experience is surprising and perplexing if it is supposed that a psychological or neurophysiological explanation is what is called for. Wittgenstein, characteristically, was not interested in the causal conditions, if there are any, underlying the phenomenon, but rather was concerned to locate the relevant use of 'to see' in our language and to identify the limits of intelligibility. Thus it is only of someone who is master of the relevant techniques that it makes sense to say that he sees something as this or that. This, I would think, is at least part of whatever truth there is in Danto's thesis that art is inconceivable apart from a community of language users.

This point about the experience of aspect perception resting on the mastery of a technique connects with the subse-

quent remark that what is seen in the dawning of an aspect is not a property of the object, but an internal relation between it and other objects (p. 212e). When I see, say, the duck aspect of the ambiguous figure I am prepared to offer a description of it as like a duck or like this other duck picture; my description notes a relation between the figure and something else. But since this ability to describe is a logical condition for the intelligibility of the statement that I see it as a duck, the relation established by the description is a logical, i.e. internal, one. It is through this requirement of an internal relation that the matter of technique mastery is connected to the opening remarks about seeing likenesses and gives us a reason for noticing a strategy in Wittgenstein's beginning his discussion with the topic of seeing a likeness.

This distinction between properties and aspects should not be understood as Wittgenstein's ontology nor should it be taken as the kind of technical distinction that demands a determination in every possible case as to whether a description denotes a property or an aspect. The distinction serves, rather, to direct our attention to some grammatical differences that it may be helpful to keep in mind when we are faced with certain philosophical difficulties. It calls our attention to the fact that some of our experiences are logically dependent on being able to offer the appropriate descriptions and comparisons, that these descriptions are parasitic on our familiarity with other things, and the derivative grammatical point that we do not teach the meaning of certain words in the context of these uses, e.g. we would not teach a child the word 'duck' by pointing to the ambiguous figure.

These grammatical reflections about aspects open a slightly different perspective on Danto's conception of the artworld. Danto speaks of an internal connection between the status of an artwork and the language in which it is identified as an artwork.[6] Apart from the misleading references to theories

[6] *The Transfiguration of the Commonplace* (Cambridge, Mass.: Harvard University Press, 1981),

and interpretations, to the extent that identifying something as a work of art depends upon seeing it as a work of art, Danto's contention would seem to be one with Wittgenstein's that the experience rests upon the mastery of a technique. Just as seeing the duck aspect of the duck-rabbit depends upon a background knowledge of language and ducks, so seeing something as art would have to depend upon a background knowledge of language and art. There is no harm in calling this background the artworld although we must be very careful about exactly what the essential ingredients are. There is also the matter of when it is in order to speak of seeing something as art, a matter to which I shall return below.

The notion of seeing a likeness between two things is an extraordinarily important one for aesthetics although its importance has not, I believe, been at all recognized. Before going on to explain that importance, however, it is necessary to make clear what Wittgenstein has in mind in talking of seeing a likeness between two faces. Let me begin with what he does not have in mind. Imagine a series of cartoon faces such as can be found in children's puzzles. On some of the faces the nose is indicated by a single line and by a double line on others, some eyebrows slant one way and some another, occasionally one eye is missing, and so on. The problem is to find the two faces that match and that is done by a one-to-one pairing of those features. Wittgenstein, by contrast, is talking about seeing a family resemblance, that the son is like the father, or recognizing the old familiar face in the altered one of a friend not seen for years. Here it is not a matter of noticing that the faces are equipped with the same furniture, two eyes, one mouth, two nostrils. In what way, then, are the faces alike? Typically we described the son as having his father's mouth or his nose, both as having the family chin, or even the same merry twinkle in the eyes. We now feel pressed to ask how the mouths or the noses or the chins are alike. It need not be the case that they are the same size or even geometrically congruent. In this kind of instance a point

is soon reached where no further explanation by way of citing common characteristics can be offered. The only explanation or justification for the likeness, if it is either, is that it is seen.

That we press for an explanation or justification suggests that we treat the report of having seen a likeness as an hypothesis that the two faces are alike and that explanation comes to an end so quickly suggests a deficiency in being unable to confirm the hypothesis. That, however, is the wrong way to understand what is going on. 'I see a likeness' is not an hypothesis and if there is anything to be confirmed it is that the expression is the honest report of how one saw the faces. What has to be noted is simply this kind of seeing, this use of 'to see'.

Nor need looking for a likeness be an idle exercise and noticing a likeness be set down as no more than a curious phenomenon. Seeing a likeness between faces can make a difference, a moral difference, in our relations with people. If I see the old face in the altered one, I can renew the old friendship and understand that person in a way I cannot do with a total stranger. To see the father's face in the son can create a sense of obligation to the younger arising out of a longstanding friendship with the elder or, in another kind of circumstance, to find in the son the same treacherous eyes can add another chapter to a story of an already poisoned relationship.

The importance of the concept of seeing a likeness for aesthetics is nowhere better illustrated than in the work of Giovanni Morelli who laid the foundations for what he thought was a scientific approach to the history and criticism of Italian renaissance art although his methods are perhaps better described as merely more or less systematic rather than genuinely scientific. Morelli's thesis was that in matters of attribution the visual evidence, that is, the look, of the painting was to be preferred to documentary evidence which is too often unreliable or lacking altogether. Painters, he believed, had characteristic ways of portraying details such as

ears and hands which tended to be invariant across their work and by taking note of these the careful observer could distinguish the works of a particular painter from those of his followers and copyists. His technique was to establish patterns of invariance by a study of known works of the painter under consideration and then to test questionable works by comparing the way the ears, hands, and other relevant details were there treated with the established patterns. His description of Botticelli's *St Augustine in his Study* is typical of how he picked out details; 'The hands are bony – they are not beautiful, but always full of life – the nails are square with black outlines.'[7] He found this way of doing hands and especially nails to be characteristic of Botticelli.

After making his distinction between physical and mental sight Morelli goes on to remark that:

> it is the privilege of those endowed with the latter to discern in the features, in the forms and movement of the hand, in the pose of the figure – in short, in the whole outward frame – the deeper qualities of the mind; while the other class of observer, even should they happen to notice these particulars, would look upon them as meaningless. (p. 45)

Morelli was trained as a medical doctor and he also did a certain amount of work with Louis Agassiz. Both of these are episodes that could only contribute to the creation of habits of close and careful observation and the development of visual acuity. It is someone with this kind of background who would be expected to take note of the way Botticelli paints fingernails. It is not enough, however, just to take note of such particulars for Morelli insists that they also be looked upon as meaningful. To look upon them as meaningful, I take it, involves becoming aware of them as common to a number of the artist's works and also the recognition that they are essential elements in the artist's style and in that

[7] *Italian Painters*, vol 1, p. 35.

respect like the flourishes that distinguish a man's signature. But more importantly, in order to recognize them as characteristic and as style-making, the relevant likenesses must be seen. The hypothesis that particulars such as Botticelli's square nails are clues to identification and attribution rests upon having noticed the likeness across various examples of an artist's production. Morelli's designation of his two kinds of sight as physical and mental is of no help; that terminology doesn't explain anything nor go any way toward the philosophical clarification we are after. Nevertheless in making his distinction between the two kinds of sight he seems to be directing attention to what is basically the same thing Wittgenstein was after in making his initial distinction between two concepts of seeing.

It was Bernard Berenson who honed Morelli's techniques into a remarkable aesthetic instrument and a case study of Berenson's mode of operation fixes the importance of these concepts of perception.

The Louvre had acquired a Madonna attributed to Piero della Francesca. Berenson argued that it was in fact by Alessio Baldovinetti.[8] Berenson compared the Louvre painting with several works known to be by Alessio, particularly a pair of Madonnas in similar poses, and then contrasted them with figures known to be by Piero. He found the faces of Piero's Madonnas to be fixed and severe, their figures massive, immobile, and displaying no emotion. The Louvre Madonna, by contrast, was very different with its refined features and pensive gaze. 'The eyes are not so protruding as Piero's, the nose is more delicate and aquiline, the mouth is smaller, the lips are thinner. All these traits you will find

[8] 'Alessio Baldovinetti and the New "Madonna" of the Louvre', in *The Rudiments of Connoisseurship* (New York: Schocken Books, n.d.). The collection originally appeared in 1902. For an account of Berenson's development of the art of connoisseurship and his relation to Morelli see David Alan Brown, *Berenson and the Connoisseurship of Italian Painting* (Washington: National Gallery of Art, 1979).

almost invariably in no matter which of Alessio's pictures
. . .' (pp. 35–6).

The faces of the Louvre Madonna and the two Madonnas
of Alessio that Berenson juxtaposes are indeed very much
alike, one immediately sees the likeness, but in what does it
consist? The outlines of the faces are not exactly congruent.
The heads are tilted at slightly different angles and were the
outlines to be adjusted to the same scale and superimposed
upon one another they would not precisely match. The
similarity does not consist in their being recognizably the
likeness of the same model. Portraits of the same person can
have quite different aesthetic character; what counts here is
identity of style rather than of sitter. The three paintings, it is
true, all answer to the same descriptions, 'delicate and
acquiline nose', 'small mouth', and 'thin lips', but these
descriptions could also be true of other paintings and other
faces artistically unlike Alessio's. It is important that the
noses are delicate and the lips thin in just the same way. In
this kind of case the similarity can be established only by
seeing and the kind of seeing of likenesses involved is, I
suggest, an irreducible species of perception, that is, we have
here a clearly identifiable use of 'to see'.

To Morelli's test procedures of comparing particulars such
as ears and hands Berenson added the search for the intangi-
ble of *quality* for 'the ultimate test of the value of any touch-
stone is *Quality*.'[9] And he was sometimes convinced that a
painting could not be the work of a particular master because
it was just not that good.

The reliance upon such intangibles stresses that Berenson's
tests were not the sort that could be applied mechanically
merely by checking off similar items, but rather rest upon a
'cultivated and refined vision'. We should resist the temp-
tation to suppose that there is anything mysterious about this
or that there is anything that remains unexplained; no appeal

[9] 'The Rudiments of Connoisseurship', in *The Rudiments of
Connoisseurship*, p. 134.

to faculties of intuition or indefinable qualities is necessary to fill the gap. It simply is a fact that some people are aware of and sensitive to these things while perhaps the greater number are not. This difference should be taken as marking a difference in concept. Just as there is a conceptual difference between seeing a face and seeing its likeness to another, so there is a conceptual difference between seeing a painting and seeing that this one is by the same hand as that.

It is this seeing of likenesses that was at work in Roger Fry's defense of post-impressionism. As I pointed out in chapter 4 Fry's 'argument', if that term is applicable at all, that Cézanne and the others are worth looking at was neither a deduction from theoretical assumptions nor an inductive stacking of evidence, but instead took the form of an encouragement to see a likeness with Giotto and early renaissance painting. That Fry's critical and interpretive procedure rests upon the experience of seeing likenesses emphasizes once more that this kind of seeing is not simply a curious phenomenon to be duly recorded in a catalogue of concepts and then passed over. It plays a crucial role in our traffic with art; it makes a difference in how we appreciate and react to works of art. Just as seeing a likeness between two faces can make a difference in our moral relation to another person, so seeing that Cézanne is like Giotto can, and did, make a difference in our aesthetic relation to paintings.

I want now to return to the matter of seeing something as a work of art, but first a few general remarks about seeing-as are in order. All seeing is not seeing-as, that is, not every object of perception is an aspect. The ambiguous figure can be seen now as a duck and again as a rabbit, but it makes no sense to speak of seeing a duck as a duck. Under appropriately poor conditions of observation I may not be able to tell that the thing yonder is a duck; I may not be able to see that it is a duck and may even mistake it for a rabbit, but it would be an error to describe this situation as a case of being unable to see it *as* a duck or of seeing the duck *as* a rabbit. Despite this last statement, there are no general criteria

whereby we can uniformly distinguish between an aspect and a perception. The matter is further complicated by the fact that the same expression, e.g. 'It's a duck', can serve both as a report of a perception and as a report of the dawning of an aspect. Which it is can only be determined by the particular circumstances of its utterance. It would likewise be an error to suppose that a conventional and unambiguous picture of a duck such as can be found in a children's nursery book is generally seen as a duck; it would take rather special circumstances to make that intelligible. We would have to imagine, say, someone from another culture who does not share our practices of making and using pictures and who therefore cannot make anything of the picture. For us, by contrast, such pictures are conceptual bedrock, that is, it is in terms of them that we teach the very idea of pictures. Aspects only come later. That is why we don't see or interpret the dab of paint in the Bruegel as legs; for us it just is a picture of legs. Nor is there anything like a theory behind our recognizing what is pictured. There is instead our cultural practice of making and using pictures together with our natural reactions to pictures;[10] small children usually see right away what is shown to them in the picture book.

If something just is a work of art, it would seem, then, to make little sense to speak of seeing it as art. But what use of 'art' is in question? If it is classificatory use, then one may know that something is art, that it has been the subject of a declaration or status-conferring performance, and no question of seeing need arise at all. Should we be talking, rather, of that other use of 'art' uncovered in chapter 3 where it is a matter of what is relevant to the appreciation of something as art, then there is room for seeing-as and the dawning of artistic aspects. Fry's British public saw Cézanne as a parody of Raphael or as something that any six-year-old could have brought off and its vision had to be rearranged so that Cézanne could be correctly seen. In a somewhat different

[10] See the *Investigations*, p. 54e (b).

kind of case I may not realize that a sculpture made of junked machine parts is a sculpture. This is pointed out to me and now I look for the design and composition in it and am struck by the contrast generated in the juxtaposition of the serrated perimeter of the rusty gear wheel and the steely smoothness of the still-polished piston rod.

What is significant about these examples is their suggestion that there is no single phenomenon of seeing something as art; there is, rather, the seeing of particular artistic aspects and there are many of those. To say that something is seen as art, then, can only be a very general introduction to a more specific description. True, I did not see the junk sculpture as art, but that failure had to be cashed in as a failure to see it as a piece of abstract sculpture with such-and-such design. This is why 'Brillo-box-as-work-of-art' is an unsatisfactory description; we want the rest of the story about the particular artistic aspects to be found there and nothing is forthcoming. The supposition that something can be seen as art – without further qualification – has to rest on the assumption that a theory, definition, or some sort of general account of art is available and in terms of which we can identify the artworld. The thrust of my arguments is that there is no such general theory and no such artworld composed of theories. There is, instead, a background of human activity and practices built up out of our natural reactions, cultural traditions, ways of seeing, ability to make comparisons, and so on. It is this background that makes our experience of art possible and our talk about it intelligible. Consequently, the only possible procedure is to turn our attention to particular aesthetic qualities and artistic aspects and what it is like to see and appreciate them on the one hand, and to what it is like to misunderstand them or overlook them on the other.

I have been at considerable pains to point out the import-ance of the notion of seeing likenesses for aesthetic appreci-ation, art history, and criticism. In the remainder of this chapter I want to point out, more briefly, the importance of some other aspects of aspect perception. It is doubtless

unfortunate that so much of the discussion of aspect perception has been focused upon the duck-rabbit example. Wittgenstein uses the picture of that anomalous beast to bring out a number of puzzles about perception and to direct attention to important features of the grammar of perception. But for all that it is by no means the only perceptual phenomenon he investigates in *Investigations II*, section xi nor does it really have much direct connection with aesthetics; serious works of visual art just don't have that kind of flip-flop ambiguity although op art has exploited some measure of that kind of thing. In questioning the possibility of explaining aesthetic qualities in terms of aspect perception Alan Tormey wrote that the anology between aesthetic qualities and aspects 'is misleading when it suggests that seeing, or hearing, an art work as *expressive* (or garish, or sentimental) is not different from spotting the face in the cloud or the duck in the figure'.[11] Tormey is certainly right to point out that the kind of perceptual experiences associated with the duck-rabbit and seeing faces in clouds cannot be the grounds for finding works of art expressive and describing them with the language of emotion. Nevertheless, despite important conceptual similarities between seeing the aspects of the ambiguous figure and seeing a face in the clouds, there are some significant differences and I believe that there are aesthetic qualities, although not the expressive ones, the experience of what can be illuminated by analogy with seeing shapes in the clouds, if not ducks or rabbits. I will reserve discussion of the expressive qualities for the next chapter.

A common experience with the duck-rabbit figure is to see it at first as one of the two and then to have the other aspect dawn, after which the two aspects may alternative in experience. With the face in the cloud, by contrast, what often is seen first is not any aspect of the cloud, but only an amorphous somewhat that then can become organized for

[11] *The Concept of Expression: A Study in Philosophical Psychology and Aesthetics* (Princeton: Princeton University Press, 1971), p. 116.

perception into a face, whale, or whatever. This is similar to seeing a constellation in the stars, where the latter first present themselves as only random elements before coalescing into the recognizable pattern of the Big Dipper. The understanding and appreciation of a work of art often depends upon becoming aware of a pattern in, or organization of, elements be they forms and colors in a painting or syllables in a poem, that may be noticed individually, but whose interrelationships may not dawn. The awareness of the design and composition of works of art is an example of the perception of what Wittgenstein calls aspects of organization, for when such aspects dawn 'parts of the picture go together which before did not' (*Investigations*, p. 208e).

The notion of things going together is, of course, of primary importance for art. It is interesting to recall how the concept of aesthetic organization and composition is explained in text books of art appreciation by reducing the forms of a painting to a schematic outline and then stressing the important connections and organizing shapes with heavy lines, arrows, and the like. The pyramidal composition typical of much high renaissance painting is shown, for example, by superimposing a triangle on a reproduction of a painting. The idea of balance is sometimes put across by representing the principal figures of a painting as standing on a see-saw whose fulcrum coincides with the vertical axis of the painting. These graphic techniques can serve two purposes. They can be used to teach the very idea of aesthetic organization and design and through the study of typical single examples prepare one to discover and appreciate the composition of other paintings on one's own and they can also be used for the critical analysis of an individual painting. In either case the schematic representations serve to direct attention and bring one to see aspects of organization that may otherwise go unnoticed.

In all of this I have simply called attention to aesthetic and artistic instances of some of the concepts of perception that Wittgenstein mentioned. No philosophical problem need

arise out of any of it; the philosophical problems arise typi-
cally when we try to explain away some or other of the
concepts of seeing as special cases of yet another, e.g. seeing
aspects of an object as an instance of seeing another object.
There is, nevertheless, another point about these aesthetic
aspects that can easily generate a philosophical problem.

In his discussion of pictorial organization Rudolph
Arnheim asks why balance is aesthetically indispensable and
answers that 'In a balanced composition all such factors as
shape, direction, and location are mutually determined in
such a way that no change seems possible, and the whole
assumes the character of "necessity" in all its parts.'[12] In a
balanced composition, then, no change seems possible, that
is, no change is wanted, and everything seems to be just right
and as it ought to be. Arnheim's remark thus points to
something that I believe to be correct, that the perception of
aesthetic balance as well as other aspects of design and
composition is very closely linked with evaluation. And that
tempts us to the conclusion that within the apprehension of
balance there must be two components, the experience of the
balance itself and a value component; traditional theory
would call it beauty and seek an account of it in terms of a
feeling of approbation, an unanalyzable quality, or some
other construction of aesthetic axiology. There is, fortu-
nately, another way to understand the business.

In the *Lectures and Conversations* Wittgenstein says that
adjectives of aesthetic evaluation such as 'beautiful' don't
have as much currency in aesthetic discussion as we are
inclined to suppose and suggests that we look instead at the
role of words such as 'right' and 'correct' or even the practice
of an artist who arranges and rearranges his materials and
then at a certain point simply leaves things as they are. He
imagines designing a door and saying 'Higher, higher,
higher, . . . oh, all right' (or '. . . *there*: thank God', or '. . .

[12] *Art and Visual Perception*, the new version (Berkeley, Los Angeles,
London: The University of California Press, 1971), p. 20.

yes, that's right') (p. 13). In the twenties Wittgenstein designed a house for his sister in Vienna. There is a story that when the house was very nearly complete he became dissatisfied with the proportions of one room and had the ceiling torn out and raised by three centimeters.[13] It would have been in order to remark the reconconstruction with 'Now it's right', or, more simply 'Now'.

Merely to substitute for beauty or some other generalized notion of aesthetic value the idea of rightness would mark no advance because we would still have to offer an account of the rightness of a design as something in addition to its proportions or balance. The question, however, can appear in a different light if we turn our attention away from the words themselves to the circumstances of their use, circumstances such as Wittgenstein with his door or ceiling. The salient feature of these circumstances is that the artist brings his manipulation of materials to a halt. He need utter no words although his cessation may be accompanied by a characteristic smile or gesture of satisfaction. The words 'Now it's right' or 'leave it alone' convey nothing that isn't already there in the situation.

What I have said about this so far is altogether consistent with a noncognitivist theory of aesthetic value and it might be thought that Wittgenstein is doing no more than offering some version of emotivism. It is a mistake, however, to understand him in this way. Both the completion and apprehension of an artistic design are frequently accompanied by a strong emotional satisfaction and this is exactly what we should expect; aesthetics, after all, is not a matter of indifference. We should not, of course, forget those other times when things go wrong and our reactions are decidedly nega-

[13] Hermine Wittgenstein, 'My Brother Ludwig', in Bernard Leitner, *The Architecture of Ludwig Wittgenstein* (New York: New York University Press, 1976), p. 21. This essay has been reprinted in *Ludwig Wittgenstein: Personal Recollections*, ed. Rush Rhees (Totowa, NJ: Rowman and Littlefield, 1981).

tive. But these reactions are connected to their objects in interesting ways. Our satisfaction or dissatisfaction with the proportions of the door is not simply a causal reaction to those proportions in the way that a stomach-ache is a causal reaction to something one ate. Wittgenstein speaks of our feelings as 'directed' to the object (*Lectures and Conversations*, p. 14) and means by this something very much like the now familiar grammatical point that emotions have 'objects' and not just causes. There is a conceptual connection between our dissatisfaction with the proportions of the door and what we are prepared to say about it and to do about it. The designer can say that it is not high enough and then can set about raising it until it is 'right'. Any aesthetically relevant emotional response is conceptually dependent upon seeing that the proportions are right (or wrong) and that the elements of the design are balanced (or fail to balance one another).

An important aesthetic use of words such as 'right' and 'correct' has now been identified and its connection with uses of 'to see' made clear: the description of the proportions as right or the composition as balanced is based upon seeing them that way. Just as there are uses of 'to see', experiences of seeing, where it is a matter of seeing likenesses, aspects of ambiguous figures, and aspects of organization, so there are experiences of aspects of organization in which the organization is seen as aesthetically right. Like any other language-game, use of language, this one is to be duly noted and any further demand for justification or grounding to be rejected.

This chapter began with a reminder of the importance of perception for aesthetics and, of course, art. That perception is thus important is generally acknowledged and certainly doesn't need arguing for. What does want investigation, and perhaps argument, is the nature of that aesthetic perception and the ways in which it is important in our commerce with art. By an exposition of and extrapolation from Wittgenstein's views about perception I have tried to indicate the complexity of the phenomena and conceptual relations involved and to show the application of some of it to some

facets of aesthetic and artistic appreciation and understanding. Wittgenstein's way of dealing with this material disposes of a number of problems that have exercised philosophers of art and also reinforces the suspicion that the search for a general theory of art rests upon a confusion. In the next chapter I want to extend Wittgenstein's investigations to the aesthetic character of poetry and other kinds of aesthetic quality including emotional expressiveness.

Aesthetics and the Secondary Sense of Words

Toward the end of his discussion of aspect perception Witt-genstein introduces the notion of 'aspect-blindness' and entertains the possibility of aspect-blind people who are unable to see aspects, changes of aspect, or experience the dawning of aspects. There are, of course, people who are unable to see some particular aspect on a particular occasion and can't find the face in the puzzle picture or pick up on the visual organization of a painting. And there are certainly people who tend on the whole to be indifferent to such things just as there are people who lack a musical ear. Wittgenstein however, is not concerned with these occasional lapses and deficiencies, but with the most general case of total blindness to all aspects. Wittgenstein never provides a definitive account of absolute aspect-blindness and in a number of possible cases leaves open exactly what it is the aspect-blind man can or cannot do. This lack of a definitive account should not be construed as the result of any failure on Witt-genstein's part, but rather as the result both of the complexity and inherent vagueness of our concepts of perception that may render any complete account impossible, not to mention the lack of point in cataloguing every detail when nothing philosophical is served by doing so:

Whatever final description, if any, of aspect-blindness may emerge, Wittgenstein points out that the importance of the concept lies in the connection between the notions of aspect perception and what he calls 'experiencing the meaning of a

word'. We want to ask, he says, 'What would you be missing if you did not *experience* the meaning of a word?' (*Investigations* p. 214e). Experiencing the meaning of a word has some analogy with experiencing an aspect and the person who cannot experience the meaning of a word can be called, analogously, meaning-blind.[1] Wittgenstein is explicit that he is not interested in the details of meaning-blindness, in the forms of mental defects found among men, but rather in the concept of such a defect and how it is to be worked out (*Zettel,* §183). He does not work out the concept and I am not at all sure how it ought to be worked out nor how deeply into the fabric of our language and life the experience of meaning is woven.[2] It is enough here to try to work out some of its implications for aesthetics.

In the light of all the things he said about meaning in part I of the *Investigations* Wittgenstein's sudden injection of the idea of *experiencing* meaning in part II has to come with a jar. He has been at great pains to insist that meaning is not something mental, that it is not anything like a mental image, feeling, or experience to which a word must refer or which must accompany the speaking or hearing of a word. In the first part of the *Investigations* Wittgenstein connects the notion of meaning with that of use so that to give the meaning of a word is to describe its use in the language. Meaning, therefore, cannot intelligibly be thought of as an experience; the use of a word, its role in language and life, is neither an experience nor a conceivable object of experience. We must eventually get the relation between these earlier strictures about meaning and the later reference to experiencing the meaning in perspective. But first we must look at some of the

[1] Wittgenstein uses this term in *Zettel* and *Remarks on the Philosophy of Psychology*, although not in the *Investigations*.

[2] In an earlier article, 'Seeing and Meaning', *The Southern Journal of Philosophy* 17 (1976) pp. 523–33, I tried to work out the concept, but made some serious mistakes in doing so. I am indebted to Thomas Mayberry for pointing some of them out to me.

examples of experiencing meaning that Wittgenstein gives us.

The meaning of a word that has more than one meaning, e.g. 'bank', is usually fixed on a particular occasion by the context in which it occurs. But the word can also be pronounced in isolation with a particular meaning. The meaning-blind man presumably would not understand what it is like to do this. A word can be pronounced a number of times in rapid succession and seem to lose all its meaning and turn into merely a curious noise. We may assume the meaning-blind man would experience no sense of loss or estrangement; it is all the same to him. A familiar word is given a new meaning as part of a code and although we understand the word in its new sense, it still sounds strange and hasn't yet 'taken on' its new meaning for us. When we read a poem, say, with feeling, a word can seem completely filled with its meaning. Wittgenstein suggests that even the way a word is spelled can make a difference here. Lionel Trilling has insightfully called attention to the fact that Blake's 'Tyger is surely more interesting than a tiger . . . [the *y*] suggests a longer-held sound and therefore supports the idea of an animal even fiercer than the tiger.' On the other hand, the very spelling and pronunciation of the name of Edward Bear's friend Tigger 'wipes out all possibility of the creature's being dangerous'.[3]

In anticipation of the later inquiry of *Investigations* part II Wittgenstein speaks of the 'soul' of words, and imagines a language in which this spiritual side of words plays no part and in which a word may be replaced by a synonym indifferently or one sentence by another with the same meaning (*Investigations*, §§530ff.). The condition of such a language is perhaps approximated when we begin to learn a foreign one and reach the point that, armed with a grammar and a lexicon, we can begin to construct syntactically correct

[3] *The Experience of Literature* (New York: Holt, Rinehart and Winston, 1967), p. 46.

sentences although we have as yet no sense of the flavor of particular words or the appropriateness of expressions to occasions and don't know whether our words will sound vulgar or acceptable or possibly old fashioned or even literary.

It is this soul that words can manifest that sometimes seems to be the very essence of poetry. It is a commonplace in the teaching of poetry that ostensible synonyms cannot be substituted for one another indifferently. A. C. Bradley makes the point nicely with Byron's lines:

> 'Bring forth the horse!' The horse was brought:
> In truth he was a noble steed![4]

'Horse' and 'steed' ordinarily would be taken to have roughly the same meaning, but the fact that they cannot be exchanged for one another in the context of Byron's verse without loss of poetic character leads Bradley to conclude that they do not have the same meaning.

There is surely something right about Bradley's conclusion, but at the same time something puzzling. We are tempted to suppose that there must be two kinds of meaning, a supposition entertained by Wittgenstein when he says:

> We speak of understanding a sentence in the sense in which it can be replaced by another which says the same, but also in the sense in which it cannot be replaced by any other. (Any more than one musical theme can be replaced by another.) (*Investigations*, §531)

A common move at one time was to distinguish between referential meaning and emotive meaning and to understand literary theorists such as Bradley to be concerned merely with the congeries of associations and feelings aroused in us

[4] 'Poetry for Poetry's Sake', in *Oxford Lectures on Poetry* (London: Macmillan, 1950), pp. 19–20.

by the word 'steed', a move made explicitly against Bradley by I. A. Richards.[5] In the following section, however, Wittgenstein retreats from the supposition that 'understanding' has more than one sense or meaning, but he is not yet ready to resolve the matter with a fuller account

The reference to music seems only to add to the puzzle. Wittgenstein makes use of analogies between sentences and music throughout his work from the *Tractatus* on. In the *Brown Book* he puts it this way:

> What we call 'understanding a sentence' has, in many cases, much greater similarity to understanding a musical theme than we might be inclined to think. But I don't mean that understanding a musical theme is more like the picture which one tends to make oneself of understanding a sentence; but rather this picture is wrong . . . For understanding a sentence, we may say, points to a reality outside the sentence. Whereas one might say 'understanding a sentence means getting hold of its content; and the content of the sentence is *in* the sentence.' (*Blue and Brown Books*, p. 167)

The corresponding passage in the *Investigations* adds this:

> Why is just this the pattern of variation in loudness and tempo? One would like to say 'Because I know what it is all about.' But what is it all about? I should not be able to say. (§527)

The picture that we have of understanding a sentence is that of being able to correlate the words with something outside the words, their referents or denotata, that is supposed to be their meaning. This is essentially the *Tractatus* picture of languages and it is one that Wittgenstein came, of course, to reject. But even if we accept the later identification of meaning with use, we seem driven to a picture of meaning as

[5] *Principles of Literary Criticism* (New York: Harcourt, Brace, 1925), pp. 273–4.

something standing to one side of language. This is the picture the tool-box analogy of §11 might seem to force upon us: here the tool and there its use. Pictures aside, however, we can explain the meanings of our words and of the things we say and it has to appear philosophically untoward to encounter notions of meaning and understanding that resist any possible explanation. It is extraordinarily interesting that Bradley employs a similar musical analogy for he says that 'There is in music not sound on one side and a meaning on the other, but expressive sound, and if you ask what is the meaning you can only answer by pointing to the sounds . . .'[6] Is it an unsatisfactory sort of meaning that can only be explained by repeating what one has said?

We do, however, speak of understanding music, but such understanding doesn't consist in correlating the notes with something else or translating them into another 'language' – there isn't anything like that to be done – nor does it essentially involve explanations in anything like the way words and sentences can be explained. That a person understands a piece of music is shown, for example, in how he plays it, in his choosing the right tempo, in phrasing it in this way rather than that and so on. This is the person of whom we say that he knows what the music is all about. Clearly this kind of knowing what it is all about isn't so much a matter of being able to *say* as it is of being able to *play* and, we should add, on the side of the audience of being able to listen appreciatively and make appropriate comparisons with other pieces of music or other performances of the same piece. Speaking a sentence with understanding is like that too. It is not just that the sentence is uttered in circumstances appropriate to its ordinary use, but also that much is conveyed by the tone of voice and accompanying facial expressions and gestures that determine *how* the sentence is said. Peter Glenville relates how Sir Laurence Olivier would sometimes ask him for a *reading*, a way of interpreting or emphasizing lines, and how

[6] 'Poetry for Poetry's Sake', p. 15.

impressed he was by Olivier's concern for the possibility of different readings.[7] This sort of understanding shows up not only in the difference between good and bad acting or poetry reading, but also in the more prosaic contrast between the hesitance with which one pronounces an expression from the foreign language phrase book in the course of some transaction abroad with the confident way in which one ordinarily goes about asking directions or ordering dinner.

Our experience of the meaning of words, our feelings of familiarity with them, that they are filled with their meaning and wear their meaning like a face, is shown, Wittgenstein says, in the way we choose and value words (*Investigations*, p. 218e). Byron chose 'steed' in place of 'horse' and we agree he was right to do so; there is, after all, more packed into 'steed', more by way of brave deeds and gallant riders, then there is in 'horse', a word that dwells with plows and milk carts. So we have the hypothesis that one word can mean more than another. One can have reservations about that. Alice had reservations about Humpty-Dumpty's making a word mean a very great deal and we are inclined to sympathize with her reservations despite Humpty's willingness to compensate with extra pay. At first reading the exchange between Alice and Humpty-Dumpty presents us with another example of the delightful nonsense that characteristically surrounds that interesting child; surely no sense has been given to the idea of meaning as something that comes in quantities. This secondary sense of the word 'meaning', however, may open a way to vindicating Humpty-Dumpty although more than likely he would not countenance it himself.

Words, it should be pointed out, are not the only objects to which such experiences attach. It is also like that with so many of the things we think of as symbols in our lives, the

[7] Logan Gourlay, *Olivier* (London: Weidenfeld and Nicolson, 1973), p. 97. I am indebted to Robert Herbert for calling my attention to Glenville's remarks.

flag, a monument, an historical figure can all be understood as filled with meaning. Laura's pitiful little broken glass unicorn in *The Glass Menagerie* sums up and embodies all the illusions and disillusions of Williams' characters, and a gothic cathedral may contain for us the entire Middle Ages. This sort of thing doubtless results from a host of connections and associations, but there are times when all of these can come together into a single image and we find the thing itself to have meaning and to be filled with its meaning.

The puzzling feature in all this is not the existence of such experience themselves, but the fact that we describe them as experiences of *meaning*. Why should we describe them that way, especially when it seems to conflict with our ordinary understanding of what meaning is? Wittgenstein responds to that question in this way:

> It is the phenomenon which is characteristic of this language-game that in *this* situation we use this expression: we say we pronounced the word with *this* meaning and take this expression over from that other language-game. (*Investigations*, p. 216e)

The first of the two language-games referred to is that in which we speak of experiencing the meaning of a word, and the other is the more ordinary one in which we talk of explaining the meaning of a word. It is in connection with this that Wittgenstein introduces a distinction between a primary and a secondary sense of a word. The primary sense of the word 'meaning' shows up in ordinary explanations and definitions of the meaning of a word as when we say that 'horse' means a certain kind of animal, the sort of definition that might have been supplied by boy number ten. Dictionaries resort to a number of devices such as citing synonyms, examples, and literary quotations in order to explain what a word means so as to fix its use in the language and make clear the post at which it is stationed. When we speak of experiencing the meaning of a word we 'take over',

as it were, the word 'meaning' from that primary language-game and use it in a different language-game where it is applied to rather different kinds of things.

Wittgenstein gives us two other examples of secondary senses right away. 'Given the two ideas "fat" and "lean", would you be rather inclined to say that Wednesday was fat and Tuesday lean, or the other way around? I incline to choose the former', and 'For me the vowel *e* is yellow' (ibid.). This pair of examples has had, I believe, as unfortunate an influence on the discussion of secondary sense as undue attention to the duck-rabbit has had on the discussion of the wider implications of seeing-as. The examples are curiously idiosyncratic and many people make no contact with describing the days of the week or the vowels in that way. Consequently there has been a tendency to dismiss the whole business of secondary sense as no more than a curious phenomenon or idiosyncratic aberration of no philosophical significance. This has led to the overlooking of examples offered in other places that are clearly examples of the secondary use of words and that are not at all idiosyncratic. (In addition to their secondary senses I shall sometimes speak of words having secondary uses or as figuring in secondary descriptions). That words have secondary senses, I wish to argue, is of great importance for aesthetics and the philosophy of art. To make clear what this importance is it will first be helpful to identify and discuss seven important features of words used in a secondary sense.

(1) When a word is used with a secondary sense in a description the thing it describes may be altogether different from what the word usually describes. The object described may seem logically inappropriate, of the wrong category, for the subject of the description. The days of the week, for example, are not the sort of thing we think of as being either fat, lean, or of any girth whatever nor are the vowels the sort of thing to have color at all. In the light of this, if one finds himself inclined to offer or accept such descriptions, a typi-

cally philosophical problem arises that can be stated this way: the description is fitting, but it is also logically aberrant. The description, therefore, cannot mean what it appears to mean and a theory must be constructed to explain the apparently aberrant use by showing it as really a special case of its ordinary use (and thereby explaining away secondary sense). This way of dealing with the matter is, I am convinced, mistaken and this pattern of argument has wrought much mischief in the philosophy of art as the rest of the chapter will try to show.

(2) When a word is used with a secondary sense it does not change its meaning. 'Asked "What do you mean here by 'fat' and 'lean'?" – I could only explain the meanings in the usual way. I could *not* point to the examples of Tuesday and Wednesday' (Wittgenstein, ibid.). This is why Wittgenstein rejects the hypothesis that 'understanding' has two different meanings when it is a matter of the two different ways a sentence can be understood. When we say that understanding a sentence is like understanding a musical theme we are using a secondary sense of 'understanding', a use, we must note, that is not at all idiosyncratic. This also gives us reason to be suspicious of the demand that we must distinguish different meanings of 'meanings', e.g. referential and emotive, each with its own criteria of application, in order to get a theory of poetry.

(3) Such phenomena as finding Wednesday fat may be traceable to psychological causes or perhaps childhood associations. Here one thinks naturally of *les jours gras et maigre*. Wittgenstein characteristically, and correctly, sets aside any causal inquiry as philosophically irrelevant. It seems implausible to suppose that our talk of understanding music or finding a word full of its meaning is traceable to associations and, furthermore, that the unearthing of causes cannot illuminate the use of words in a secondary sense nor can it explain the fittingness and aptness that so many secondary

descriptions have. I, too, agree with Wittgenstein that Wednesday is fat and Tuesday lean, but I do not have to share his associations, whatever they may have happened to be, either in order to understand him or to agree with him.

(4) It may be thought that to use a word in a secondary sense is really to use it as a metaphor. This is an example of an attempt to explain away and deny any independent status to the notion of a secondary sense. Wittgenstein denies that secondary senses can be explained away as metaphors when he says of the expression '*e* is yellow' that 'I could not express what I want to say in any other way . . .' The implication seems to be that metaphors can be paraphrased while secondary uses cannot. There is a certain vagueness in the notion of a metaphor that may suggest it is necessary to advance a theory of metaphor or at least rehearse the various theories and controversy surrounding the figure before any such implications can be verified. Fortunately we do not need to do this to sort out what is going on. Despite warnings about the heresy of paraphrase we can paraphrase metaphors in order to explain them and to help someone see their point. Cleanth Brooks, for one, does a good job of this with respect to such lines of Donne's as 'We're Tapers too, and at our own cost die . . .'[8] The purpose of such paraphrases is generally not to go as substitutes of the original expressions, but to help others to see the point of and to appreciate the originals. Paraphrasing can be much like helping someone to see visual aspects by tracing out the face in the puzzle picture or the ears of the rabbit in the ambiguous figure. With an expression such as '*e* is yellow', however, paraphrases and explanations can find no place.

The assumption that lies behind the attempt to explain away secondary uses as metaphors is doubtless that metaphor depends upon the apprehension of likenesses, similarities, or

[8] 'The Language of Paradox', in *The Well Wrought Urn* (New York: Harcourt, Brace, 1947).

analogies of one sort or another. I have long been inclined to believe that the distinction between metaphor and simile is a purely surface one and that nothing much but the scansion turns on whether we say the sun is a frying egg on the blue Teflon of the evening sky or only that it is like a frying egg. Both figures trade equally upon a genuine likeness between two yellow-orange circles against a blue background. But not every metaphor lends itself to this treatment. Romeo says that Juliet is the sun. In another possible literary world he may have said that she is *like* the sun; it makes no difference. To someone who did not understand what Romeo is saying we could explain that Juliet is like the sun in that she illuminates Romeo's world, that she is the focus about which all his concerns now revolve, and so on. This explanation, however, is importantly different from that of the frying egg figure. The key terms 'illuminate', 'focus', etc. in this context are themselves metaphors for which we can demand explanation by way of exhibiting additional similarities.

If a theory to explain metaphor in terms of similarities is to be carried through consistently a problem must be faced. The similarities that the theory relies on to explain and justify the metaphorical use of words must be identified and located independently of any description of them by means of the words they are to explain. Wittgenstein said that what is perceived in the dawning of an aspect is not a property of the object, but an internal relation between it and other objects. The secondary use of words in this respect bears some analogy to aspect descriptions. The words whose secondary senses we have been examing obviously do not denote properties of their objects, but neither do they denote similarities or likenesses whose existence can be established independently of the secondary descriptions. Let us not deny that Juliet and the sun have something in common; they both have the power to attract – and no matter that we impute properties to the sun that may have been recognized neither in Romeo's nor Shakespeare's cosmology. Now there is the task of explaining how the allure of a maidenhead is like the

gravitational field surrounding a star. It's no good repeating that they both attract for that was the very description that wanted explaining. This may be the point at which the stock of likenesses runs out. If we assume, however, that Romeo's trope depended from the beginning upon using words with secondary senses, then there need be no demand that we rummage for similarities. It is my suggestion, then, that many metaphors turn out to be really secondary uses and, surprisingly, it is in terms of secondary sense that we often must explain metaphor and not the other way around.

(5) The foregoing leads to the next point that there need be nothing in common between what a word ordinarily denotes or describes in its primary sense and what it is used of in its secondary sense, and further suggests that the usual sort of reasons and criteria that govern the application of a word do not work to explain its transference to a new range of things.

In the *Brown Book* Wittgenstein presents the following example of what I take to be a secondary use of words:

> A man holds a weight with out-stretched arm; his arm, his whole body is in a state of tension. We let him put down the weight, the tension relaxes. A man runs, then rests. He thinks hard about the solution of a problem in Euclid, then finds it, and relaxes. He tries to remember a name, and relaxes on finding it. (*Blue and Brown Books*, p. 129)

Why should we talk of tension and relaxation in connection with proving a theorem as we do when muscles struggle against physical forces? Our immediate philosophical inclination is to ask what those various cases have in common that makes us describe them as cases of strain and relaxation and Wittgenstein notes the strong temptation to insist that 'Surely a similarity must strike us, or we shouldn't be moved to use the same word' (ibid., p. 130). Wittgenstein refuses to yield to this temptation and concludes that there is no necessity for there to be common properties or for one to be struck

by a similarity in order to use the same word of different things. Indeed, in some instances no sense can be made of talk about similarities. Wittgenstein's strategy in this is to exhibit a number of examples where it makes good sense to speak of different things having something in common and then to contrast these with others in which there is no sense in speaking of common properties. We can say that the fire engine, the traffic light, and the apple all have something in common in that they are all red, but to the question of what the property is that two shades of red have in common that makes us call them both red there is nothing to be answered. The only possible response to the question is to repeat the original description: They are both red, or: Don't you see? This response is not the report of seeing a likeness (although if someone insisted on putting it that way, it could perhaps be described as a limiting or degenerate case).

When we describe two shades as both red we are not dealing with any secondary sense of the word 'red'. One cannot teach, for one thing, the use of a word by beginning with its secondary applications; we would not undertake to teach a child the meaning of 'red' by reference to the vowels, but any one within a certain range of shades will do just as well as any other in teaching a color word. Although this example is not of a secondary use, it is nevertheless useful in helping to break the hold on us of the assumption that there must always be something in common, something that makes us use the same word of different things, and the corresponding notion that we must be struck by the similarity in order to use the same word.

In *Tractatus* 2.0123 Wittgenstein says that to know an object is to know all its possible occurrences in states of affairs. Each object has, as it were, an ontological valence that determines the possibilities of its combination with other objects to form states of affairs. Since *Tractatus* sentences are pictures of states of affairs in which names go proxy for objects, an implication of the *Tractatus* is that each name (word) must have a corresponding logical valence that deter-

mines the possibilities of its combination with other names to form sentences. It follows, therefore, that to understand a word is to know all its possible occurrences in sentences. It is precisely this view of words and how they work that is denied by the admission that words can have secondary senses. The possible secondary applications of words cannot be determined beforehand from a knowledge of their primary senses. There are, therefore, more things in language than are dreamt of in most philosophies.

(6) The ability to use a word in a secondary sense depends upon understanding how to use the word in its primary sense. In this respect secondary senses are analogous to aspect perception in that the substratum of the experience of perceiving an aspect is the mastery of the appropriate language. Just as the intelligibility of the report that someone has seen the duck aspect of the duck-rabbit figure depends upon his knowing how to use the word 'duck' in more ordinary circumstances, so the intelligibility of describing Wednesday as fat or *e* as yellow depends upon 'fat' and 'yellow' having primary senses that are already familiar to us.

(7) There are no criteria that justify the application of words used in their secondary senses to their new objects. If words in their secondary use do not change meaning and if there need be nothing in common between the objects of their primary and their secondary applications, then it clearly follows that there are no criteria for the secondary use of words. There are no explanations, no reason, for using words so: there is nothing about the days of the week that justifies our talking about them as we talk of fat and thin people. This point, however, can be easily misunderstood. I can imagine myself giving a reason for saying that Wednesday is fat: I see it sitting squarely in the middle of the week and squeezing Tuesday and Thursday in between Monday and Friday. This 'reason', obviously, depends upon using other words in secondary senses and this is the result of transferring, as it

were, an entire package of language from its usual domain to another. The words within that package keep their familiar connections, e.g. 'fat' goes with 'squeezing out' one's neighbors, and so on. Within the secondary usage it may be possible to make room for reasons and even criteria although the role of reasons in these matters is rather variable. I may simply say that Wednesday is fat without the inclination to surround it with any such picture as I just sketched or call *e* yellow without wanting to tell any story at all about the vowels.

Secondary uses may be appropriately said to form a kind of continuum with colored vowels at one end and some rather sophisticated descriptions of musical passages at the other. Tinting the vowels is truly idiosyncratic, but then nothing depends upon whether we find *e* yellow or some other color or whether we express incomprehension at the very idea. For aesthetic descriptions, by contrast, we often demand reasons and explanation and here much more can generally be said, but then something does depend upon finding a piece of music sad, triumphant, building toward a dramatic climax, or the like. These descriptions are connected with how we hear and understand the music, how we perform the music, and even whether we are to allow music to enter our lives. I shall return to these matters.

While it is true that frequently no reasons can be given for a secondary description, even within the context of secondary usage, the point I want to insist upon is that it is the transference of the language, whether a single word or an entire package, to the new secondary domain for which there are no criteria and for which there can be no justification.

Wittgenstein speaks of the importance of *inclination* as responsible for our use of words in secondary senses. In the absence of justifying criteria it may seem that the appeal to inclination is either an attempt to offer an alternative explanation to criteria or to disguise the lack of an explanation; it is neither. He is merely calling attention to the existence of a

precinct of our language where a demand for criteria and the giving of reasons can be out of order.

It will surely seem to many that such an apparently unregulated use of language is inadmissible – in two senses of that word. It may not be admitted that there is such a thing as a secondary sense (except perhaps as a linguistic freak) and should anyone propose such a use it ought not be admitted into the language (unless as an act of charity it be given an obscure corner where it can do no harm). The only appropriate response to these misgivings is to reaffirm that there is indeed this use of language and that it plays a larger and more important role in our lives than some may want to believe, and then to ease the misgivings and defuse some possible objections.

In the first place, although the secondary use of words is unregulated to the extent that there are no justifying criteria, their use is not therefore hopelessly chaotic. The secondary use is logically dependent on an understanding of the primary, and the aptness of the secondary use derives from that along with the fact that a word can retain its usual connections with other words also used secondarily. Our inclinations needn't always run off in just any direction. In the second place, the secondary use of words will naturally appear wayward if it is seen against a background of uses which are taken as paradigmatic of what language is supposed to be all about. It is worth reminding ourselves that the everyday and often pedestrian uses of words that underwrite secondary uses are not always so neatly regulated as some philosophical models of language would have it. With the right shift in perspective it can appear as a remarkable, and even disturbing, fact that parts of our language can approximate to a calculus (are we who use language that way, then, like robots or talking computers?) Finally there may be a confusion between the justification of some particular description and the justification of an entire way of using language, that is, a language-game. Ordinary descriptions, the kind many would think of as proper, are frequently

justified in terms of the facts of the situation and criteria of meaning; that, of course, need not be true of secondary descriptions. In other words, there is a language-game(s) in which all such things as criteria, reasons, and verification play a role. It does not follow, however, that this language-game is justified or that whether this is the correct way to use language is subject to verification.

We can get a better view of this matter by considering an interesting passage from René Etiemble's investigation of the curious associations and imagery of Rimbaud's sonnet 'Voyelles' which paints *A* black and buzzing with flies. Etiemble can find nothing in Rimbaud's history to explain these connections and rejects all proffered explanations such as the pseudo-phenomenon of synaesthesia as inadequate.

> Why 'flies', 'tents', 'lips', 'bugles'? Because the poet has seen them. Why has he seen them? Because he is a poet. It is unfortunate that literary critics, vexed by their own sterility, try to suppress this *vision* which obeys neither the laws of 'literary history' nor those of 'source criticism'. This original symbolism, which is impossible to reconstruct, to formulate in an equation, must be accepted, submitted to.[9]

What cannot be explained but must be accepted and submitted to is that words have secondary senses and that it is poets who have the knack for so using them. Etiemble's remarks open up two possibilities. The first is that we must be content with merely accepting the poet's use of language because we are unable to explain it. This naturally suggests that there is something to be explained and, since we cannot explain it, something that must remain a mystery. The second is that explanations are logically inappropriate and there is nothing but the acceptance of the fact of poetic language. It is this second option that is Wittgenstein's for it is one of his main contentions that philosophy can only describe a language and

[9] *Le Sonnet des Voyelles* (Paris: Editions Gallimard, 1968), p. 221. My translation.

can give it no foundations. A language-game cannot itself be justified; its existence can only be noted and it can be described and its relation to other language-games mapped. So we can note the existence of another language-game(s) in which criteria, reasons and verification either play no role or interestingly modified ones. This language-game has no less justification than that other one, but no more either.

These reflections on meaning and secondary senses should allow us to answer two questions that have much exercised philosophers of art in recent years. The first is about the emotional expressiveness of art, in particular how we can experience and describe works of art as we do the emotional and motivational life of human beings. The second is whether there are criteria for the application of aesthetic descriptions. There are three familiar and obvious assumptions that have marked the boundary of the venue on which the first of these questions has been debated. In the first place, emotions belong only to human beings (or, at most, to some range of sentient beings) and consequently, cannot characterize inanimate objects such as works of art. In the second place, words that name and describe emotions can have meaning only by denoting the affective states of people or, by paronymous extension, their faces, gestures, and situations. Finally, we do find emotional character in art and describe works of art by means of the language of emotion. Since that last seems inconsistent with the other two assumptions, the philosophical problem has been understood to be one of trying to avoid the apparent contradictions.

Traditionally there have been two kinds of philosophical theories that have had a go at this. One kind proceeds by denying the third assumption and claims that the apparent reference to the emotional character of a work of art is really a disguised reference to the emotion of either the artist or his audience. The second species of theory insists that art really does have emotional character and, since it accepts the other two assumptions, is forced to devise some quasi-psychological mechanism or other to explain how people's

feelings get embodied in, empathically projected into, or somehow 'fused' with, works of art. All of this has been criticized many times and in great detail; it requires no further comment.

The question was given quite a different turn by O. K. Bouwsma[10] who suggested that the problem had been misconstrued, that it arises because philosophers have much too narrow a view of the workings of language, and that it is simply false that the only legitimate use of the language of emotion is to refer to the affective states of people. Bouwsma introduced the philosophy of art to the power of Wittgenstein's insight that words play many different roles in language and that philosophical problems are a consequence of not keeping this in mind. Bouwsma diagnoses the problem as the result of trying to understand a sentence such as 'The music is sad' on the model of 'Cassie is sad' when Cassie has just heard the bad news about her beloved cat and bursts into tears. With Cassie as the model, the music surely does seem to be of the wrong category to be a subject of sadness despite the fact that we do hear the sadness in the music; this puzzles us. Bouwsma says that 'The puzzling is relieved by discerning the similarity between the offending use and some other use or uses' (p. 33). His strategy for discerning the similarity is to offer a series of additional sentences of the form '. . . is sad' to close the conceptual gap between the description of Cassie and the description of the music. He offers the following examples:

1 Cassie is sad. (She got the news about her cat.)
2 Cassie's cousin is sad. (Disappointed in love, she lived out the rest of her maiden life with neither tears nor voiced regrets.)
3 Cassie is sad reading the book. (She sheds tears over the

[10] 'The Expression Theory of Art', in *Philosophical Essays* (Lincoln: University of Nebraska Press, 1965). The article was originally published in 1950.

fate of the characters, all the while munching popcorn and petting the cat.)

4 Cassie's reading is sad. (Now the mature actress, she reads with controlled expression.)

5 Cassie's dog is sad. (He mopes while his mistress is away.)

6 The book is sad. (It is Dostoevsky's passage about Alyosha and the boys.)

7 Cassie's face is sad. (A permanent character trait.)

8 The music is sad.

It is doubtful whether these are in fact all examples of different uses of 'sad'. I do not believe that Bouwsma has properly captured Wittgenstein's notion of use and hence has failed to make the necessary distinction between different *uses* of a word and the different *things* to which the word may apply under one of those uses. We have been shown how the word 'game' can apply to a wide variety of activities linked only by the over-lapping strands of similarities characteristic of a family resemblance, but we have not thereby been shown different uses of the word. Both chess and football can be called games without any reason to suppose the word is being used differently. To say, however, that a boy played a game of football and then made a game of his chores is undoubtedly to use the word differently. The former describes the *kind* of activity he was engaged in while the latter describes the spirit in which the activity was under-taken. The connections between the two are, of course obvious: that spirit is characteristic of the way games are often played, and so on. I don't think that (1) and (5) need be thought of as different uses although there are some things that we can go on to say about a sad Cassie that we cannot go on to say about a sad dog. (1) and (2), on the other hand, may well be different uses; (1) characterizes a rather brief episode in someone's life while (2) refers to a permanent character or even to an entire life.

Bouwsma's strategy, interestingly enough, does not really

require him to show how the use of one of his sentences is like that of another; what he is really about is to show the likeness (as well as differences) between the *people* and *circumstances* described by his sentences. Thus we are shown how the situations of Cassie and her cousin are alike – there is the bad news, the want of a beloved, perhaps loss of appetite, and so on – and how they are different – tears here but not there, and so on. The sadness of the Alyosha passage has connections with Cassie and her cousin for all share a range of human relationships and concerns, loves, hopes, and losses, despite the one being only a story about these things.

Bouwsma contends that 'The music is sad' is to be understood in terms of its resemblances to (4), (6), and (7) rather than by any more direct connections to the other sentences. And here the difficulty in his thesis begins to emerge. We understand 'The book is sad' in part because it leads us into the same web of human concerns that includes Cassie, her cousin, and even, by extension, her dog. Why, however, should we speak of her face or, especially, her reading as sad? The reading, after all, is not really like the speech of someone overcome with sadness for the reading is calm and controlled. There are, to be sure, certain similarities between the music and the reading. The passage can be read with or without feeling just as the music can be played with or without feeling and in neither case is there anything that can be identified as the feeling apart from the reading or the playing. Bouwsma succeeds in giving us only differences between this set of examples and the others, e.g. no sobs, no tears, no loss of a beloved. When we want the similarities laid out for us so we can understand these to be instances of sadness along with the others, Bouwsma does not oblige, but instead instructs us, in seemingly enigmatic fashion, 'Look and you will see' (ibid., p. 32). There appears to be a failure in Bouwsma's strategy at this point. There is good reason for this appearance that can be understood more clearly after an examination of one or two other theories that have something in common with what Bouwsma was doing.

The recent tendency in explaining the emotional expressiveness of art has been to eschew questionable psychological mechanisms in favor of likenesses and similarities that are to be found between works of art and relevant aspects of human beings. Richard Wollheim, for example, says that

> When we endow a natural object or an artifact with expressive meaning, we tend to see it corporally: that is, we tend to credit it with a particular look which bears a marked analogy to some look that the human body wears . . .[11]

Wollheim's suggestion that there are analogies and likenesses between the facial expressions, gestures, postures, etc. of people, on the one side, and other things, including works of art, does seem to be true in at least some instances. The headlamps and radiator grille of some cars seen head on make a face with a quite definite, usually surly, expression and the configuration of a weeping willow can remind us of the drooping posture of dejection. A few strokes of a cartoonist's pen could quickly anthropomorphize the picture of the tree into the very image of dejection.

Similar things are, of course, true of much visual art. In Carlo Crivelli's *Crucifixion* in the Chicago Art Institute the atmosphere of despair and suffering is in part the result of the contours of the background rocks and trees duplicating the contorted contours of the body of the angonizing Christ. This kind of an account, however, won't do for all cases of expression. It won't do, for example, as an explanation of the emotional character of color. Colors and their relations can be strong or weak, violent or serene, but it is incoherent to look for some sort of congruence between, say, a violent gesture and the violent clash of discordant hues. Something else will have to be said about all that.

What Wollheim says is reminiscent of Langer's contention that there is an analogy between musical tones and emotive

[11] *Art and its Objects* (New York: Harper & Row, 1968), p. 28.

life although he would not have to agree with Langer's stronger claim that music is isomorphic with human feeling. Indeed, it is difficult to see how anyone could agree with a thesis which, in the absence of any correlating function that isn't hopelessly metaphorical, lacks a clear sense. Wollheim's view is also consistent with Carroll C. Pratt's remark that *'Music sounds the way emotions feel'.*[11] The remark seems to offer an obvious invitation to ask two questions: How does music sound? and How do emotions feel? It goes without saying that there are contexts in which it is appropriate to describe music as sounding grief stricken, joyous, triumphant, and the like, but it is not at all clear whether it is intelligible to talk about how *emotions* feel. We would do better to ask how *people* feel and answer by ticking off 'sometimes grief stricken', 'sometimes joyous', and all the rest. What this succeeds in showing, however, is only that some of the same vocabulary finds its way into both descriptions of music and descriptions of people and not that there are any analogies or similarities to justify it.

In a recent book Peter Kivy[13] has offered what is doubtless the most detailed and clearly presented essay in the exploitation of resemblances between man and music to explain musical expressiveness. Kivy's work is significant in that not only does he set out to explain how music can have emotional character, but also to show the importance of expressive character for the understanding and appreciation of music and, as well, in a very interesting fashion trace the antecedents of his view in seventeenth and eighteenth century musical thought.

According to Kivy musical expressiveness can arise in three different ways. A single melodic line can resemble human speech and its changes in pitch, tempo, and the like replicate the changes in the human voice which make it a

[12] 'The Design of Music', *Journal of Aesthetics and Art Criticism*, 13 (1954), p. 291.

[13] *The Corded Shell* (Princeton: Princeton University Press, 1980).

major vehicle of human expression. At one point in Bach's *St Matthew Passion*, for example, the music is said to sound quite literally like a cry. This account is not, however, sufficient to explain expressiveness in more complex polyphonic forms. Here we must invoke resemblances to human posture, gesture, and a range of action and behavior in addition to the voice alone: '. . . we hear [some complex musical line] expressive of sadness, because we hear it as a musical resemblance of the gesture and carriage appropriate to the expression of our sadness' (*The Corded Shell*, p. 53). For example, 'Don't we hear the melodic line droop in the oboe solo of the first Brandenburg?' (ibid., p. 55). A third way in which music can be expressive is through conventional practice and association. That the minor keys are expressive of the darker emotions Kivy believes is largely a convention of western musical culture. It is the convention of the major key and diatonic melody that is responsible for the (inappropriately) happy quality of Orfeo's *Che Faro*.

I want now to question whether in this way the philosophical problem about the expressiveness of music – and art generally – is solved. Despite the musical insightfulness of Kivy's analyses, I believe the philosophical problem remains untouched. From what was said earlier in this chapter the strategy of my objection should be apparent. When we hear a piece of music as expressive, not merely in the minimal sense of hearing the music as sounding like the human voice, but in the full range of expressive capabilities, we can explain and describe the characteristics of the music in terms of the vocabulary that describes the full range of human expressive potential. It is at this point, I believe, that Kivy gives away the case. Referring to that wider vocabulary he says, 'For we move here from the literal to the sinaesthetic and metaphorical.'[14] He goes on to point out that the criteria for

[14] *The Corded Shell*, p. 54. The word 'synaesthesia' here denotes no curious psychological phenomenon, but merely points out the fact that we describe music that we *hear* with the same vocabulary we use for peoples' movements, gestures, and the like that we *see*.

musical expressiveness are criteria that are parasitic on the public criteria of expression (ibid., p. 67). The public criteria of human expression are simply the things revealed in that full range of faces, gestures, postures, and the rest. The implication of this is straightforward. The similarities and resemblances that are to be found between music and people must be described by means of that very language that the resemblance is supposed to underwrite.

The situation with respect to music is exactly parallel to that encountered earlier in attempting to explain metaphors in terms of similarities when the similarities could not be specified except in terms of further metaphorical expressions that themselves want explaining. The musical descriptions, like the metaphors, exhibit all the marks of words used in secondary senses. If the application to music of the language of emotion is in fact a secondary use of that language, then the interesting consequence follows that the resemblance theory is not an answer to the philosophical question about how art can be expressive. It does not, and cannot, provide a general justification for our practice of finding music expressive.

This objection may strike some as a flagrant denial of the obvious in the face of the many convincing examples of musical expression that Kivy displays for us. But the philosophical problem, as that has traditionally been conceived, cannot be solved by any parade of examples. The examples show the language of emotion being used to describe music and compare it to human beings and show how particular descriptions can be explained and justified by reference to particular resemblances and comparisons. What philosophy has always tried to do, however, is to ground those descriptions in the nature of things by demonstrating that music shares properties with people that justify the common descriptions. The method of examples stands this on its head by arguing from the existence of common descriptions to common properties.

What Kivy has in fact done and done very well, in effect, is

to describe a language-game. What he has not done, and cannot do, is to justify or ground that language-game on properties identifiable independently of that language-game. My own suggestion, obviously, is that in musical and other forms of artistic expression we are frequently dealing with words used in secondary senses, with what is to all purposes a whole body of language taken over from its primary use in talking about people and applied to another range of things where the various likenesses that we cite as reasons or justifications for particular descriptions are identifiable only within the context of that secondary usage. I shall explain this point with an example when I come to discuss Kivy's treatment of the term 'stretto'.

We may now get a better understanding why Bouwsma's strategy of tracing similarities between people and situations appear to fail. It may be that there are no relevant similarities to be described; indeed, it becomes difficult to imagine what might count as a relevant similarity apart from our tendency to describe different things in the same way. This failure at the critical juncture can be explained if 'The reading is sad' and 'The music is sad' employ the word 'sad' in a secondary sense. If that is so, then there is no need to look for the connections required to justify the descriptions because there needn't be any such connection at all. Bouwsma's instruction to look and see can now appear in quite a different light. Instead of appearing enigmatic, it comes across as exactly the right one, only not for the reasons we are inclined to think. It is not an instruction to look for similarities, the only thing to do is to look or listen, and let yourself be struck by the thing before you and then you will be inclined to describe the reading or the music that way. It makes sense to ask what Cassie and the music have in common only when we are already inclined to talk about the music in the same way we do the vicissitudes of that passionate soul.

The answer to the philosophical question about the emotional expressiveness of art, that is, how we can intelligibly use the language of emotion for things that seem to be of the

wrong category to be described so, can now be summed up in three propositions. (1) In some cases we can see or hear a likeness between a part of a work of art and a human being, e.g. the twisted rocks as like a twisted body, the music as like a cry. These experiences can be understood in terms of the various notions of seeing-as. (2) As the consequence of various associations and conventions a word – or a work of art – can be experienced as 'filled with its meaning', the kind of thing Wittgenstein talked about under the heading of experiencing the meaning of a word. (3) Other cases are the result of using words with secondary sense and for which no further explanation is wanted beyond the noting of the language-game itself.

The second question that the discussion of secondary sense will help clarify is whether there are criteria for the application of aesthetic terms. The desire that there be such criteria doubtless arises from the same motivation that generates the search for a theoretical definition of art. That motivation was not simply the abstract intellectual desire for an orderly catalogue of the furniture of the world, but was primarily to settle disputes about what is and what is not art, to determine what is relevant to the understanding and appreciation of art, and to settle questions of artistic value. A theoretical definition, as pointed out in chapter 1, depends upon the identification of a property, or properties, A which under the most charitable interpretation is best understood as a general cover for any and all artistically relevant aesthetic qualities. A theory, then, can be no better than its defining properties A and if A's are the necessary and sufficient conditions for art, the program of the theory ought to demand necessary and sufficient conditions for A's. Traditional theories, however, never concerned themselves with these details and never really bothered to ask how particular artistic and aesthetic qualities are recognized.

More recently, a great deal of attention has been paid to the nature of particular aesthetic qualities and the logic of our talk about them. I do not want to survey this attention as in any

way in the service of some more general theory of art or aesthetic value, whether it is a neo-classic penchant for rules of composition and criticism inspired by rationalistic successes in mathematics, or a romantic rejection of rules in the name of sensibility and the creative genius of the artistic soul. What is important, rather, is how these qualities and their identification enter into our actual commerce with art and thereby enter into our lives.

The point of departure for much of this recent attention has been Frank Sibley's thesis that aesthetic terms are not 'condition-governed'.[15] He says that although reasons and explanations can be given for the use of these terms, these do not constitute criteria in the shape of either necessary or sufficient conditions for their application. He cites as examples of this kind of reason-giving the description of a painting as delicate because of its pastel shades and the judgment that a painting lacks balance because one group of figures is so far off to the left. The use and understanding of these aesthetic descriptions are supposed by Sibley to depend upon what he calls taste and sensitivity and he goes on to connect the exercise of taste and sensitivity with a kind of seeing. His remarks about seeing suggest that he has Wittgenstein's notion of seeing-as in mind, but his views are not worked out in the detail required to make them fully clear and explicit.

Peter Kivy has charged that on Sibley's view aesthetic terms would become 'ungovernable' – it is the same kind of objection that many would bring against the very idea of words having secondary senses – and argues against Sibley that at least some aesthetic terms are condition-governed. He offers the musical term 'stretto' as a counter-example and cites the definition of the word from the *Harvard Dictionary of Music*, '. . . the imitation of the subject in close succession, with the answer coming in before the subject is complete'.[16] Kivy is absolutely correct to point out that the word is

[15] 'Aesthetic Concepts', *The Philosophical Review*, 68 (1959), pp. 421–50.
[16] *Speaking of Art* (The Hague: Martinus Nijhoff, 1973), pp. 38–9.

applied on the basis of the criteria specified in the definition despite a certain vagueness in what is to count as the subject and the answer. There are a number of other important words in the artistic vocabulary for which this is also true. Art historians, for example, seek to establish criteria for style and period designations such as 'mannerist' and 'baroque' although there is considerable disagreement about just what these criteria should be.

An alternative to these two opposed positions is offered by Roger Scruton who proceeds from the commonly held assumption that concern for the meaning of any word has to involve concern for the truth of the sentences in which that word occurs. Meaning is thus a function of truth conditions.[17] Scruton is not, however, concerned with truth conditions as they figure in formal semantical theory, but rather in what he calls the 'strong epistemological' sense of the observable features of the world by means of which empirical statements are verified. Scruton contends that aesthetic terms denote *aspects* of things, in Wittgenstein's sense, and follows Wittgenstein in denying that aspects are properties of objects. Since aspects are not properties and aesthetic terms denote aspects, it follows that the sentences in which they occur cannot have truth conditions as ordinary descriptions do; they have instead *acceptance* conditions. The acceptance conditions for aesthetic descriptions are experiences of the sort that can be elucidated under the various notions of seeing-as. Thus there are no truth conditions for the sentence 'It's a duck' said of the ambiguous figure although we can *accept* the description if, and only if, we see the figure as a duck. There are, of course, truth conditions for 'He sees it as a duck', but that's another matter altogether.

Scruton's thesis can be read as a necessary emmendation of Sibley which takes into account the absence of truth conditions as a characteristic feature of aesthetic descriptions, but

[17] *Art and Imagination* (London: Methuen, 1974), 'Introduction' and chapter 4.

saves Sibley from the undesirable consequences that otherwise such descriptions are wholly arbitrary. Scruton's thesis that aesthetic qualities are aspects thus stands in diametric opposition to Kivy's contention that many aesthetic qualities, the expressive qualities of music, for example, are genuinely objective properties of the music.[18] My suggestion that descriptions of expressive qualities are secondary descriptions can, I believe, adjudicate this difference of philosophical opinion and help bring out the difference it may make to an understanding of art how the question is settled.

There is enough similarity between the logic of aspect descriptions and secondary senses to justify the supposition that secondary descriptions refer to aspects. The converse, however, is not true; not every aspect description entails a secondary sense. So far, this would seem to put me on Scruton's side but for having already endorsed some of Kivy's views about criteria. It remains to get a clearer view of the relation between aspects, secondary senses, and criteria. Here it will be useful to parade in some detail Sibley's examples of pastel shades and compositional balance, Wittgenstein's duck-rabbit, and finally Kivy's example of the stretto.

Pastel colors are defined as soft and subdued colors. The description of a color as soft is clearly a secondary use of 'soft' where the primary use is in speaking of soft pillows or perhaps soft voices. The ground of the ascription of softness to a color is, of course, the way it looks. The description of a color as soft is grammatically very much like that of *e* as yellow. In neither case does the word change its meaning and in neither case are there criteria for the application of the word. Just as we do not take *e* into a better light to determine its true color, so we do not apply any empirical test to determine the relative hardness of the color. Here it is evident

[18] *The Corded Shell*, p. 60. Kivy several times speaks of hearing music as expressive, as like a gesture, and so on, e.g. pp. 53 and 58. It may be that his insistence that expressive qualities are objective properties is not consistent with his use of the 'hearing-as' locution.

that there are no truth conditions for 'This color is soft'; we can speak only of the acceptance condition of seeing it as soft which can be evidenced not only by the inclination to use the word 'soft', but also by an appropriate tone of voice and relevant gestures.

Balance is obviously a more complex notion. The aesthetic use of the word to describe a composition is derivative from its primary use in referring to mechanical equilibrium and any understanding of this compositional feature must presuppose that primary sense. In art appreciation text books balance is sometimes explained as an artistic principle by means of a schematic representation of a painting showing the figures as if standing on a see-saw whose fulcrum is on the vertical axis of the picture. Indeed, there seems to be no other way to introduce the concept of compositional balance than by reference to see-saws and their kin. The usual criteria for mechanical equilibrium cannot, of course, apply to paintings. There are reasons and explanations for why a painting has or hasn't balance: 'This smaller figure balances the larger one because of its stronger color', 'This figure is too far off to the left', and so on. In this respect balanced paintings are unlike soft colors, but these reasons are not truth conditions.

The fact that there is so much more to balance than there is to soft colors may suggest the possibility that there are uniquely aesthetic or artistic criteria for balance distinct from the criteria for physical balance. This possibility has to be ruled out, however, and the example of another use of 'balance' can help show why. We speak of balancing the account books and that use is plainly borrowed from descriptions of see-saws and laboratory scales; when the books are in balance there is the same quantity on both sides of the ledger. There are, nevertheless, precise and technical criteria for determining that the books are balanced that have nothing to do with either dynamics or statics and the analogy with physical equilibrium is no help at all in teaching the concepts and procedures of accounting; another term for that condition would do just as well – could we not speak of the books

being 'satisfied'? The bookkeeper's sense is not a secondary sense of 'balance' and the special criteria and ways of teaching the word are justification for saying that it now has a different meaning. If there were independent aesthetic criteria for balance, the word would have a different meaning and its connection with the original notion would be broken. In the case of such a rupture the aesthetic description could not have the point that it in fact does.

The duck-rabbit provides an interesting contrast to both the preceding examples. To say we see the duck aspect is not to use 'duck' in a secondary sense. We can see in the picture many of the same features we see in a real duck – head, eye, bill, and in some versions even feathers. These are some of the very features that serve as criteria for identifying the creature on the pond or the thing in the conventional picture as a duck. We can even imagine someone seeing the ambiguous figure only as a bird or fowl of some kind or other and then coming to identify it as a duck rather than a goose or perhaps even a particular species of duck. Thus, it would appear that there are criteria, that is, truth conditions, for at least some aspect descriptions. The fact of the matter is, interestingly enough, that these truth conditions are themselves aspects which do not come into existence until the dot is seen as an eye, these lines as a bill, and so on. There are no truth conditions for the description of the dot as an eye and the lines as a bill; here there are only acceptance conditions.

These reflections allow us to get a better understanding of Kivy's stretto example. There can be no objection to identifying truth conditions for the statement that there is a stretto, but it must be remembered that the recognition of these conditions rests upon being able to apply the terms in the definition, 'subject', 'answer', 'complete', etc. These words in their musical application, I strongly suspect, are being used in secondary senses. To recognize a stretto one has to be able to hear a series of tones as a theme and then find it appropriate to call that theme a 'subject' and then to hear a variation on it as an 'answer' and finally to hear the answer as

seeming to 'interrupt' the original statement. This is another case of a whole package of language being taken over from one field, in this case conversation, and applied in an altogether different one. Interestingly enough, the word 'stretto' is not itself used with a secondary sense; in that respect it is like 'balanced' as a bookeeping term. It has come rather far from its original meaning which was something like 'strict' or 'compressed'. It is not at all necessary to refer to that to explain stretto as a device within the fugue.

Whether aesthetic qualities are 'objective' properties of works of art or only aspects is not to be determined by discovering whether there are criteria for the presence of at least some of them for, as we have seen, the existence of criteria is consistent with their being the objects of secondary descriptions. What, then, turns upon settling the question? I think it is this. If artistic and aesthetic qualities are aspects and if aesthetic descriptions are reports of experiencing aspects or are secondary descriptions, then it follows that art is not an isolated department of human activity sufficient unto itself, but is of necessity connected with and parasitic upon other areas of human action and interest. The ability to see aspects and use words in secondary senses rests upon the mastery of a technique, the technique of using the relevant words in the language-games which are their first home.

It is commonplace of aesthetic theory, but none the less significant, that art has important connections with the world and with human life – even the Art for Art's Sake movement never wholly or consistently disavowed the connection. The contention that aesthetic qualities are aspects is one way of representing and capturing that traditional insight. If, on the other hand, aesthetic qualities are 'properties', in Wittgenstein's grammatical sense, then the words designating them could be taught and their meaning understood by reference to works of art alone independently of other things and other compartments of life. That the aesthetic character of art, then, should resemble or duplicate important features of the world and human life would appear only a contingent and

accidental fact. I think that is an unacceptable conclusion. Given what I take to be the importance of secondary senses for an understanding of our talk about art, I believe it may not be amiss to think of art, paronymously, as a secondary activity.

Afterword

I have not argued that a philosophical theory or definition of art is impossible; I don't know what would show that. It is not that art can be proved to be an 'open' concept and not amenable to definition and it is not as if all possible defining properties have been surveyed and found to be neither common nor peculiar to all works of art. What I have been trying to argue is that the very idea of a theory or definition is a confused one. It is just not clear what could possibly count as a defining property of art; we don't know what can intelligibly be said to be a candidate to play the role of property A. In addition I have sought to eliminate the major motivation for traditional philosophical theorizing about art by insisting that the problems theories were to solve are really practical ones to which theory is not relevant.

Does not my stance, however, rule out all generalizations about the arts and make it impossible not only to discover, but even to look for, common threads and similarities within the work of a single artist or the art of a period or even between various art forms? If we could not look for and sometimes find such connections we could not define a style or characterize an age; we could not have art history and our understanding of a culture would be needlessly impoverished. Of course we can do these things and my attack on the philosophical theory of art rules out nothing of the sort. Wylie Sypher's cross-media comparisons, for example, are perfectly intelligible. So is Walter Pater's even more compre-

hensive generalization that all the arts aspire to the condition of music. What has to be made clear is the nature of such comparisons and generalizations.

When Sypher speaks of tensions and contradictions as common to mannerist painting, poetry, and architecture it is obvious that these terms are being used in secondary senses and we would miss the point of the comparisons if we persisted in trying to turn up the property common to all the situations where we impute tension. Sypher is referring to aspects that depend upon our seeing and reacting in appropriate ways and not to properties denoted by predicates occurring in statements for which there are necessarily truth conditions. I don't think a theory can be built upon aspects and the secondary uses of words; these are not the stuff of which theories are wont to be made.

When Pater cashes in his remark about all art aspiring to the condition of music, it is always in terms of some particular charm or aesthetic quality of some particular poem, painting, or example of architecture. It is as if he is encouraging us to see whatever it is as like a musical phrase. He, too, is directing our attention to aspects and his generalizations are always in the service of his own rather rarefied kind of appreciation; there is nothing there from which to make a philosophical theory.

Wittgenstein said that the real philosophical discovery is the one that makes me capable of stopping doing philosophy when I want to (*Investigations*, §133). There is some obscurity in that section, but that's all right because I want to appropriate the remark for my purposes regardless of its probably being about the use of examples in philosophy. The discovery, as I see it, is not that I can bring this essay to an end; I could always have done that merely by laying down my pen. It has, rather, something to do with recognizing the nature of philosophical problems, that they arise out of confusions and that attempts to solve them lead into blind alleys, into fly-bottles that echo with the buzzing of our discontent. The discovery, then, is that when we have taken one of those

false steps and ended up on a fly-bottle we can retrace our steps and regain the high road; that is, we can stop doing philosophy.

So this essay is in part an essay at stopping doing philosophy of art, in one sense of 'philosophy', and a plea for disentangling the questions we want to ask about art and the understanding we seek of it from philosophical questions and theories. I have not, however, stopped doing philosophy in that other sense of the word that seeks a clear view of our language and life, and tries to show just where the high road lies and marks the false turnings for what they are. But all the false turnings will ever get marked because new ones are forever being made. In this light I see what I have written as only a skirmish in the constant battle against the bewitchment of our intelligence.

Index

8 50 1 7 7 8 5 8